Who Cares

Who Cares

essays by
ANNE PASTERNAK
DOUG ASHFORD

participants
DOUG ASHFORD
JULIE AULT
GREGG BORDOWITZ
TANIA BRUGUERA
PAUL CHAN
MEL CHIN
DEAN DADERKO
PETER ELEEY
COCO FUSCO
CHITRA GANESH
DEBORAH GRANT
HANS HAACKE
K8 HARDY
SHARON HAYES
EMILY JACIR
RONAK KAPADIA
BYRON KIM
STEVE KURTZ
JULIAN LaVERDIERE
LUCY LIPPARD
MARLENE McCARTY
JOHN MENICK
HELEN MOLESWORTH
ANNE PASTERNAK
HEATHER PETERSON
PAUL PFEIFFER
PATRICIA C. PHILLIPS
MICHAEL RAKOWITZ
BEN RODRIGUEZ-CUBEÑAS
MARTHA ROSLER
RALPH RUGOFF
AMY SILLMAN
ALLISON SMITH
KIKI SMITH
DAVID LEVI STRAUSS
NATO THOMPSON
THE YES MEN

CREATIVETIME

Published by
Creative Time Books
307 Seventh Avenue, Suite 1904
New York NY 10001
212-206-6674
www.creativetime.org

Designed by
Project Projects

Managing Editor
Melanie Franklin Cohn

Distributed by
D.A.P./Distributed Art Publishers, Inc.
155 Sixth Avenue, 2nd Floor
New York NY 10013-1507
212-627-1999
www.artbook.com

ISBN: 1-928570-02-X

Rockefeller
Brothers Fund
Philanthropy for an Interdependent World

Please note that the views expressed
by the artists are not necessarily those of
the Rockefeller Brothers Fund.

Printed by
Kromar Printing Ltd., Canada

Statement of Support

Ben Rodriguez-Cubeñas

The Rockefeller Brothers Fund (RBF) is pleased to support Creative Time and its *Who Cares* project. Creative Time's history of presenting new, risk-taking programs that address important contemporary social concerns reflects the RBF's aim to foster an environment in which artists and the creative process can flourish in New York City. In supporting arts and culture, the Fund is inspired by a conviction that art creates beauty, invites discovery, stimulates reflection, and generates self-knowledge, and that engagement with the arts promotes deeper understanding of human experience among diverse communities.

Through its work with artists, Creative Time documented that public discourse and action on social issues is declining in New York City. Inventive voices in the public realm are drowned out by commercialization, lack of space, and strict funding programs. By addressing important obstacles to the creation of art in the public realm, Creative Time's *Who Cares* provided a safe space and the resources for convening a diverse pool of cross-generational artists and intellectuals. The dialogues generated from the project underscore the need for more artistic and other intellectual reflection and interaction, and recognize that the absence of spaces to gather seems to be a root cause for the lack of responsive work.

The RBF hopes that the *Who Cares* artists' projects inspire, provoke, and spark debate on some of today's most important public issues. Artists offer the public unusual vantage points from which to understand contemporary culture and society and help move conversations about important issues into deeper discourse—and, hopefully, social action.

About the Rockefeller Brothers Fund (RBF) Founded in 1940, the Rockefeller Brothers Fund encourages social change that contributes to a more just, sustainable, and peaceful world. The RBF's grantmaking is organized around four themes: Democratic Practice, Sustainable Development, Peace and Security, and Human Advancement. Though the Fund pursues its four program interests in a variety of geographic contexts, it has identified several specific locations on which to concentrate cross-programmatic attention. The Fund refers to these as "RBF pivotal places": sub-national areas, nation-states, or cross-border regions that have special importance with regard to the Fund's substantive concerns and whose future will have disproportionate significance for the future of a surrounding region, an ecosystem, or the world. The Fund currently works in four pivotal places: New York City, South Africa, Serbia and Montenegro, and Southern China.

Ben Rodriguez-Cubeñas is the program officer for the New York City portion of the RBF's Pivotal Place program.

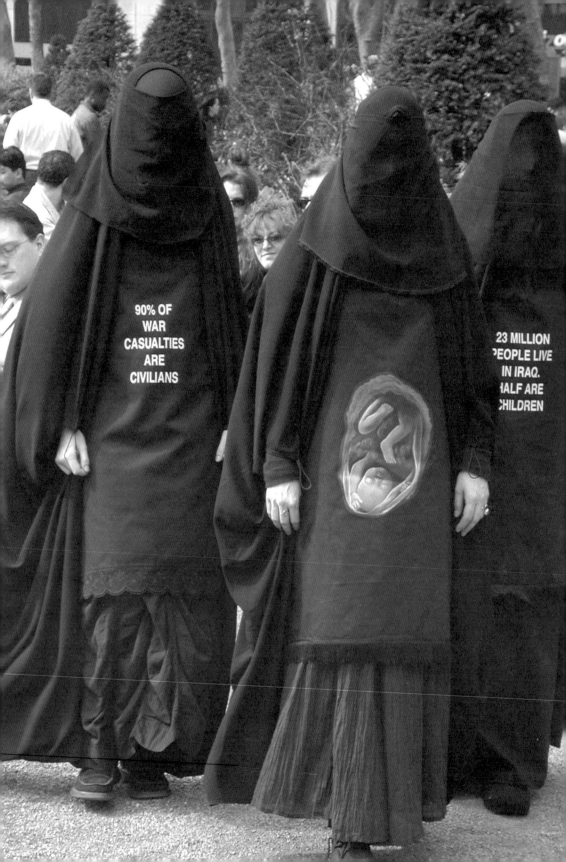

Introduction

Anne Pasternak

Working at an organization with more than three decades of experience in presenting timely, socially conscious public art projects, Creative Time's staff started to wonder in 2001 why there seemed to be a noticeable decline in "politically-engaged" art over recent years. Our questions mounted into concern as wars ensued and hard-won freedoms were undone, yet it was hard to find evidence of discontent by surveying galleries, museums, and magazines. At this moment of rapid change in American culture and art, *Who Cares* was conceived as an attempt to investigate artists' evolving relationships to social action through the perspectives of artists themselves.

Our primary goal was simple: Creative Time wanted to bring artists together to discuss their views on art's relationship to social action in a safe and free environment, and we wanted to disseminate our findings to a broad audience. But if artists were not terribly interested in this kind of socially engaged practice, why did Creative Time seek them out? We felt that the need for artists' voices in public dialogue perhaps had never been greater. And yet we feared that if fewer artists were making so-called "socially active" works, the power of artists to shape public discourse and social consciousness could diminish and likely already had. Corporations, media giants, and politicians are in increasing control of the dissemination of public information, ensuring that our engagement with diverse perspectives on contemporary issues grows ever more impoverished. We wanted to do our part to shift this trajectory.

We also hoped to provide a source of support for artists whose projects are too time-sensitive and/or content-sensitive for the long grant cycles of foundation, government, and corporate donors. In the process, we hoped our efforts might sustain New York City as a place where artists have the freedom to spark insightful and informed reflections on the world. While there is little support for socially progressive art in this country, the Rockefeller Brothers Fund fortunately stepped forward and underwrote this initiative—from the dinner forums and this book to the commissioning of several timely public art projects.

Throughout Creative Time's history of commissioning and presenting adventurous art in New York City's public arenas, we have helped artists freely address current public issues and embraced difficult, and at times, controversial topics. Creative Time's programs took the activist spirit of our peer alternative arts organizations outside to the dynamic and unpredictable forum of urban public space. In the 1970s, for example, exhibits in derelict and vacant urban sites, such as *Custom and Culture* (1977 and 1979) and *Ruckus Manhattan* (1975), responded to New York City's rampant decay and promoted a more promising vision for the revitalization of the city. In the mid- to late 80s, projects like Gran Fury's bus posters, *Kissing Doesn't Kill: Greed and Indifference Do* (1989), evinced Creative Time's commitment to artists' bold stances on important social issues like AIDS, racial injustice, and domestic abuse through the appropriation of mass-media advertising spaces. And with the onslaught of the American "culture wars" in the late 80s

and mid-90s, Creative Time supported artists like Karen Finley in taking strong platforms on freedom of expression when other organizations turned away for fear of negative consequences (i.e., from media attacks, public protests, and the inevitable threat of withdrawn public and private funding).

But after the "culture wars," it seemed as though it was becoming increasingly rare to find compelling artwork that addressed timely public issues. Were artists more apathetic or overtly disinterested? Like so many cultural institutions, was it possible they were fearful of negative public reaction or market reprisals? To more deeply probe this situation, Creative Time organized its first artists' forum in 2001. Participants shared with us their difficulty in finding financial support systems that fostered socially timely work. They expressed frustration at the limitations imposed by project-specific grant programs and long grant award cycles that made it nearly impossible to present time-sensitive projects. They were frustrated that many traditional avenues of support (e.g., government agencies and foundations) stopped funding individual artists—again, out of fear of offending constituents and attracting negative attention.

They also recognized that experienced artists who investigated such artistic pursuits were most often marginalized by the art public—especially the gallery, museum, and collecting audiences—so younger artists were further discouraged and, therefore, disinclined to engage in creating art about public issues. Work with overt social implications also had begun to seem outmoded and was at times dismissed as simplistic rather than thoughtful, layered, and having multiple possibilities of interpretation.

This attitude seemed to be largely a by-product of the assault on artists by conservative interest groups during the "culture wars." And their efforts took hold. Take, for example, the backlash against Okwui Enwezor's documenta 11 in 2002. It was an intelligent exhibition featuring significant works, yet many critics vehemently dismissed the show for the curator's political thesis. At the same time, with the art market in a fast, unprecedented expansion, art's value was becoming more and more aligned with money. For many, an artwork's value as a commodity became at least as important as its message. Despite this situation, Creative Time continued to encourage artists to address public issues.

During this time, Creative Time supported several timely projects that helped us further shape the *Who Cares* initiative. For example, as the United States prepared to invade Iraq, artist Adelle Lutz conceived a public intervention to promote awareness about the direct effects of war on women and children. In a slow, meditative journey through the city's streets, twelve artists joined Adelle in donning black burkhas silk-screened with statistics about war, encouraging thousands of unsuspecting passersby to pause and consider the likely repercussions of the ensuing war. At the same time, artist Ignacio Morales was compelled in the aftermath of September 11th to create an understanding of how current events are influenced by complex histories of foreign policy with his comic book entitled *9-11/9-11*. Featuring a fictional story of an immigrant family in New York City, this work drew parallels between the events of September 11, 2001 and the Chilean Revolution of September 11, 1973. In both projects, Creative Time assisted the artists with modest financial, legal, and marketing support. But we wished we could do more. So, in November 2003, Creative Time's staff actively began to design what became the *Who Cares* initiative.

Throughout the course of a year, the staff debated what we could and should do while interrogating the popular notion of artists as leaders of social change. We had many differences of opinion, but we did share a passionate belief in the fundamental idea that art can encourage us to look at our surroundings in unusual, and often profound, ways; that art can foster insightful dialogue on important public issues; and that art can convey and foster a sense of personal involvement and responsibility. We also agreed that it would be best to hear from artists directly on these subjects.

Who Cares was thus designed to provide intimate forums where artists of diverse generations and backgrounds could be free to share opinions, debate positions, and incubate ideas and strategies. In thinking about the right person to contextualize and moderate the conversations, we turned to artist, activist, and professor, Doug Ashford. As a principal artist of Group Material, he had excellent experience in creating socially engaged art projects. As a teacher, Doug had lectured and written extensively on radical art practices. And, as an activist, he had strong opinions about the role of art in society, one that he balanced with a generous attitude toward the diverse opinions of others. Enthused to take on this effort, Doug worked with the Creative Time staff to create a list of dream attendees (artists along with a few esteemed writers) and structured the conversations around three core themes: "Anywhere in the World," "Beauty and Its Discontents," and "War Culture." He then wrote an introductory text to illustrate the themes we would discuss over our dinner forums, hoping artists would be as interested in these topics as we were.

Much to our delight, we received an overwhelming response to our invitation to attend the three dinner forums that took place in November and December 2005. Truth be told, each of the discussions strayed from the themes, allowing participants to discuss what mattered most to them. As a result, common threads and views are found throughout each conversation. Some participants were so impassioned by the topics at hand that they dominated conversation; others felt shy, unsure, and even confused and mistrustful of Creative Time's intentions, and so they participated less. Some participants wanted more meetings; others wanted them to be structured differently. Regardless, each night featured robust discussions and an incredible range of ideas was exchanged. We published this book to share the artists' thoughts with a wider audience and to do so quickly for the benefit of those who might be craving similar conversations. Our hope was that by producing an inexpensive paperback, artists, students, and scholars alike would be able to engage with its ideas and challenges. Throughout the process, we were open about organizational biases, agendas, and limitations. We respected the participants' voices, inviting them to shape their contributions to make sure their thoughts had the weight and importance they deserved. We then commissioned four public art projects to be presented in the fall of 2006. (See Appendix 7, pages 168-171, for descriptions of these projects.)

It has been a personal privilege to be a part of these conversations, and I am excited to be sharing them with you now. This effort took the dedication and hard work of many people who cared. Above all, I applaud Doug Ashford and all the artists, writers, and curators who openly and bravely devoted themselves to this process. I cheer my staff, past and present, who helped design this initiative. Carol Stakenas, Peter Eleey, and Vardit Gross

were particularly central to the program's design as was Heather Peterson, our ever-talented Deputy Director. While Peter brought critical insights and creativity to the design and shape of the conversations, Heather expertly guided the project's every detail with the care and respect it deserved. Our communications team of Maureen Sullivan and Brendan Griffiths worked hard with us to make sure the book had the look and feel we desired. All of us were fortunate to be supported by our dedicated interns Emma Curtis, Paloma Shutes, and Lilly Slezak.

Conceiving of the book and managing its contents was a herculean and complicated effort, managed with care, constancy, grace, and a generous spirit by our wonderful managing editor, Melanie Franklin Cohn. Likewise, it has been a privilege to work with Project Projects, the graphic designers for this initiative and this book, as well as with D.A.P./Distributed Art Publishers who is ensuring *Who Cares* reaches a broad audience.

I thank Creative Time's fantastic board members who encourage our inquiries and support our risk-taking spirit. Thanks, in particular, are due to our visionary Board Chair, Amanda Weil, and to former Creative Time Board member, Michael Brenson, who has encouraged us to share our inquiries with larger publics. We take a bow to Dillon Cohen, who made sure the dinners would be comfortable by opening his home and heart to our conversations. Finally, my most sincere gratitude is extended to Ben Rodriguez-Cubeñas, program officer for the New York City portion of the Rockefeller Brothers Fund's Pivotal Places program, and his colleagues at the foundation, who believe in art and its relationship to social change and, therefore, took a chance on this initiative.

Finding Cythera:
Disobedient Art and New Publics

Doug Ashford

The idea is that the activity we undertake with each other, in a kind of agonistic performance in which what we become depends on the perspectives and interactions of others, brings into being the space of our world, which is then the background against which we understand ourselves and our belonging. I find this a compelling account because it stresses historical activity and human creativity, but without falling into a naive view of individual agency or intentionality. The world made in public action is not an intended or designed world, but one disclosed in practice. It is a background for self-understanding, and therefore something not purely individual. It is also immanent to history and practice, unlike ideas of community or identity, which tend to be naturalized as stable or originary.

—Michael Warner, "Queer World Making"[1]

My experiences with the capacity of art to re-create public life through performance and play has been made understandable through a history of collaborations: in classrooms, in the museum, in the street, and throughout the social contexts occurring between them. The conflict between these spaces, and the habits and events that inform them, is the matter that inspired the planning for the conversations that follow. As a consultant on the organization and documentation of *Who Cares*, I was often reminded that the collaborative work artists do to effect public life is intimately linked to the performance and play of conversation—those that we have between ourselves and our audiences. The possibility of transforming a politically silent art system into a collection of discursive and engaged forums has occupied a signal community of artists for many years, as part of a larger desire to obtain and defend a truly public context for culture in this country— a struggle that is far from over.

In helping to plan the *Who Cares* project, I looked for political proposals in an unexpected place: easel painting. Historically, painted pictures have modeled a world decolonized from the constraints of official power and subjective pose by visualizing the social relations that can only be built or arranged in a purely invented place. This idea of a painted picture as a performed invention is perhaps as old as pictures themselves. And the dialogic performance of a picture—the collective speculation in the space we hold between ourselves in the viewing of art, the way an image hanging on a museum wall defines a public forum in front of itself—is also very old, reaching back to the Enlightenment concepts of the public realm, the parliamentary room, and the politics of virtue. Before stumbling back onto the moments of collective speculation that painting once instigated (and still does), I began with the psychogeographic drift of the sixties and I worked back from that era of radical public art practices through other precedents.

Jean-Antoine Watteau,
A Pilgrimage to Cythera, 1717.
Musée du Louvre, Paris

I found painting to be one possible origin of our ability to see contemporary dialogue as an exercise, simultaneously aesthetic and political.

In the beginning of the eighteenth century, many paintings were made based on the liberating effects nature was assumed to have upon social conversation. There were two works from this period in particular that drew my attention: *The Pilgrimage to Cythera* and *The Embarkation for Cythera*, both painted by Jean-Antoine Watteau between 1717 and 1719.[2] Each depicts lovers in transit, interrupting an ongoing public communion they are having with each other and the arcadian setting they transverse. I looked to these images for a way to imagine a resolution to the anxiety I felt (and still feel) when confronted with the conflation of the sensual and political demands we place upon social dialogue: on one hand, we look to conversation for pleasure; on the other, we have trouble considering it apart from its ethical functions, its foregrounded role as the basis of a free society. But these paintings represent more than the traditional salon *parler*.

Although painfully elitist in many ways, these pictures offer the symbolic possibility of conversation leading to collective excursion, a departure from what is expected in an improvised performance. For me, this is an extremely contemporary proposal. Watteau insists that the tension between the drive toward pleasure and the social necessity of politics are intricately linked in the performance of every cultural exchange. When we dance, we pose and reform. When we converse, we challenge and accept. Paintings of social escape and interaction ask that a viewer accept happiness and knowledge as two dialectically interdependent notions.

Cythera is the island where Venus was born from the collision of the son-castrated genitals of Uranus with the foam of the sea. For Watteau and his audience, it is understood as dramatically metaphoric, a figurative place inspiring the reassignment of desire and morality according to the social hopes of the libertine's imagination. The social conversation that generated the period's approach to sexuality was imperative in discussing this transformation, especially in its insistence that we ignore all existing aesthetic and political expectations in the alliance with passion. What is key here, though, is that it was the possibility of conversation as a subjective experiment that was the bridge to this realization, both for love to develop and for knowledge to be produced. Watteau's scenes represent the ambiguity of conversation as a form of free association—talk as performance, conversational address as drag, and discourse as a form of call-and-response—that in turn predicts and parallels the parliamentary social entreaty described in the Enlightenment as a potential basis for emancipation. So these paintings of lovers on a trip are more than signposts to pleasure—they are guides to the challenges faced by public expression. Viewing them, one can imagine how social space must be emptied if it is to be designed to accept the discourse of emancipation. Such an "empty" space—capable of representing dissent and difference—still stands as a metaphor for democracy.

Now that the three conversations of *Who Cares* have taken place, I conjure Cythera again as a reminder of how this project began as a series of meetings separated from the producing and commissioning work of Creative Time, informal spaces that could be somehow emptied of purpose and

utility. We wanted participants to be able to speak of the public culture that seemed impossible to speculate and realign. The poverty of responsive, socially active visual culture in New York City was the genesis of Creative Time's proposal and of my involvement. My contribution began as a reflection on artists' insistence for the dialogic nature of art, for art's potential to create contexts in which groups of people could re-design their relation to each other, to fairness, and to happiness. I wanted these conversations to reflect the potential of art to call for non-normative models of happiness, models that resist those profitable pleasures engineered by the increasingly consolidated ownership of culture. Such calls are a consistent character of all countercultural practices: if we want our happiness, we have to design our own forms of interaction, both physical and social.

My insistence on the viability of counterculture as an organizing theme for these meetings was not particularly unique.[3] There have been calls for reprogramming culture and intellectual life in America for more than a hundred years now—from the search for alternatives in museums to free presses, from war resister leagues to commercial-free journalism, from community schools to food co-ops, and more. Such calls are now increasing under a condition of growing intellectual expression management which takes form in things like the anti-abortion and pro-oil lock down on scientific research, the self-censorship of journalists, and the ideological invasion of the academy by censorial "watch groups." Art and its attending institutions have cyclically responded to such crises, but recent cultural repression, dominated by the explicitly dark conflation of a planned deprivation economy and the social terror imposed by our government's relentless sponsorship of war, poses a particularly immense social field of repression.

For many involved in cultural organization and discourse today, the progressive role for public art sponsorship, presentation, and promotion depends on representing often subaltern histories of radical public uses for art—possibilities that are difficult to discern in today's market frenzy. Many institutions of art and criticism seem to have selective amnesia concerning work that questioned the ownership of our economies of production, the use or development of cities, and the social function of urban institutions. The paucity of historical thinking in America is an epidemic any teacher can attest to, but it is curious that the capacity to imagine countercultural discourse has diminished even in New York—a city that has inspired so many re-inventions of self and space and that has seen definitions of pleasure change and adapt to the imaginations of its residents.

Accordingly, even though the participants of Who Cares were asked to describe new possibilities for critical visual forms, they spent a lot of their conversation describing what kind of visual dialogical tactics worked in the past. Artists do this. We list and compare, trying to recognize new examples and hoping to mis-recognize official taxonomies of received ideas. Indeed, my inclusion of Watteau on a list of progressive public art practices—which for me includes James Brown, The Guerilla Art Action Group, Archigram, and Louise Lawler—speaks already to this process. One purpose of the Who Cares meetings was to compare these lists, to set a new agenda for the possibilities of resistant art rolling into the future, and to collectively build, through conversation, a foundation of examples that could be used by future practitioners. Suitably, this publication includes a partial enumeration of references, definitions, and inspirational examples that can be read alongside

the testimony and inquiry of the three conversations. In other words, as these discussions evolved as performance, the possibilities of the past could be set up for consideration alongside speculation for the future.

The following conversations diverted in another important way from planning expectations. Although I wrote in my letters to the participants that I wanted the evenings to be "working meetings," a central reverberating image for the whole project was not "work" at all. It was play—or at least ludic interaction as a potential form of research. This is something embodied by Watteau's pictures and presented or theorized by other Enlightenment projects, from the French socialist Charles Fourier's utopia of "conviviality" to the "play instinct" identified by German poet, philosopher, and dramatist Friedrich Schiller. Play and experiment is exemplified in many of the practices and problems discussed in these transcripts. For the critical efforts that we have labeled countercultural, much that is important about play begins with conversation. Equally important, though, is an understanding that the emancipatory moment for new communities demands privacy. It is, after all, hard to play in public. Private play, claiming freedom from interference to generate independent discourse, is crucial to developing countercultures. Imagination looks to be separated from the constraints of late capital's mediagenic complicity and the false ideals of "participation" that our neo-liberalism has perfected. Of increasing importance to many activists and artists alike is the achievement of some kind of separation from garish examples of marketing as "interaction," the introduction of a disobedient voice into the consolidation of media ownership into tinier and tinier spheres of self-reflection, and a rejection of the literal selling of electoral outcomes through advertising onslaughts.

Although seemingly in contradiction with our topic of the possibilities for public art, the consideration of social subjects is incomplete without an understanding of privacy—that is, how communities redesign themselves in opposition to, or in separation from, dominant culture. I would like to include all communities in this definition: those seeking to escape normative boundaries for desire and sexuality, as well as those clubs, labor unions, consumer cooperatives, user-groups, and civic associations of all kinds who create new languages and subjectivities out of the possibilities that association gives them. Two generations of feminist and queer social practices attest to the critical relationship that separated non-utilitarian conversation has to power. In order to raise consciousness, we might need to be alone for a while! Importantly, these critical trajectories help us to distinguish between the forms of isolation that are impressed upon us. With financial deprivation and compulsory pleasure regimes being projected from on high, it is important to realize the resistant effect of autonomous programs we can determine and construct for ourselves. More than ever, artists need to be alone to re-think their relation to an industry overwrought with competition and overrun by market promotion.

In a context of increasingly commercialized relations for visual art production, the management of expression has as much to do with implicitly forcing speech as it does to actively squelching it. A repressive apparatus of official censorship not only manages our expressions, it also pressures a population to adopt certain stances and attitudes. It is hard to tell which is worse: being told that certain images or ideas are offensive to the majority

by a militarized state, or being told that to be accepted we must speak a certain way or say a certain thing, as illustrated by recent official demands that we speak English, have a flag on our car, or get married in a chapel. This insidious form of public management through compulsive affirmation has a direct effect on artistic practice. As artists we are barraged by signals in our industry to be positive, encourage participation, and "keep the faith."

Private dialogue as experience can be understood as an independent aesthetic product in the re-establishment of privacy and friendship.[4] For my purposes here, it was critical to accept early on that the *Who Cares* conversations would be justified in themselves, separate from any use they might have in the future; and separate, certainly, even from their potential publication. The discussions were justified simply in the bringing together of individuals in a temporary space of mutuality. The private, separated time for conversation is a potential space for multiform inclusion. It is here that we might censor ourselves just a little less than in public. Through the experience of juxtaposition and comparison, the diverse and competing lists of points and ideas that arise in conversation stand in for a larger exercise in democracy. Conversational comparison can be seen as a map or a plan, a proposal or a picture. Abstract and romantic in an art historical sense, this visual form of inclusiveness, as evinced in Watteau, is part and parcel of post-Enlightenment aesthetics—from Schiller's suspension of the self and his notion of the world in play, to the affect of a subjectivity that is always in a state of becoming, what the painter Linda Besemer refers to as the "stammer of inclusion."[5]

Hans Haacke reminded us in the 1970s that "art is social grease."[6] As most of us know, going public is always risky. To the managers of public spaces today, relational practices that are based upon the open-ended inclusion of audiences in art world celebrations fit frighteningly well into the logic of uneven social development. An art festival, a public art program, or an art center might be more persuasive and less expensive than a police officer's baton. Just as meta-advertising designers incorporate leftist progressive political trajectories to sell sweaters and suits, public art projects can legitimate the smooth, uninterrupted authority of urban renewal and its attending erasure of cultural difference. Cities now find distinction through art and its industry's symbolic capital. As Miwon Kwon has clearly argued, public art's currency comes in giving cities the identity they have lost to redevelopment while they continue to redevelop.[7] The expected intervention of what came to be called "new genre public art" under the official guise of community-based art production was arranged neatly during the 1990s to re-enforce the idea of city as a paradigm of controlled and developed appetites. Even this publication, and the process it seeks to engender, risk a dilemma: the linkage of public practices to the policies of development of a new "cultural class," a demographic addicted to an unending consumption of newness and promotion. This narrative for art is now coupled to the design of experiences that form a symbolic foundation of capitalist accumulation.

The difficulty of planning democratic contexts that will effect a replacement of existing discourse is not to be underestimated. Although the discussions for *Who Cares* were planned to make room for the failures that privacy allows, our exchanges often reflected work and careers. The implicit and invisible weight of institutions in the sponsoring and organizing of supposedly speculative critical forums needs to be better understood.

How are these conversations going to be used, and by whom? Artists' collaborative agendas, even if designed in private, can be appropriated into the boutique factory that has become the American city. For many (and specifically, for some who were invited to these talks), any engagement in conversation without the concrete commitment for art sponsorship that allows us to disassociate our work from this spectacle is like polishing silverware in a burning house.

From talk to love to revolt. Since the beginnings of modernity, we have seen the notion of happiness linked to emancipation. Again public conversations are asking what kind of freedom particular public practices predict. If we are free, then what are we free to do? In a way, this is one of the first questions informing the modern disruption of private concerns and public occupation. The members of Watteau's libertine crowds are in a sense "free" to pursue their own subjective transformation in the separated context of theatrical play. In the associative roles they perform, in what amounts to a hybrid private-collective escape, we can find new subjectivities and experimental forms of political understanding. Michael Warner has argued beautifully that the shared performance of private understandings can change broader conceptions of democracy.[8] To make private models into what Warner calls "inhabitable worlds," artists need to convince, seduce, cajole, and strike. For democracy to be modeled in a new way, participants need to be able to speak in dialogue outside of the need for promotion or success. To make private models into inhabitable worlds, artists and all residents of the city need to demand that culture represents the true complexity of their happiness. If that happens here at all in this document, let it be as a model for more.

1 The epigraph to this essay is drawn from Annamarie Jagose, "Queer World Making: Annamarie Jagose interviews Michael Warner," Genders 31, 2000, http://www.genders.org/g31/g31_jagose.html#n11 (accessed June 11, 2006).

2 For a complete discussion see Mary Vidal, Watteau's Painted Conversations: Art, Literature, and Talk in Seventeenth and Eighteenth-Century France (New Haven: Yale University Press, 1992).

3 See the full text of my letters to the Who Cares participants in Appendix 1, p. 146.

4 See my essay "The Boy in the Park, or The Miniature and the Model" in Wolfgang Tillmans, ed., Jochen Klein (Cologne: Walter Konig, 1998), p. 75–92. The essay examines how the discrete art object is equal to the more "respected" process of institutional critique in terms of proposing re-alignments of political and aesthetic thinking.

5 See John Rajchman, The Deleuze Connections (Cambridge: The MIT Press, 2000). I connected to the possibility of the "stammer of inclusion" as a radical formal method through Linda Besemer's writing on the politics of painting. See Linda Besemer, "Abstraction: Politics and Possibilities." X-TRA Contemporary Art Quarterly 7, no. 3, 2004, http://www.x-traonline/vol7_3/bessemer_abstraction.htm (accessed August 18, 2006).

6 Hans Haacke, e-mail message to author, July 17, 2006, in reference to his work On Social Grease, 1975.

7 See Miwon Kwon, One Place After Another: Site-Specific Art and Locational Identity (Cambridge: The MIT Press, 2002).

8 I am indebted throughout this essay to Michael Warner's thoughts on performance, politics, and the public sphere: Michael Warner, Publics and Counter Publics (New York: Zone Books, 2002).

Anywhere in the World

Conversation 1
November 14, 2005

This *Who Cares* discussion was motivated by the cultural phenomenon of
art biennials and urban art festivals, and their parallel rise with the growth
of transnational corporate power. A number of globalized industrial and
corporate practices—notably the outsourcing and distribution of individuals
and labor, often without ties to any particular city, country, or continent—
find similarities with the way artists today are asked to be both everywhere
and nowhere, and their practices transportable, transferable, yet in some
way specific to their location or community of presentation. In this context,
creative practice is challenged to map and model new experiences of
citizenship and occupancy.

But in the post-9/11 moment, the promise of participatory and
socially engaged art practices has been met by formidable barriers to free
artistic exploration and expression. When we consider this in light of the
history of the institutionalized "community-based" practices of the 1990s,
the compounded factors that inhibit those seeking to inspire, fund, or
produce sustained radical art practices begin to take shape. It is perhaps
fitting, then, that this discussion begins with a look at the impact of these
forces on the nature of artistic expression through the participants'
personal experiences, from the tightening of security to the reactions of
a fearful public.

The dialogue touches upon the need for discursive spaces—places
where people can come together and share discussions on art and social
issues—and examines how these spaces have enriched artistic practice
in the past. Many participants communicated their belief that local issues
generate sustained involvement by a broader audience and fuel larger,
global actions. For much of the conversation, the participants consider ways
in which art practices can create dialogic and collective representations
and effects. Although the discussion revisits the question of art's political
efficacy, eventually the group focuses on how to see beyond the ideologically
convenient museum and art fair celebrations of socially relational forms,
to a real horizon of new audiences, their politics, and the practices that might
affect them.

The Yes Men, *Twenty Years
Later, Dow Does the Right Thing,*
December 3, 2004

participants
DOUG ASHFORD, moderator
ANDY BICHLBAUM (THE YES MEN)
MIKE BONANNO (THE YES MEN)
TANIA BRUGUERA
MEL CHIN
DEAN DADERKO
PETER ELEEY
CHITRA GANESH
HANS HAACKE
LUCY LIPPARD
ANNE PASTERNAK
PATRICIA C. PHILLIPS
MARTHA ROSLER
DAVID LEVI STRAUSS

DOUG ASHFORD The purpose of tonight's conversation is to discuss the context in which we find ourselves, as scholars and artists, in what we now understand as a globalized economy. There are two parallel things that, for me, exemplify this moment.

One is that, as artists, we're expected to do projects that work everywhere, that can function in the present festivalized moment and that, increasingly often, don't speak to local or coherent communities of concern. In terms of the art world's current methods, art is considered socially relational, yet nonspecific. Ideas of local or timely concerns are being left behind.

The parallel for me, which I think is interesting and also perverse, is that in the same way artists are expected to be global and itinerant, whole sections of the economy are also expected to be nomadic. People are expected to work in whatever countries they can find employment while often being denied citizenship. So, I'm hoping that we can speak to that larger economic moment.

I'd like for each of us to describe individual experiences we've had that demonstrate how the nature of public expression has changed in the last five years, and I will start. I had a student, Otto Gillen, who was taking photographs down by Federal Plaza. This was a nineteen-year-old kid involved in a simple photojournalistic project. He was taking photographs across the street from the Federal Building and guards came and stopped him. They took him into the basement of the Federal Building and made him empty the film from his cameras. As a teenager, he had little sense of his rights and no idea how to protest legally. When I started doing stuff in the street in 1981, it was an open place for discourse, but now it is seen and experienced by this generation as tremendously regulated.

PATRICIA C. PHILLIPS I am also a teacher and teach at the State University of New York. A SUNY trustee is advancing and advocating for the Academic Bill of Rights. This is another very significant public realm or public sphere that is becoming subject to regulations and controls about what people teach and how they teach. It's a disturbing dynamic. I don't want to focus this on academia, but I think it's interesting and alarming how the public is regulated—and who assumes the authority to do this.

ASHFORD Well, now this student and his colleagues are in their studios with eighty other kids making little cardboard cameras that don't have film in them. They're going to go back down there next week and they're going to stand around Federal Plaza with fake cameras that have no film in them and see how the security system responds to the fictional cameras.

MEL CHIN Well, I'd advise the students to be cool, but to continue using creativity and to lie, if necessary, to keep from being beaten or arrested. You know, in 1991, I took

Oto Gillen, *Federal Plaza*, 2005

The Academic Bill of Rights is a document introduced in October 2003 by Students for Academic Freedom (SAF) and right wing activist David Horowitz. It lists eight principles that call for an academic environment where decisions are made irrespective of one's personal, political, or religious beliefs. The Bill has come under sharp attack, however, for using egalitarian principles and a self-identified "bipartisan" framework to promote and instill a specific conservative agenda.

Oto Gillen, *Cardboard Cameras*, 2005

Mel Chin, *Support*, 1991

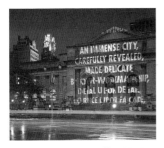

Jenny Holzer, *For the City*, 2005
Projection at New York Public Library.
©2005 Jenny Holzer, member Artists
Rights Society (ARS), New York. "Love
Lies Sleeping," from *The Complete
Poems: 1927–1979* by Elizabeth Bishop.
©1979, 1983 by Alice Helen Methfessel.
Used by permission from Farrar, Straus
and Giroux, LLC.

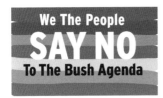

Artists Against the War,
rainbow flag

six hundred yards of the best selling yellow ribbon and made a thirty-foot rope. I made a noose out of it and hung it up in an oak tree at the McGuinness Boulevard exit of the Brooklyn-Queens Expressway where all the traffic flowed into, what was then, the densest yellow-ribbon neighborhood in Brooklyn.

These women came up in a Cadillac and they were from the Veterans of Foreign Wars outpost there. They knew something was up. We were dressed covertly—we had jumpsuits on—and we looked like workers. So we blamed somebody else; that's the first step.

But they said, "Excuse me, exactly what does that mean and what is it for?" And I thought about describing, as an artist, why I did it: How I saw that the war was coming to an end and instead of rejoicing people were crying in their Midwest neighborhoods about wishing the war wasn't over because it meant the yellow ribbon tying club was ending. I was concerned about this emotional suicide—the lack of knowledge about the origins of your emotions—because you should be happy that the war is over.

But instead, I just told them that it was a symbolic rope to hang Saddam Hussein and she said, "Okay, fine." To me, it was more important to have the statement be maintained for as long as it could be, so that there were possibilities for other discourses to happen outside of it, you know?

LUCY LIPPARD You could have told her it was giving her enough rope to hang herself with.

ANNE PASTERNAK When Creative Time did Jenny Holzer's *For the City* project (2004 and 2005), fire engines and police vans were called in to inspect the New York Public Library projections because they had gotten a 9-1-1 call that there were terrorists communicating on the library façade.

LIPPARD One if by land, two if by sea. I live in a very small rural village and I had one of those rainbow flags that said, "We the people say no to the Bush agenda" on my barbed-wire fence before the election. And my friends said, "Well, that will last one day." It lasted two days and then it came down and I didn't expect to ever see it again. The day after the election, it turned up—folded very neatly—in my mailbox. Now, what does that mean?

MARTHA ROSLER Those rainbow flags were created by the artists' group I'm associated with, Artists Against the War. It was formed on the basis of a group of meetings in the summer of 2002 when we realized that the shit was going to hit the fan.

The group did a draw-in at the Metropolitan Museum, drawing Assyrian objects. They did an erase-in where they drew the objects and then erased them. They had a stroller action, wheeling strollers down Fifth Avenue because half the Iraqi population is under fifteen. We've just done a project, which I really wasn't part of because I was away too much.

It's a DVD, *Disarming Images*, which I think was shown just last week at the School of Visual Art here in Manhattan.

We were intending to do projects that would be in the street. We printed 25,000 of those rainbow flags and they really have been everywhere. We felt that we needed to draw the public into a dialogue about what was going on and hopefully to agitate against the war and against the Bush presidency. We'll do more things.

DAVID LEVI STRAUSS *Disarming Images* was screened four days ago (on November 10, 2005) at the School of Visual Arts Amphitheater, and Barbara Pollack put together a little group of us to speak afterwards. She asked us all—Anne Messner of Artists Against the War, Michael Shulan (who, with Charlie Traub, was instrumental in putting together the *Here Is New York* photographic response to 9/11), Paul Chan, and myself—to respond to two questions: Can artists and writers play a role in creating a culture of dissent? And how do images influence public opinion at a time of war? My response was later published as the article "The Line We're On" in the *Brooklyn Rail*. One of the things that came up in the discussion after the screening was young artists' confusion about how to negotiate the "art and activism" split, and Paul Chan was, I thought, especially articulate about this.

ASHFORD I'm embarrassed to ask a question on these terms, but since art has become legally actionable by our government I'd like to discuss how this kind of work—like what is being done by Artists Against the War—illuminates the perceived distinctions out there between art and activism. I know that these distinctions are things that some of us have been battling against for a long time, but do you see that as activism or do you see that as art practice and how did it get started?

ROSLER Well, it was started by a bunch of people sitting around in living rooms, mostly on the Upper West Side, actually. People were saying, "What are we going to do? We have to do something." And, of course, we see it as activism, but it's artists' activism. That is, it takes the form of symbolic activity.

LIPPARD And I hate that distinction.

ASHFORD I know, I know, that's why I said it's something we've been talking about for awhile. On the one hand, as artists, we don't want to limit the capacity our work has to engage the social imagination towards disobedience and regeneration. On the other hand, the instrumentalization of culture, including so-called "relational" art practices, seems to liberate only biennial openings.

ROSLER Well, it's too bad Paul Chan is not here, because this is my biggest argument with him. He always says publicly, "My art and my activism are totally separate."

Artists Against the War (www.aawnyc.org) is a New York-based organization that protests the war in Iraq through visual actions. Since 2004, they have demonstrated at the Metropolitan Museum and Grand Central Terminal, as well as creating flags, T-shirts, postcards, and stickers that address concerns about the war in Iraq and give voice to dissent.

Erase-In project at the Metropolitan Museum of Art

Disarming Images is a 60-minute, three-screen DVD installation documenting non-violent protests in the U.S. against the Iraq War and the "war on terror." Copies of the DVD are available for purchase through Artists Against the War.

David Levi Strauss, **"The Line We're On,"** *The Brooklyn Rail*, March 2006, p. 8, available online at http://www.brooklynrail.org/2006-03/express/the-line-we-rsquo-re-on (accessed August 18, 2006).

And I always say, "Can't you say they're on a spectrum?" "No, they're totally separate." It's ridiculous that I'm speaking for somebody else, but I think his point may be that his art is riddled with doubt and ambiguity, but there's nothing ambiguous about activism or about what it stands for.

MIKE BONANNO (THE YES MEN) Well, we have a close friend, "Bob," who we work with all the time who thinks that art is totally ineffectual and that activism is only social organizing. Our friend is an artist and he says his art is political, but he says it is also totally ineffectual and, therefore, is not activism.

CHITRA GANESH And does "Bob" feel that the activism is effective in comparison to the art?

BONANNO (THE YES MEN) Well, he considers activism a way of building social networks and social organizing, so that you can have a mass movement. And he constantly says that the thing that builds social networks is not the art, but going door to door, talking to people, and forming coalitions. I don't know. Andy and I don't necessarily believe that, but "Bob" is really convinced of it. He's been part of activist struggles, even armed activist struggles, over many years, so he's kind of hard core about it.

But it's part of the discussion, right? How do we bring the symbolic into the development of social networks in new ways? And at what point do you feel uncomfortable with that?

GANESH Well, I think a lot of activism feels symbolic these days too. Meaning, I sometimes wonder whether people are working within outdated organizing structures, particularly certain types of meetings, rallies, and protests, that perhaps were once more effective means of effecting change, but in a contemporary context really may not reach the broader public that they aim to involve—especially within particular sectors of, for example, current anti-war movements or mainstream feminist movements. It can feel like the same group of people over and over again. So these days it seems like the same small group of people at Union Square, perhaps rallying around a cause you believe in and may want to participate in, but it doesn't feel like it's generating a mass movement any more effectively than art does.

TANIA BRUGUERA Yeah, I don't want to offend anybody, but I also think the methods that are being used for activism are really old. They should catch up with new technology. I'm not saying let's use the Web site the way every Web site is used. I'm saying, let's analyze the new media and let's see how we can bombard things from those media in a way that's going to reach people that we are not currently reaching because we are using old methods. We are using

old ways to communicate ideas and I think that's where Democrats lose the battle.

For example, I went to Mexico and I saw an impressive demonstration by farmers. There were at least five hundred people on the street every day for about five hours, shirtless and with their butts out. That was the best art piece I've seen. And, of course, that was very unusual. I'm not saying people should do that, but it was a very effective way to demonstrate anger and to demonstrate how low things have gotten.

I have to say, coming from a different place, Cuba, that I feel things are very safe here in the U.S. I mean, people protest here in a very safe way. I don't want anyone to go to prison or whatever, but it's safe in the way the protesters structure the methodology of fighting.

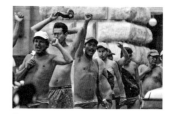

Demonstration by farmers from the 400 Pueblos

ASHFORD You know, reading about the anti-NAFTA demonstrations in Buenos Aires, Argentina two weeks ago, it was pretty incredible.

BRUGUERA You think?

ASHFORD Yeah. Since Seattle and before—ACT UP, May 1968—the street has been a platform for collective art making. Civil disobedience is an art history, too. Emphasizing difference between symbolic and real dissent brings great comfort to those who manage expression.

Anti-NAFTA demonstrations

BRUGUERA And I think we need to learn from real people. As artists, we are not real people. We need to listen and see like real people and not be so literary. Real people have amazing ways of communicating, because they cannot talk, they don't have newspapers, they don't have anything, so they talk with gestures, symbolic gestures, and that's very clear.

PASTERNAK I have to disagree. We are real people. I think it's really important for us to honestly take a look at who our audience is and recognize that we're a part of the audience. That idea of us being separate is elitist and really reinforces our marginalization within the culture.

ROSLER I don't know if we're "real" people or not. I certainly take your meaning, Tania, to be that we are an educated group and have sophisticated backgrounds of one sort or another. But, regarding the question of old methods, I think that there's one thing every ruling group knows, which is that feet on the street bring down governments and that there's no arguing with that. When you can get people out into the street, it shakes governments and it shakes regimes and that is the endgame.

BRUGUERA But are these groups bringing "the people" to the street or are they bringing a small number of dedicated people to the street?

Republican National Convention

LEVI STRAUSS Upwards of 750,000 real, dedicated people went into the streets here in New York on the eve of the Republican National Convention, to say "No, you will not come in here and use this city as a backdrop for your war-mongering propaganda," and "No, you will not hold your party here and push your corporatist agenda and expect us to just stand by and watch." It was a symbolic gesture, yes, but symbolic gestures are what's driving the whole thing from the Right. I think the idea, put forward by the regime now in power, that "real people" necessarily have different political and social interests than the "intellectual elite" (including artists and writers, but also the press) needs to be confronted and criticized. Bush/Cheney and company have put on "real people" drag (a symbolic gesture), but they represent the real (corporate, financial) elite in this country, and their interests are definitely at odds with the interests of the vast majority of Americans.

ROSLER I actually also wanted to address Chitra's argument, your rightful uncertainty about the same group meeting over and over again. I see this as the old-fashioned flame analogy, that sometimes it's a pilot light and it burns low, but it's a form of internal organization. It keeps a transmission and a confirmation of ideas that have certain ritualistic qualities that are absolutely essential, so that you don't have to start over each time.

It took how long to end the Vietnam War? At least ten years. And yet the organization of people out there protesting, for example, at the Republican National Convention happened in an infinitely shorter time.

I think that there are many ways in which artists engage in what's been called interventionism and I don't think there are too many artist-interventionists at this table, except for The Yes Men. But think about Tutte Bianchi in Italy and Yomango, or even ATTAC, which was formed by the editorial board of a monthly newspaper, *Le Monde Diplomatique*, and yet has had resonance in various countries. These are people who engage in performative events that are, nevertheless, political in intent. I think it's a mistake to say that one thing works and another doesn't. I think the Right shows up with its base and so do we.

As a young person protesting against the Vietnam War, I will never forget my friends who were ten years older saying, "That street stuff—that's old. It's been done; it'll never work." And so I now want to say to my younger friends who say, "But it's old, it doesn't work": Yes, it works.

GANESH Well, I'm young and I think it does work, But I would like to see this organizing expand the contexts in which it happens. When it's happening in Union Square, it can feel very abstract and people are often shopping and not paying attention. But say it was happening in your local subway station or in your neighborhood where you are a familiar face and you were standing out there; then people might actually come up and ask you, "What are you doing?" and then you

would talk to them, and have a much more intimate engagement. I think it's crucial to organize and dialogue in specifically local residential contexts, such as your own neighborhood, or in neighborhoods where those affected by a said issue may live or work. I have noticed certain issues that slip under the radar of the mainstream press—such as, for example, the homophobic murder and dismemberment in the subway of a gay youth by the name of Rashawn Brazell, the police harassment of transgender youth in the West Village, or the inhumane treatment of detainees in the Metropolitan Detention Center in Brooklyn—have gotten local residents to mobilize around them. And in this way, the local and global intersect as several cross sections of ethnicity, class, and religion come together to address local instances of broader issues, such as human rights violations, or gender-based discrimination.

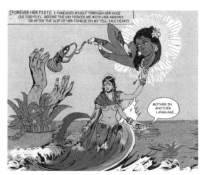

Chitra Ganesh, *Forever Her Fist*, 2006, from the comic series *Tales of Amnesia*

DEAN DADERKO I've also had an interesting experience that relates to this. I was part of a discussion that was organized by an artist named Matt Keegan. It was basically about gay visibility in the art world. A large group of people came together, and what's most important and pertinent to this discussion is that the group was intergenerational. Everybody started talking and, all of a sudden, an artist, who was of an older generation, stood up in the back and said, "Well, we've been through this already." I then stood up and said, "What's important here is that NOW we're all here together in this room, and we can help each other."

What I think is really interesting is that there are these opportunities to bridge past and present so that work that has already happened, like community organizing, doesn't have to be done over and over again.

CHIN That bridge is also good for getting advice. Bill Dobbs and I were at an ACT UP presentation. And I remember I saw the ACT UP drag queens up there, and I said, "Bill, Channel 13 is going to give you three seconds and they're going to shoot that as a protest and that will make your message ineffectual." We can all take a lesson from some of the older generation's efforts, such as the 1968 Olympics and Tommie Smith and John Carlo's black power salute that embedded in our memory a powerful image of civil disobedience.

It's not like you're wrong with your method or your belief isn't firm. I think understanding the methodologies that will enhance or catalyze public expression is probably what we're talking about. I mean, just get to step one first.

I think the desire to win has taken away people's ability to even begin to express themselves, and that includes myself. Art as activism is often about method. So it's like organizing, if you can't get to the end product, create the pool to begin the catalytic thrust of the work.

Rashawn Brazell—a 19-year-old African-American gay man from the Bushwick section of Brooklyn—disappeared from his home in February 2005. His dismembered body parts were found a few days later in garbage bags in the NYC subway and in other locations throughout the borough. Though his story was initially not covered in most mainstream media outlets, it incited overwhelming responses from bloggers, activists, and outraged community members. A community effort helped set up the Rashawn Brazell Memorial Fund with a set of initiatives that include creative responses to social injustice, support for LGBT teens, and critical attention to issues of intolerance.

ACT UP (AIDS Coalition to Unleash Power) was founded in New York City in March 1987. It is a diverse, non-partisan group of individuals united in anger and committed to direct action to end the AIDS crisis.

Suzanne Lacy and Leslie Labowitz collaborated on several activist projects in the late 70s. In December 1977, they organized *In Mourning and In Rage*, a response to the sensational media coverage surrounding the Los Angeles Hillside Strangler. They used the media as a performance venue by designing a press event as a performance. [For a full description of the project see Moira Roth, "Interview with Suzanne Lacy," 1990, http://www.aaa.si.edu/collections/oralhistories/transcripts/lacy90.htm (accessed June 10, 2006).]

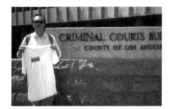

Mel Chin, *Truth Hertz*, June 20,1994

ARTISTS CALL Against U.S. Intervention in Central America was a nationwide mobilization of writers, artists, activists, artist organizations, and solidarity groups that began in New York in 1983. Quickly mobilizing artists and their organizations across the country, ARTISTS CALL collectively produced over two hundred exhibitions, concerts, and other public events over a period of twelve months. These events increased awareness of our government's involvement in state terrorism across the hemisphere, linked the notion of aesthetic emancipation to revolutionary politics, and provided concrete resources for the cultural workers, and public intellectuals in the region and in exile. An excerpt from the ARTISTS CALL general statement published in January 1984 reads, "If, as artists, we can silently witness the destruction of other cultures, we forfeit the right to make art of our own." Image: **Peter Gourfain, Button for ARTISTS CALL Against U.S. Intervention in Central America, 1984**

LIPPARD In the late 70s, Suzanne Lacy and Leslie Labowitz did media analysis—monitoring TV coverage. Then they made their visually dramatic protest performances on violence against women just the right length for a TV spot, so the media would be less likely to edit and the artists would have more control over what went out. That's a lesson that seems to have been lost, or wasn't picked up by other artists.

CHIN But now the media is multinational; they are global networks. The Yes Men have been able to do some amazing incursions into it. My own incursions were not so much planned artworks, but ways to find out what motivates media, so I did some experiments. I was selling O.J. Simpson T-shirts in front of the Los Angeles Courthouse on the day of his arraignment. The shirts said, "Truth Hertz"—neither guilty nor innocent, justice was for lease.

It was a weird experience. Because, at the same time, there was an activist demonstration in the street against violence against women, with actresses. And everybody had their O.J. T-shirts. Suddenly the cameras noticed and someone said, just like wildfire, "They're merchandising murder." And the cameras flipped and they spent all their time on the vendors. The whole day was spent on that.

So the question becomes: How do you even create the methodology to spark another kind of attitude? How do you use rumor effectively?

The point of sharing this story was that I was surprised. I was doing this research, but trying not to be an artist. Instead, I was trying to make a couple bucks and cash in like those vendors in the street. And then I learned something about how the street reacts. It's almost like we have to hit the streets again in order to see what they are about.

ASHFORD Over the years there have been so many projects that have created a symbolic power from human interaction and today such protest is either not growing into larger forms of public expression or isn't being supported by art institutions.

As artists, we've banded together periodically. A great example is something Lucy Lippard, Martha Rosler, and I were involved in, ARTISTS CALL Against U.S. Intervention in Central America in 1984. It mobilized art institutions across the whole country—from galleries to museums to the covers of magazines—to speak out publicly against U.S. military intervention in this hemisphere.

LIPPARD Thirty cities across the country, some thirty galleries in New York City, and some events in Canada too.

ASHFORD It was a way in which the legitimating capacity of our industry—of our institutions—was mobilized. So often I think we separate ourselves from our institutions artificially. As Peter reminded me, these are our institutions. How do we now, in a moment of political crisis and war, mobilize our own institutions? ARTISTS CALL Against U.S. Intervention in

Central America and other examples prove it has been done before. Activism and art were put in proximity to show how both create contexts for truth.

LIPPARD When we're talking about how 750,000 people came out for the Republican National Convention, how were they gotten out? I'm a dinosaur since I'm not even on the Internet and don't do e-mail. I live off the grid, I haul water, and so forth; I'm like in another world. So, I'm curious, what type of community access do we have now? Was the organizing all done on the Internet? No more getting small groups together and getting them to go out and have more meetings...none of that?

PASTERNAK There doesn't seem to be much of that kind of intimate organizing. There has been a recent shift in public opinion about the war in Iraq. Do you think it is related to activism or that it's the result of the media's change in strategy?

LIPPARD Well, the media has to pick up on *some* things that are going on, but they control the spin.

ROSLER Yeah. I heard some guy on the radio this morning, a political correspondent for *The Daily News*, the chief of their Washington bureau. He said forty-seven times, "The American public has made up its mind about Iraq. It knows what it thinks."

BONANNO (THE YES MEN) Mm-hmm. But I think that what Lucy just said is kind of critical. Right now, we could organize a flash mob over the Internet that could maybe get a couple of thousand people to show up at an instant to do something ridiculous in any given place. The Internet creates a context for social networks, but it doesn't actually make them. And I think that's why our friend, "Bob," who I referred to earlier, says that art isn't activism. I think this is the critical issue, what kind of networks are those and are they temporary or are they more sustaining?

ASHFORD We know that those social networks are there, we also know that there are coherent communities that exist and we know that there's a sense of public outrage. Why is it so difficult for artists to be put into sustainable working relationships with those communities?
 We seek people out individually in our practices. We're asked by curators and organizers to do a project at this festival location or this biennial and we participate in it, site-specifically as artists parachuted in as social actors. It's often a short-term relationship. But there are many other people and historical practices, like Iñigo Manglano-Ovalle and Street-Level Video of Chicago or Rick Lowe and the Project Row Houses of Houston who have developed larger social collaborations that have sustained themselves.

Street-Level Video began as a one-day video-installation block party called *Tele-Vecindario: A Street-Level Video Project*, organized by four video artists including Iñigo Manglano-Ovalle. The project taught video techniques to over fifty teenagers from Chicago's West Town neighborhood, who represented their lives and experiences on the seventy-five monitors installed up and down the street. The success of the event led to the founding of Street-Level Youth Media, a storefront project that teaches kids media literacy and video production skills.

Project Row Houses is a neighborhood-based art and cultural organization located in Houston, Texas's Third Ward. It was established in 1993 on a site of twenty-two abandoned shotgun houses to connect the work of artists with the revitalization of the community. The project was inspired by the work of African-American artist Dr. John Biggers, who celebrated the social significance of the shotgun house community in his paintings.

I would like to get to some sort of tactical discussions. Who are our audiences? When and where and how do we work with them in ways that will create public expressions of resistance in public places?

I remember years ago, Hans, you telling me when I was your student that it's not the work, it's the writing and all that information that happens around the work that matters, the secondary expressions.

BRUGUERA The problem I've found in contemporary practice is that artists are talking to artists. They're not talking to a broader audience that is not involved in the art world.

LIPPARD But this has always been a problem. I mean, in the old days, I remember spending months doing huge art projects for a big Washington march and having the organizers, Leslie Cagan or somebody, saying at the last minute, "Oops, we're running out of time, we'll just cut the poetry or we'll cut the performances with these giant sculptures," that we'd spent months making... [Laughter]

PHILLIPS In a recent performance at the Bardavon 1869 Opera House in Poughkeepsie, New York, Laurie Anderson talked about a trajectory audience. She said that you start as a child performing in your home for your family and friends. Then as you develop as an artist, of course, the audience becomes much, much larger and more diverse, and, finally, at the end of your life, you end up back in that home with family and a group of friends. It is a Shakespearean life and artistic trajectory.

I thought it was interesting, but I also thought it was too linear. I think it actually works in a much more cyclical way. There are opportunities to work more intimately and at a smaller scale, and then there are those opportunities to work much more broadly and expansively and they somehow have to work together. You have to figure out how to do both.

Maybe this goes back to methodology, which we're also talking about. I think it's never just either/or, it's trying to determine how to navigate or orchestrate a number of scales and trajectories.

ASHFORD From my own experience, working in the 1980s and 90s, the momentum around public art practice and particularly the idea of community-based arts initiatives put artists in a context in which we were asked to seek out relationships with audiences that were different than traditional museum audiences. But we were also loaded with reductive ideas of audience often designed by social workers.

This instrumentalized "community-based" culture created a context in which artists were at the service of institutions. Not just institutional development, but of urban development overall. This has happened to everybody at this table, I would think.

ROSLER Pink frosting on gentrification.

ASHFORD Yeah, a new gentrification.

ANDY BICHLBAUM (THE YES MEN) I think it comes down to the local/global thing that Doug started out with, such as the fact that the art world privileges a kind of pseudo-global view of things. And local issues are often what are most generative of effective art that can gather people together and get large numbers of people directly involved in things. Look at the mass protests that have actually changed things. In 1943, President Roosevelt changed some major legislation just because of the threat of blacks converging on Washington to protest segregation at a time when blacks were so important in the war effort. You know, that was a visceral issue and, so often, art is about issues that are disconnected from anything that's going on. I think institutions need to focus differently and encourage different sorts of practices, but I don't know how that can be done.

PASTERNAK Artists can work without institutions. Let's not forget about the power of the artists' individual and collective practices...

BICHLBAUM (THE YES MEN) Actually, we've depended on institutions. But I'm not putting ourselves forward as the kind of artists who work on local issues. I mean, we've definitely worked on global issues, almost by definition. I'm talking about people who react to local concerns, local situations; who create things, do things that address those situations effectively; and who get other people on board. Art institutions almost never see those relationships as valuable.

LIPPARD But the art world brings legitimacy and resources to activism. Let's face it, the general public is bored by all the information they need to make sensible decisions, and artists can give it a twist, a jolt that makes them pay attention. For instance, I'm involved in an organization in the Southwest working on environmental issues, especially water, and when we had a water symposium at the Center for Contemporary Art a lot more people came than to a similar thing at the community college that sounded boring even though it probably went deeper into the issues. I'm not sure it was the art itself that brought people in, but it was the mixture of art and information that was attractive. So that mixture can be potent, but our art institutions do about a tenth of what they should do to follow this up.

CHIN Yes, but art is scary right now. We live in a time of fear in art. It's kind of a scary thing. This thing about institutional support is complicated. Do you really think the people on the boards of those museums are really all like-minded like those of us sitting here? I don't know, maybe there are a couple of spies sitting right here, you know? [Laughter]

Chitra Ganesh and Mariam Ghani,
Index of the Disappeared, 2005
(installation view)

Cities, Art, and Recovery Summit,
curated by Radhika Subramaniam
and sponsored by the Lower Manhattan
Cultural Council, was held from
September 8-11, 2005. The event
featured roundtable discussions,
performances, films, and art installations
that promoted a public exchange
on how people remember and rebuild
after tragedy and how the arts are
crucial to recovery.

At the museums, you have some extremely conservative people that believe in art of a certain fashion. It's about class and they're still there. So how are you going to come in and say, "Well, we want to hit the street and shake things up"? There are relationships with the military and economic forces, and we're just a little peanut, you know?

ASHFORD One institution that has protected me over the years is the social project of the academy. As a teacher among others, sharing skepticism as a creative tool has been crucial. And teaching is a creative practice of intense complexity.

GANESH There's no doubt that the skills I've been practicing as a teacher have definitely helped me figure out how to engage multiple audiences with my own work as well. As we had just mentioned, it's not just about the art alone, but also how the art gets written about critically. And I think this is equally true with how the art is discussed and brought into everyday conversation or a broader public.

ASHFORD Can you give an example of using pedagogical tools to change the audiences addressed in public work?

GANESH Sure. I've been working on an ongoing collaborative project with a friend and colleague, Mariam Ghani. Recently for the Lower Manhattan Cultural Council's *Cities, Art, and Recovery Summit*, which looked at what roles artists play in responding to tragedy or crisis, we built a reading room and library around detention and deportation. It was there throughout the conference, but it wasn't clear from the conference materials how people should use this space, or that they were even invited to interact with the materials in our installation. It became our responsibility to get people in there and invite those who had contributed materials to our archive to use the space and in turn bring their own people in. But this was difficult to actualize because many of them are extremely busy, full-time activists who weren't able to put this extra effort in. So, understanding the fact that actively bringing in an audience was part of our role and incorporating that into our practice necessitated the use of those pedagogical tools I use in my own teaching— bringing in a group of viewers who may not be familiar with contemporary art, having them interact with an art-going audience that may already be familiar with the Lower Manhattan Cultural Council's programming, and facilitating discussions between two pretty divergent audiences. And in this process, using the strategies you might use for seventh or twelfth grade classes—asking open-ended questions, eliciting the viewers' prior knowledge and experience, and connecting that to the artwork—are all successful techniques for having a critically minded discourse around the work with adults as well.

ASHFORD A space that creates conversation between different people is beautiful.

DADERKO I think one of the things that's probably most lacking in New York, at least for me, is the idea of the discursive space. Because these days certainly, you walk into a gallery and you walk out. You're not there to talk about what's there or to have these conversations. And somehow I think that really is the most problematic thing, that this kind of ideology doesn't circulate within that system or doesn't very often.

ASHFORD But then, Dean, you have organized and designed many different social contexts in New York City where that has happened. Parlour Projects functioned as a discursive space, right?

DADERKO I was seeing work in studios and I was realizing that this work wasn't being presented in galleries because the galleries didn't know how to contextualize, engage, and sell it. It's a whole other side of the system, it's a monster, in a way.

I'd worked at a commercial gallery, as director for Andrew Kreps, and when we had an exhibition we'd ask the artist, "Okay, do you want to come in and we'll do a public talk about the exhibition?" And that was radical for people. People didn't expect the artist to come in and be available to talk about their work.

LIPPARD But that's why artists' groups have been so effective. I think back to the Art Workers Coalition. I got radicalized by sitting around with artists brainstorming about what to do next, listening to people who were better informed than I was and had wild ideas that were contagious.

ASHFORD And to differ with you, Mel, I sort of believe that those agendas can be understood by even the most conservative museum board as being an important part of your institutional mission. I mean, there are examples of this happening. Even in the context of a war culture like we live in, corporations can be shamed into understanding that the radical discourse between artists is one of the reasons that art happens. If they want to be involved in it, they have to be involved in all of it.

CHIN How long can you wait for change? Strategy can also be put into this context of patience, of what you catalyze in order to have the next effect happen; to provoke thought or even to provoke expression may be good.

In 1995, the GALA Committee was founded to create a conceptual art project for two years on prime time television inserting ideas into *Melrose Place*. It's a project where it's hard to gauge impact because of its viral lifestyle. Jump to 2001. You have a chemical industry newsletter, in England, where an article on RU-486 shows women

Parlour Projects, whose name was inspired by the French *parlour*, meaning "to talk," operated from January 2000 to November 2004 in the front room of an apartment in Williamsburg, Brooklyn. Curated by Dean Daderko, Parlour Projects presented mostly solo exhibitions and paid particular attention to work that was performance-based or interactive. Exhibition artists included Daniel Bozhkov, Karin Campbell, Anoka Faruqee, and Inhwan Oh.

Art Workers Coalition (AWC) was a New York-based anti-hierarchical organization of artists founded in 1969. The group's early agenda was refined during "Open Hearings" in which artists and critics spoke. The group demanded equal exhibition opportunities for artists of color and women, and expanded legal rights for all artists. The AWC split in 1970. One faction became involved in the anti-war movement, while another became the Art Workers Community, which continued as a service organization for several years, offering health insurance, a credit union, and publishing the *Art Workers News*.

The GALA Committee (whose name is a conflation of Georgia/Los Angeles) was a group of students and faculty from the University of Georgia and CalArts founded in 1995 by Mel Chin. The group was organized around developing site-specific art objects/props for the set of the TV series *Melrose Place*. After two seasons and the creation of more then 150 props, the project entitled *In the Name of the Place* ended by being sold at auction at Sotheby's Beverly Hills branch and was included in the 1997 exhibition *Uncommon Sense* at the Museum of Contemporary Art, Los Angeles.

Santiago Sierra is a Spanish performance artist internationally known for his controversial work. In a work titled *245m³* (2006), he pumped car exhaust fumes from six parked cars into a former synagogue in Pulheim-Stommeln, Germany. This created a gas chamber filled with lethal levels of carbon monoxide. After signing wavers, visitors were allowed to enter the synagogue while wearing gas masks.

Barbie Liberation Organization (BLO) was founded in 1989 when it switched the voiceboxes of three hundred Barbie™ and G.I. Joe™ dolls during the Christmas shopping season. The BLO's goal was to correct the problem of gender-based stereotyping in children's toys. After completion of the operation, the G.I. Joe doll said phrases like, "I love school. Don't you?" while Barbie said, "Dead men tell no lies."

protesting in the streets, right? And then the side picture is a still of Alison of *Melrose Place* with her RU-486 quilt, as seen on the show. So you have a conceptual public art project related to a public protest. I mean, things take time.

I see an anxiety in this discussion, but there are different kinds of strategies that could free us or free the art community and institutions. Do you think institutions would support things that take time? Because usually they want immediate gratification. How many people saw that show? How many people did it transform? Time is everything!

LIPPARD I think it's also important to talk about the failures, because one reason we're always reinventing the wheel is, frankly, every artist who's done anything in public thinks that it was a great success, even when it was clearly not. But they say, "Oh, ten people came up to me and said their lives have been changed," and so forth. It's hard to get people to even admit to the failures.

HANS HAACKE Perhaps I should pick up on what Doug remembered me saying about secondary expression, as he called it, namely the talk and the writing that is triggered once a work is out in the public arena. It can, indeed, have an important impact. It is unpredictable, though. You can rig it to some degree but the means to do so are limited. In the terms in which we are talking at the moment, it would be a "success" if it is picked up by the media. Whether it is also of interest in other respects is an entirely different story!

PASTERNAK Usually, Hans, widespread dialogue means controversy is brewing.

HAACKE Yes, for better or worse that is often the case. The Yes Men have done it very well. On the other hand, the games Santiago Sierra has been playing are distasteful.

ASHFORD Yes Men, maybe you can speak publicly about using press releases and stuff. I'm remembering the Barbie Liberation Organization, where press releases were secretly sent behind the scenes to get the press to respond in ways that were not expected.

BONANNO (THE YES MEN) If the goal is to have a public message, then the goal is to have a public message go through the media, which has its own set of compromises. So controversy can be useful and, if you get shut down, it could be desirable, but it depends on whether it's important to have the art presented or not, because not having the art could be more powerful in terms of the message getting to people.

But it's not necessarily a better thing or a worse thing, because then there's the question of whether the art is useful politically or not. And it can be, I think it can be.

PASTERNAK Success could be defined by the controversy an artwork garnered.

BONANNO (THE YES MEN) I don't think that you could say, across the board, that it's either one way or the other.

BICHLBAUM (THE YES MEN) Regardless, though, I think we have to realize that we're talking about one of two kinds of successes. All of this is the pilot light kind of success. Keeping the hope alive, keeping the message out there so that we don't have to rebuild everything next time around and when the conditions for change arrive, then, it must have...

ROSLER Well, you're helping to make new conditions.

BICHLBAUM (THE YES MEN) Yeah, maybe contributing to making them arrive, but mainly that happens somewhere else, somehow else—namely, with the other kind of success, which would actually be bringing change on, and I think that would depend on having more local approaches to things, institutionalizing local approaches somehow and making that more palatable.

BONANNO (THE YES MEN) Andy is talking about these galvanizing community projects and I was thinking about a predecessor to the Yomango people who go out and shoplift, as the only uncommodifiable act.

ROSLER But they make a big show about it...

BONANNO (THE YES MEN) Yeah, they do. It's very clever, it's fun, and they do make theft fashionable.
But, prior to that, some of them had been part of this group called Fiambrera Obrera, and they were engaged in community projects that were really quite incisive. Through food and music, they would really get community support for anti-gentrification measures and things like that. They built these incredibly strong social networks that were able to successfully overturn new laws and efforts for gentrification in Madrid and Seville, and in Barcelona, to a lesser extent.
To come not full circle, but partway back, that kind of makes use of the idea of pre-Internet social organizing. I mean, they were doing things that didn't involve the Internet at all, that just involved their roots in their community, and making sure that they could talk to everybody locally as well as their elected representatives.
And then, through the Internet, they would distribute this internationally. Through a Web site they could say, "Hey, look what we did through these symbolic acts," A lot of their projects were symbolic, like going through the city of Seville and putting these little tiny flags in every pile of dog shit. This is an important example that I come back to in terms of seeing the local and bringing it to the global.

Fiambrera Obrera is a Barcelona-based open collective that intervenes in arenas of high political conflict, such as the borders between rich and poor countries, or the inner cities of Madrid, Barcelona, or Seville. They believe in direct action using tactical principles both in the street and on the Internet. Image: **Fiambrera Obrera,** *Si 8 Do,* 1999

BICHLBAUM (THE YES MEN) They also tapped into local customs. There would be these big parades where they would carry the saints through the streets and they would work with the people organizing those parades to protest things. So, for example, at a certain point in the parade it's traditional for a flamenco singer to turn and belt out a big flamenco song for the mayor who's on the balcony. And they arranged it so that it was a protest song that he belted out. I can't remember the exact issue; it was about building, turning a park into a garage. But things like that made Fiambrera's actions really powerful.

PASTERNAK Hans, earlier you mentioned that media coverage and the talk around a project can determine its success. But if the media's message takes over, that personal encounter an individual has with an artwork is diminished or even lost.

HAACKE I am not suggesting artists should operate according to the criteria that determine the news cycle. In fact, I am a bit uncomfortable with our use of the word "success," particularly when applied to evaluating artworks. It risks reducing them to something rather one-dimensional. Communication and interaction among people are more complex. Reaching them and affecting their perception of the world occurs at many different speeds and many different levels. Even though we have reason to be impatient about what's happening today, we shouldn't underestimate the potential of the slow burn.
 In the "good old days" of the Vietnam War and Ronald Reagan's messing around in Central America, the art world was politically engaged; artists (among them many blue-chip artists), prominent galleries, and collectors got involved. Today that's not cool. It can hurt one's career and one's business. Sure, everybody agrees, the U.S. invasion of Iraq is a complete fiasco, with an unconscionable toll that's rising every day. But who really cares? Over here we are safe, there is no draft, a lot of money is around, and the art market is doing well.

ROSLER Well, actually, a lot of people care, come on! Let's get back to Dean's discursive space argument.
 The education department at, of all places, MoMA, ran a panel last summer before the election on what artists can do about politics. And it was really interesting for many reasons. First, that it happened at all. Second, that it happened at P.S. 1 in Queens, so it was basically held at the outpost. Third, that everybody chosen for the panel (except for one person who was a friend of the man who organized it) had some kind of identity politics as the rationale for being there.
 So, it was invoking a past model in order to justify something else. And everybody except Adrian Piper, who arrived late and gave a really wonderful talk about the shape of things, was vacillating, saying "On the one hand, on the

other hand." The cartoonist Tom Tomorrow was there, and he kept saying, "Luckily, I'm not in the art world."

So this audience was full of young artists sitting, leaning forward on their seats, and it wasn't until Adrian came in late and gave them an analysis of what was going on in the real world that they sat back and breathed a sigh of relief, because they were waiting to be told.

Of course, this was before the election. "This is what we can all do. Let's all rise up now and we'll have group meetings and we'll do this." In other words, people really wanted to have some kind of discussion about how they could insert themselves in the political process.

DADERKO Yeah, that's right. And I wonder whether those people that were sitting forward were given a chance to speak during that panel?

ROSLER Well, they all expressed disappointment that everybody was so mushy. But the other thing is that back in the 80s when theory (that is, conversation) was fashionable, the Whitney used to run these wonderful seminars for artists and you couldn't get in the door; they were so oversubscribed. So I'm on the education board, I'm looking at their upcoming lectures and I say, "So these are art-appreciation lectures, right? How about the ones we used to have where it would be subjects of interest to artists?" And they said, "Oh, that's an idea."

So my current thing is "Why don't we go back?" Because, in fact, I think there is a significant cohort of younger artists who are interested. 16 Beaver, for instance, what they do is sit around and educate themselves and make contacts—and it's not like they're a political cabal. They're not a cell, they're artists. They are completely involved in reading, educating, and making contact with artists who are activists elsewhere and bringing those artists in for talks; and yet they have a very low profile here. But I take it that there's a lot of desire for conversations and so on.

LIPPARD But I think it should come out of the artists rather than the institutions. I don't trust the institutions.

ROSLER There's often not a place for it to happen. I'm saying that, in the few instances I've seen where there is a little door open, people rush to come in.

DADERKO Yeah, I often go to the Studio Museum in Harlem, because the public programs that Sandra Jackson is organizing up there are fantastic. The level of discussion feels really vital.

I was at a discussion where Glenn Ligon was sitting up on a stage and somebody said to him, "What you're doing isn't art. What's art about what you're doing?" And just to be able to have that level of questioning happen

Tom Tomorrow is the creator of *This Modern World*, an award-winning weekly cartoon of social and political satire.

16 Beaver is the address of a space in New York City's Financial District initiated and run by artists to create and maintain an ongoing platform for the presentation, production, and discussion of a variety of artistic, cultural, economic, and/or political projects. Since its inception in 1999, the group has organized more than two hundred events in a range of formats including lunches, walks, film screenings, readings, panels, and artist presentations.

Glenn Ligon, *Prisoner of Love #4*, 1992

Mel Chin, *Revival Field*,
1991–present

openly, you know it's a fantastic thing that they're doing.
That is encouraging.

CHIN People who know me from *Revival Field* think I'm
an eco-artist because of it. But it's a lesson about success
and failure, because when the chair of the NEA rejected
it, everybody—ABC, NBC—wanted me to argue for it on
television. I said "No," to all that, because a year before, when
I gave up making all studio art to investigate this concept,
the first polluter I called was in petroleum and he was being
prosecuted. I told him the idea, this would be the first project
in the world and it would be great PR and all this stuff. And
he just said "No," flat out. He said, "If you're an artist, all you
want is publicity, because that's what I know about artists."
 So, I did not go on television. If I had, I would have been
on the news fulfilling his prophecy. It would have been
a year of negotiations with a state senator and everybody
on up, in order for him to say, "I told you so. I'm not going
to allow him to do it." So I reduced the conversation to
the issue of how public funds are generated and how they
are spent and decided by one person. Meanwhile, I continued
the negotiations to start the first *Revival Field*. And so,
failure in a sense. But, now there are labs and businesses
all doing green remediation because of that. And, someday,
there will be a *Revival Field* because of it.
 You have to make some decisions, if you're going to
be an activist. To me, it's a success, but what we're talking
about is time and delaying gratification.

ROSLER You know, there's the *succès d'estime* and the
succès de scandale. So the question is: Which one are
we interested in? I think they do often conflict, but, obviously,
if these are agitational things that we're involved in there
are differences between an ecological issue and a directly
political issue and one related to something like a war. We
can see it's not that one has priority over the other, but they
do have different time scales in which they can unfold.
 There's a certain urgency to try to organize people for
an election, for example, or against killing people in foreign
lands, which is again a little bit different.

CHIN We have fifty years of American foreign policy that
began with a certain kind of ideology by George F. Kennan
and Truman. Noam Chomsky indicated from his under-
standing and exposure of their policy that the critical term
that would have obstructed us from being the number-one
global power after World War II was the word "human rights."
And the way we have to obscure our actions in the world
is to say that we're there to defend or promote democracy.
So every time I hear "democracy," it scares me too.

LIPPARD But artists do provide models. And it's not always
easy. Martha, remember that time we were sitting around
in somebody's studio trying to make signs for a march
in Washington around the beginning of the Reagan regime?

We'd decided to have no words, just images. The bad guys were easy—we did death squads and generals and stuff in black, white, and gray and then Xed them out in red. But when it came to the good parts like health care, diversity, the environment, and school lunches—the things being cut and damaged by the Reagan administration—that was really hard. I remember you or somebody drawing a little barn in the country…it just didn't work. Then finally Mike Glier came up with single iconic colorful objects—a red cross, a glass of milk, a leaf—and it looked great. His was one of the most successful march things we did because it was all visual. Everybody understood the message and they knew we were artists…they even clapped when we went by.

ASHFORD I want to keep Martha's idea alive, that intense set of social relations between artists where artists were meeting regularly. We've known each other for twelve years. We have worked together. We don't talk about practice that much, but we see each other every other week. Why isn't it possible that we can, amongst ourselves or with institutional support, make settings where these contacts and discussions can be brought up repeatedly? The slow burn and the long-term can be discussed as it goes on, but we could also move to the immediate. We need a space for this.

It takes so long for institutions to respond to timely issues. For example, you want to do something about the election and by the time you get people together, resources together, contacts together, and sites together, the election could be over.

PASTERNAK I think we're not acknowledging the elephant in the room. Artists feel like they're participating in the political process today by voting or by donating artwork for a benefit to raise money for political candidates. But so many are not using their voices, their skills, in a more public and potentially more powerful way. I think that's a difference between the 70s and 80s and artists today.

ROSLER That has to do with the collapse of the art school and its conversion into a hothouse for getting a gallery. "Thinking is bad for studio work"—I've been told this over and over at the wonderful institution where I work—that thinking is bad and it's an impediment and…

HAACKE It doesn't sell.

ROSLER Well, not only doesn't it sell, it's a stopper. It prevents these young artists from really finding their *métier*.

PASTERNAK But it's not just young artists, Martha.

BICHLBAUM (THE YES MEN) I think there are tons of artists who are participating in the political process, but I think the bulk of them aren't called artists and they aren't acknowledged by anybody.

I mean, in what way does door-to-door activism not constitute art? When you go door-to-door, you do a little performance for whoever's answering the door. You figure out, "Okay, what do they want to see?" It's art.

There are plenty of institutions that are interested in doing that. They're not art institutions; they're organizing institutions, they're something in between. There's culture-jamming resources that know plenty of people who are doing things. We attempted to do something like that with ®™ark. It was all symbolic, but there are real examples of people trying to foment this at a lower level. Maybe what art institutions could do is to devolve some of the authority and just fund those institutions.

Look at an organization like protest.net, which is a Web site that keeps up with what protests are happening around the world and puts a lot of people in touch with each other to figure out how to do the protests. On the site there are expression of exactly what is needed where. In some cases, it is collaborations. In some cases, it might be financial. You know, maybe somebody needs to buy a catapult or needs to figure out how to build one. That's definitely art, when you build a catapult to protest the FTAA as a new…

ROSLER Right, they were flinging teddy bears!

BICHLBAUM (THE YES MEN) That's definitely a political use of art. And I don't know if the people who did that considered themselves artists; I don't think so, but they are.

Let's say someone would offer funding and enable those people to actually buy a catapult—just using protest.net as an example.

ASHFORD Oh, I have an example from someone that we wanted to be here but he's traveling, a man named Naeem Mohaiemen, who directs a collaboration called the VISIBLE Collective. Since they work with actual organizations that are invested in non-citizen and citizenship rights in New York, an arts agency could be invested through them in terms of a larger collaboration or activist projects in the city very easily. It would be easy because there are so many artists who are leading these double lives invested in some political and studio practices. As a collective, they are working in the contexts of art of mass media and the contexts of social movements, equally.

GANESH They've also already been collaborating together. The VISIBLE Collective has already created the projects and dumped their money into it. And they're really committed to getting it to travel to different places. It would be great, because it's site-specific. They redo it every time.

ASHFORD One of the first casualties of the "culture wars" was the NEA's decision that many artist groups would no longer be funded. In a way, this changed our material, our

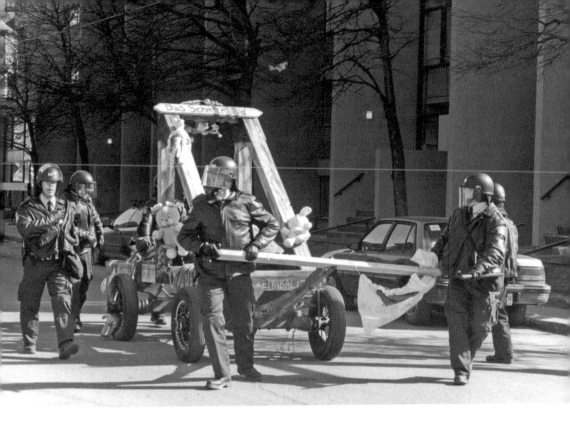

conception of artists' dialogue with each other and with new audiences. First, in 1983 or 1984 when Frank Hodsell was chairman, they eliminated direct grants to writers and critics. Then, they terrified support organizations and withdrew support from artists' organizations.

ROSLER Not to be a devil's advocate, but why are we talking about funding? It's not the issue. It's not so much the source of funding, but how to get people together. You can't really expect institutions these days to hand a bunch of money to people who are going to catapult teddy bears across a barbed-wire fence into a group of delegates.

CHIN I think it's about climate building. I think we may be too insular in this realm. The galleries form their own kind of insulation and the museums form another kind. Then you have this group of rabble-rousers and that's a whole other thing. How do you invite people into that who are not traditionally activist types?

LIPPARD Open meetings.

ROSLER Right, and using non-traditional means, like Internet organizing. MoveOn has made such good use of this in producing house parties bringing together "ordinary people." They are engaged in online votes and chats and discussions and every so often, real-world events are held around online addresses by celebrity spokespeople or around MoveOn

Deconstructionist Institute for Surreal Topology's teddy bear catapult taken during the FTAA Protest at the Quebec City G8 Summit, April 20, 2001

MoveOn.org Civic Action was started by Joan Blades and Wes Boyd, two Silicon Valley entrepreneurs who shared deep frustration with the partisan warfare in Washington D.C. On September 18, 1998, they launched an online petition to "Censure President Clinton and Move On to Pressing Issues Facing the Nation." The petition met with a huge show of support, which led to the formation of MoveOn with the goal of bringing real Americans back into the political process. MoveOn.org now has over 3.3 million members.

**Oil, Chemical, and
Atomic Workers Union**

Gallery 1199/Bread and Roses was
founded in 1979 in New York City as a
cultural resource for union members,
students, and others who would
otherwise have little access to the arts.
Bread and Roses is the not-for-profit
cultural arm of New York's Health and
Human Service Union, 1199/SEIU.

screenings, like Fahrenheit 9/11, or just in direct relation
to electoral strategies.

PASTERNAK Mel, maybe it's not about driving people into
our meetings, but going to other people's meetings.

CHIN Yeah. That's for sure.

PASTERNAK Why aren't we aligning ourselves with unions,
for example?

CHIN Yes.

ROSLER Well, there's a problem with that and I would like
to speak to it a little bit, because that's what I was going
to talk about an hour or so ago. There is a reason why
artists don't necessarily attach themselves to groups like
unions. Their vision of what art is and what to expect from
an artist is very different. They believe that an artist is
essentially a contract artist-producer. Back in the day, in
the early 1970s, when we were trying to work with some
unions in California, specifically with Tony Mazzocchi of the
Oil, Chemical, and Atomic Workers Union who was an
absolutely fabulous guy, they wanted us to do silk-screen
posters, but we wanted to do mass-produced posters.
For them, it wouldn't be art if it was a poster that looked
like a poster. We would be just like any other graphic artists
they might hire, only more trouble to work with.
 The other thing is that there's this problem with irony.
Artists tend to think in terms of statements that are ironic.
But for unions and so on, they feel their membership doesn't
understand an ironic statement.
 Even though our culture's pervaded with irony, it
resides on television. It doesn't reside in political campaigns.
And it's funny because in other countries, of course, ironic
statements abound, but our culture is very literal.
 So you wind up either trying to be the servant of
the union or being much more radical than they want you to
be. It's very hard to be a bureaucrat-artist. I don't object
to people doing it, but I have a feeling that nobody sitting
here really would find that a rewarding mission.

LIPPARD Well, for several years, Jerry Kearns and I did shows
at District 1199, the union headquarters in the West 40s, and
we tried to blow up their pretty conventional ideas of what
art from or about unions should be. We did some conceptual
works on organizing and an anti-Reagan comic show,
Who's Laffin Now?, with Ida Applebroog, Peter Gourfain, Keith
Haring, and others. And the union membership loved them.
 But one of the things we did was Hans Haacke's
absentee landlord piece, which had caused the Guggenheim
to cancel his show in 1971. We'd thought it might be
too subtle for this audience, but instead it was too obvious.
The union members said, "Hey, we live in these places.
We already know this."

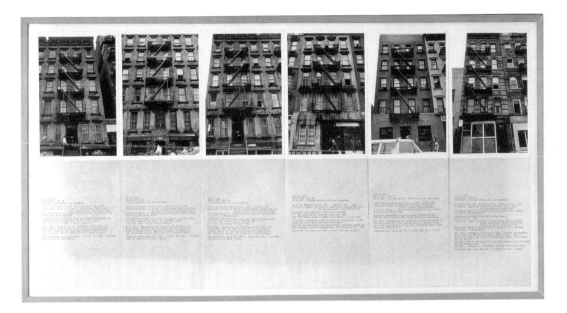

Hans Haacke, *Shapolsky et al. Manhattan Real Estate Holdings, a Real-Time Social System, as of May 1, 1971,* **1971** ©Artists Rights Society (ARS), New York/VG Bild-Kunst, Bonn

Then there's the whole problem of artists' love affair with irony. I've said, "the people's voice is not ironic," and I got in a lot of trouble. But it's right.

I remember another time when Jerry Kearns did a poster with the Black United Front—a beautiful photograph of black people surging across the Brooklyn Bridge (to protest killer cops, I think), with light glowing through the banner, really kind of uplifting. And it was successful in the streets, but John Perreault wrote about it in the *Village Voice* and said something to the effect of nobody would fall for this, it's too obvious. So here was a very effective political image being dissed because it wasn't subtle or ironic enough, but it worked in context.

This kind of thing happens when the art world confronts real people. And frankly, I think it's a liberal idea that "artists are real people too." I don't think we are. We're coming from another angle, which makes it all the more imperative to know not only who our audiences are, but also how they see, how they think.

GANESH I have a bunch of thoughts on what Anne mentioned about aligning ourselves with different organizations. It really seems to depend on clearly articulating the project with the group you might be working with, and giving them enough time and leeway to participate at their own comfort level and pace. I've found that some activists or organizations that my collaborators and I have approached can be initially suspicious of our intentions and motives. Because in their previous experiences with artists, a lot of times a project might go like this, "Okay, we need your help right away because this needs to be produced in a hurry, and be ready for this deadline in two weeks," and after that the artists don't interact with that organization again.

Mariam Ghani and Chitra Ganesh, *How Do you See the Disappeared?*, 2004, http://www.turbulence.org/Works/seethedisappeared/ (accessed June 10, 2006).

Desis Rising Up and Moving (**DRUM**) organizes low-income South Asian immigrants, families facing deportation, and detainees of color to end detention, deportation, and policing of immigrant communities. DRUM is a membership-based organization that builds power in communities for racial, economic, and social justice. Desi means people of South Asian descent: Bangladesh, Bhutan, India, Nepal, Pakistan, Sri Lanka, and the diaspora including Africa, England, Fiji, Guyana, and Trinidad.

So I think the idea of funding a continuous project or collaboration, something that may even go on or develop over a number of years, would be really interesting. That type of project would allow all parties involved—artists, activist organizations, youth workers—to solidify and retain their commitment over a period of time. Unlike what often happens in the art world context, where after the press release is sent out, the opening happens, and the show maybe gets reviewed, it's no longer so urgent or pressing an issue.

Another aspect of my collaboration with Mariam Ghani involves a questionnaire around detention and deportation that eventually gets posted onto a Web site that is called *How Do You See the Disappeared?* Basically, it was created in opposition to Special Registration questionnaires that targeted immigrant groups were forced to fill out after 9/11 so the government could collect cold, hard data about them that could then potentially be used to detain or deport them. The questionnaire of our project asks people open-ended questions that are not necessarily demographic in nature—which we call warm data—but still make a narrative around detention and deportation. Since the questionnaire is on the Web site, its not like "Okay, we have three weeks, and we're going to make all our friends answer the questionnaire and put that up so that everybody can see that a lots of folks have responded." Instead, it's more like, "Oh, we noticed there was a big jump in how many people interacted with the Web site after something we did at the end of October." It's ongoing, though it was originally launched around the Republican National Convention. We're going to revisit the questionnaire and reassemble the *Index of the Disappeared* reading room installation again in March 2006 in the context of *DETAINED*, an upcoming exhibition around detention and Asian and Arab communities at the Asian American Arts Centre in Chinatown. This way organizations that we work with or request contributions from for the next edition of our zine see that our commitment is ongoing, and won't get defensive or feel used and say "Oh, you just call us when you need something or show up at meetings when you want a bit of research, but then we never see you again."

ASHFORD But for me, outside of a school, those sustained relationships are hard to find, at least in the context of the art world, right? I mean, what allowed that to happen? Was it your own initiative, your own energy, that sustained it?

GANESH Well I had already been working within the South Asian community around this issue, through **DRUM** (Desis Rising Up and Moving), and had activist friends and colleagues working with groups like the Asian American Legal Defense and Education Fund or on special projects of the ACLU. But I think that persistence is also a key part of it—being open and going to meetings again and again to make the connections. Also, continuing to enter activists' domains,

rather than exclusively inviting people into our spaces or networks. And since it's an exchange over a period of time, its not like we have to go crazy going to twenty-five meetings a week for three weeks before we organize a show and then forget all about folks who are continuing to do that work in their own space.

DADERKO And I feel like it's also important to realize that these are often cumulative efforts. It goes back to this idea of the slow burn. There are artists, because of their investment and interest in specific topics, who have sustaining practices. Ultimately I feel like it's about having a kind of sustaining practice more than it is necessarily about "Okay, here's this project and how do you judge its successes or its failures."
 Parlour Projects started out by inviting some friends to put up some work. Of course, I did want a dialogue, so I made sure that happened. By the end of the program, the e-mail list grew to thirty-five hundred people. I would have two hundred to three hundred people show up for an opening at a space that was fifteen-by-twenty-feet.

PHILLIPS There are a couple of different ideas that I hope to connect about the questions of time and temporality that keep coming up. We've talked about time-sensitive work and artists who work spontaneously or on short-lived projects and yet we're also talking about more prolonged practices that deal with sustainability and more enduring issues. Mel and others have talked about who sets the terms for success—and that success can often be very fleeting or belated. It seems that success itself is very temporally influenced.
 At the 2005 Istanbul Biennial, I was very interested that the curators, Charles Esche and Vasif Kortun, actively engaged emerging artists who had time to participate in Istanbul-based residencies to develop site-responsive projects. They emphasized this as a tactic of their curricular practice. They wanted to work with artists who had time to involve themselves in residencies in Istanbul. They weren't as interested in artists who had big names, hugely successful practices, and significantly less time to commit to Istanbul. I think the question of sustainability and how that plays out is a big part of this.

DADERKO Well, it also ties together with the idea of how you grade a success. Because, ultimately…

PHILLIPS …who sets those terms?

DADERKO …if I had decided whether I would continue the Parlour Projects based on what kind of press I got…

PHILLIPS …or how many people showed up…

DADERKO …it would have been over immediately.

The 9th International **Istanbul Biennial**'s concept statement written by curators Charles Esche and Vasíf Kortun stated that, "the 2005 Istanbul Biennial promises a distinctive approach to the burgeoning phenomenon of international biennials, one that is rooted in the place it is shown while always looking out at what is relevant for the rest of the world." The curators had half of the fifty-three artists in the exhibition live and work in Istanbul for one to six months. They also worked in sites that had a reference to the everyday life of the city (rather then using historical monuments). Finally, they created a "Positionings Programme," which "highlighted specific local and international constellations within and beyond the city," the central feature being the Hospitality Zone where Istanbul artist initiatives exhibited work, a famous city magazine set up shop, and an international student workshop and an archive of contemporary art books was housed.

Claire Bishop, "Antagonism and Relational Aesthetics," *October* 110, Fall 2004, p. 51-79.

Joe Scanlan, "Traffic Control," *Artforum* XLIII, no. 10, Summer 2005, p. 123.

PHILLIPS And I think that is a critically important question: Who is setting those terms of success? Is it about the media and the press? Is it about the number of people who show up? What are the other kinds of conditions that we might want to talk about or think about in terms of our practices?

PETER ELEEY On the biennial front very generally, I think we've been starting to see a shift away from the dominance of the relational aesthetics paradigm over the last few years. There is this idea of "relational" work being characterized by its active nature—in actually producing social relationships, rather than simply reflecting them—that has made this kind of work seem "political" to many people. And yet, these works are political primarily by their creation of a *framework* that's ostensibly democratic and free, such as Rirkrit Tiravanija's work, where people are just supposed to show up and have a conversation and be free to do whatever they want within it.

In other words, the work takes no explicit position. It's completely non-prescriptive, perhaps to a fault. But I think what is interesting in the context of our discussion is how well this structure navigates the globalized, decentralized condition that characterizes much art-making today. What I find brilliant about so many "relational" works is how they manage to be site-specific and yet transferable. On one hand, the work is simply a structure, and it can easily travel to a variety of locations. On the other, many of these works depend upon the active participation of the local viewers at a given venue in their construction of meaning, which immediately localizes and grounds them. I think we can look to "relational" work as an example of how globalism has compromised political practice.

Now people are starting to pull back somewhat. We had hoped that both Claire Bishop and Joe Scanlan could be here tonight. Joe wrote a nice piece called "Traffic Control" in last summer's *Artforum* that picked up on a point made by Claire Bishop in her larger critique of relational aesthetics (published in the Fall 2004 issue of *October*), about how these supposedly open structures essentially legislate a kind of forced "freedom" where people feel like there are still certain kinds of rules prescribed.

LEVI STRAUSS How do you think Thomas Hirschhorn's project at documenta 11 fits into this? Claire Bishop said that the independent stance of that work implied "the readmittance of a degree of autonomy to art," wherein "the viewer is no longer coerced into fulfilling the artist's interactive requirements, but is presupposed as a subject of independent thought, which is the essential prerequisite for political action."

ELEEY I've talked with Thomas about it. On the basis of those discussions, and what I know of the project otherwise, I think that it is open-ended in a way that combines two different frameworks: the community of the housing project that helped build this work and then, obviously, the

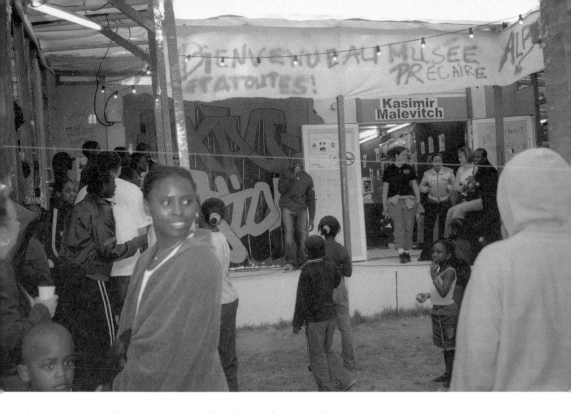

Thomas Hirschhorn, *Musée Précaire
Albinet* (Vernissage Kasimir Malevitch),
Aubervilliers, 2004 © Thomas Hirschhorn

documenta 11 audience, the art world audience. Importantly,
those who had helped build the piece in the local community
eventually owned it, since all of the elements of the artwork,
including the Mercedes that was ferrying people back and
forth from the main show, were given away by lottery.

One thing that is problematic for me about that project
is the same issue I find with Rirkrit's, which is a certain
resistance to criticality. What is success and failure in these
pieces and what sort of evaluative criteria can we apply
to them? In Hirschhorn's case, it seems like the thing that he
would point to is that he lived in the housing project when
he was making the piece. Very early on his electronics
equipment was stolen. They were eventually returned. He
said to me that a great thing was being able to get his stereo
equipment back without involving the police. So, on that one
level, the project seemed to me to be about a larger effort to
demonstrate and earn respect for the artist in this community
that otherwise saw him as just this interloping foreigner.

I think the fact that the work was called the *Bataille
Monument*, generated around the philosopher Georges
Bataille, is distracting, a kind a red herring for the critical
press. Because, really, I think the structural aspects
of these projects (including his other "monuments"), rather
than their explicit content (such as a given philosopher),
is where they are most interesting. Take the project that he
did near his studio in Aubervilliers, just north of Paris,
the *Musée Précaire Albinet*, where he borrowed works
from the Centre Pompidou and showed one artist a week
in this "museum" built in and by residents of a nearby

housing project. I think these are both examples of very localized practices.

ROSLER But I think I disagree with you about his Bataille project. Tania, did you want to address it?

Hershey, Pennsylvania

BRUGUERA Just a little, yeah. I just want to say that my problem with all of these projects—and I've done some of them as well—is that, in a way, the educational part is missing. I was laughing when you said that he was happy the police were not involved. I think getting the equipment stolen is a symptom of a privileged power relationship. And I'm not talking about Hirschhorn specifically, I don't even know him. I'm talking about a phenomenon that happens in our world where we go to places, and we say, "Oh, because we stayed five months, that's a long time, wow." That's not good.

The educational part is missing because we go there and we impose our aesthetic point of view. We don't make a link between the art history these people know and the art history we know. So I think there is a gap between what they understand and what we are proposing to them.

I think that's something that, in general, should be a goal for the institutional work as well. If you're going to work in a space, how are you going to create a space for discussion, not only between artists, but also between the artist and the people from this local place? I'm not saying "real people" any more, because people are offended. How do we create a dialogue with all the people who have less knowledge of the way contemporary artists make metaphors?

Thomas Hirschhorn, *Bataille Monument*, 2002 © Thomas Hirschhorn

ROSLER Do you know about Pullman, Illinois, or even Hershey, Pennsylvania? There are these towns that were built by capitalists for their work force—company towns, in other words.

PHILLIPS That's true, these were communities formed by industrial paternalism. Employees were housed, provided for, and regulated.

ROSLER Yeah, well, I kind of see Thomas Hirschhorn's Bataille Monument that way. I spent a number of hours talking to him about it there, but the first thing that struck me was the relentless masculinism of it. Because it was one hundred percent male and all the interests were male and all the people running it (except for the café where it was run by a family) were male.

I spotted these women all around. I know this is going to sound sentimental, but if you saw it you would know how powerful this was. The women were always behind the window, but out on the lawns were these artworks made out of sheets. They had all pink sheets or all blue sheets and they were on these square drying frames. And so in and around Hirshhorn's cardboard structures that were constantly

collapsing were these artworks by the women who were doing their ordinary chores, but just in an aesthetic way of their own. I mean, they were invisible, it was completely not an artwork, and it had nothing to do with the project, but for me it became a metaphor of this parallel universe.

Hirschhorn said that he had gone around to all the towns in the area, because he wanted a town that was willing to do the work and to take care of it. And he had this contract that they would work on it. And he said that he moved in there because, in the last community project that he did, everything in the project was vandalized and he realized he had to live there in order for that not to happen.

So, in a way, it was this enormous effort to create what appeared to be a harmonious relationship of basically Turkish workers in Germany for the delectation of the international art appreciation crowd. And I didn't understand why more people didn't seem to question this at all.

ASHFORD I love the analogy to Hershey, Pennsylvania. I feel that way with this "relational" art moment, too, its promotion of "celebration as resistance" seems so invitation only. And I'm not sure that I am the real audience for this, because I often feel that I'm not privy to what is active in those practices. Maybe that privacy is part of the critique.

ROSLER But, you know that people like Rirkrit Tiravanija didn't write that theory. They never meant to have their work become this kind of synoptic practice that engages us all as a model for how to run the world.

If anything, it fits into another text, which I don't like very much, Foucault's *Heterotopias*. I think it's the smallness of scale that interested Rirkrit, just this gesture of here we are, sitting around, talking and sharing ideas.

DADERKO I was just going to say, it's funny that we're bringing Rirkrit up. I had this strange dream the other week that, in the aftermath of Katrina, I got a grant to take a Rirkrit project to New Orleans. And so, I think that, ultimately, it becomes this thing about contextuality and how art works.

CHIN I have learned if you want to be an activist you have to go beyond the artwork. Perhaps the real job would be to create a place where the academic practices could be liberated from their own tyranny.

PASTERNAK Are people satisfied with the level of activity that they see going on?

LIPPARD Activity—what kind of activity? Activism. Hell, no.

ASHFORD No. No one here is. But neither are you, right? You're not satisfied either.

Michel Foucault, "Of Other Spaces (1967), **Heterotopias**," 1967/1984, http://foucault.info/documents/heteroTopia/foucault.heteroTopia.en.html (accessed June 10, 2006). The preface states, "This text, entitled 'Des Espace Autres,' and published by the French journal *Architecture/Mouvement/Continuité* in October 1984, was the basis of a lecture given by Michel Foucault in March 1967."

In May 2004, **Steve Kurtz** called 911 when his wife experienced heart failure. The lab equipment used by Kurtz for CAE projects alarmed the responding paramedics. They contacted the FBI who searched Kurtz's home and confiscated many of his things including art materials and computers. Six weeks later, a federal grand jury charged Kurtz with mail fraud for obtaining small amounts of benign bacteria. As of publication, the trial is still pending.

David Levi Strauss and Daniel J. Martinez, "After the End: Strategies of Resistance," *Art Journal*, Spring 2005, p.42-49. David Levi Strauss and Daniel J. Martinez, "After the End: A Modest Proposal," *Art Journal*, Summer 2005, p.52+. David Levi Strauss and Daniel J. Martinez, "Teaching After the End," *Art Journal*, Fall 2005, p.28+. See Appendix 6, page 158, for full text.

Accuracy in Academia (AIA), is a nonprofit educational watchdog group based in Washington D.C. that promotes conservatism and opposes what it perceives as liberal thought on college campuses. AIA's mission states that it "wants schools to return to their traditional mission—the quest for truth." Founded in 1985, AIA is an outgrowth of Accuracy in Media.

PASTERNAK No, but I think we're taking it for granted that we're not satisfied. We're not really thinking about why. And I'm curious if any of you can conjure a project that had real resonance for you?

BONANNO (THE YES MEN) Well, the thing that comes to mind is the **Steve Kurtz** case and how that personally impacted so many people. It triggered a very immediate kind of emotional reaction and that's what gave it strength and that's why it's still going. You know, it wasn't an abstract issue at all and that's why it was powerful. I think that's why any issue is powerful.

And I think that's often why art is ineffectual and why it doesn't pass over into real activism, I guess, by our friend "Bob's"definition. But it is a pilot light and for real social organizing activism to happen, I think it has to be local and it's often not going to be defined as art. It's going to be a challenge for art institutions to find out how to define that as art, either through an intermediary or directly.

PASTERNAK Won't art institutions define it as art if artists do?

ASHFORD I think that institutional understanding of social and dialogic practices is key. As a young artist, I was invested in both art and activism practices as something that I thought were valuable and interesting, exciting and contemplative and worthwhile. I feel that the art school is a part of the art world. And, as someone who has managed and designed programs for an art school, I think it's extremely important for that academic world to exemplify those practices. Whether they're understood as having particular authorship, and whether they're understood as being part of an historical canon, I don't really care.

PASTERNAK Doug, I don't disagree with you, I just wonder whether institutions are actually artists' allies for socially progressive and direct work right now when their culture is fearful of reprisals for supporting publicly unpopular views?

DADERKO I've worked with a number of artists who present programs here in the city who aren't getting museum exhibitions and certainly aren't getting gallery exhibitions, but are showing all over the place in Europe. And so, I feel like if institutional support—just in terms of public visibility— is not going to come from the galleries, there's no reason why there shouldn't be some kind of institutional responsibility just in terms of being able to further dialogue.

LEVI STRAUSS One of the most active institutional sites for this dialogue now is, of all places, art schools. At Patricia Phillips' request, I just did a series of **three conversations with Daniel J. Martinez** on the politics of teaching art that were published in *Art Journal*. We talked about how the classroom or studio is one of the last radical autonomous zones in America, where you can do virtually whatever

you want. As soon as you step out of the studio or classroom, you have to deal with the politics of the larger institution, which are as screwed up as any, but inside the studio, it's wide open.

Mel Chin and BFA/MFA candidates of East Tennessee State University, *The WMD: Warehouse of Mass Distribution*, 2004

LIPPARD You've never been hit by **Accuracy in Academia**.

LEVI STRAUSS Not yet, no.

LIPPARD I've been hit by them and I don't even teach.

ASHFORD The academy is a temporary autonomous zone at best, there's no question.

CHIN I took a stint at East Tennessee State University, because it's in my local area. I basically became a Basler Chair of Excellence for the Integration of the Arts, Rhetoric, and Science for one semester. We built a full-scale **WMD singlewide trailer**, hauled it down to Texas, and won first place in the Art Car Parade. We hand-built this MX missile. We thought that since most people couldn't find one, we would make one. [Laughter]

It was inspired by Reverend Forbes's quote "Poverty is a weapon of mass destruction." It was the *Warehouse of Mass Distribution*, because instead of weapons it could carry food and serve as a distribution center for people who were hungry.

Chris Hedges, a *New York Times* reporter and veteran war correspondent, was booed off the stage in May 2003 while giving the commencement address at Rockford College in Illinois due to its anti-war sentiments. The full text of the speech is available online, http://www.granta.com/extracts/2100 (accessed July 10, 2006).

The school paid for it and this is East Tennessee State. But when it came time for the press release to CNN, the president's office held it back. They were scared. I had written one: "WMD Found." But the university president's office rewrote it. They rewrote it so well that it became, "Come see this little froufrou thing that this guy did in the yard," and that was what they sent out. That was the authorized version, so no press would pick that up. So, art schools may be free of it, but these academic institutions are terrified and prone to self-censorship.

LIPPARD Art schools aren't free of it. When I was giving a commencement speech at the Art Institute of Chicago just after we started the Iraq war, I was booed for anti-war statements—actually booing at the Art Institute!

VARIOUS SPEAKERS Wow.

LIPPARD Not overwhelming; it wasn't a Chris Hedges moment, but I was just amazed. Luckily, I had Studs Terkel on the platform with me… [Laughter]

LEVI STRAUSS It occurs to me that much of the current malaise is due to the fact that no one has any time, anymore; certainly no "creative time." Both art and criticism take a lot of time, so the lack of it (or the "management" of it) affects these acts disproportionately, and this has a political dimension. Frank Luntz, the Republican PR guru (he was largely responsible for making the specious connection between Iraq and 9/11 stick), is now busy building a "free time agenda," since his focus groups tell him that the biggest complaint among twenty- to forty-year-old women voters is that they no longer have any free time (and they remember when they did). My sixteen-year-old daughter knows she doesn't have enough free time—to think, to read, to make things happen. I find myself talking to my college-age students as if they have time to think, and they tell me that's all over. Everyone's run out of time.

So it seems to me that one of the things that programming and granting institutions like Creative Time—that want to have an effect—can do now is to slow things down, to give artists and writers time. The disappearance of free time has far-reaching consequences, and this lack will continue to haunt us.

ROSLER It haunts us creatively.

LIPPARD It's always a matter of priorities, when it comes down to it. How do you spend your time?

BICHLBAUM (THE YES MEN) How does an institution actually further work that creates social change? We've talked a lot about the problems—how it can't work because of boards of directors or because of the way it plays out

in the art world—but maybe strategizing how it could actually be rethought could be a discussion.

I think we have had a bunch of concrete examples of techniques, you know? Such as, how to diversify the practices, how to create sustained relationships with other kinds of institutions and settings.

ROSLER Well, it's true. I mean, a friend of mine who is a museum director in Europe said it was all fine as long as he had these nasty interventionist-type artists inside the institution, but once he funded their projects outside the museum, he almost lost his job—it was really serious. So I think there needs to be some neutral space where it doesn't make the institution go down in flames.

HAACKE I believe I heard tonight that some audiences are considered worthwhile and other audiences are of lesser or no interest. The same distinctions seemed to be made between institutions. Obviously, one doesn't have limitless energy and therefore is likely to address the kind of audience one is most comfortable and competent to work with. I believe it would be wrong, though, to dismiss, generally and in principle, any segment of the public. For better or worse they all affect the zeitgeist. We are dealing with a social continuum. The institutions are part of the same society we are part of. We participate, we benefit, and we are its victims—simultaneously. When we think about the possible effects of our work, we should not only consider the public of today but also audiences five years down the road, about how we can—with a bit of luck—incrementally change the climate of this society. Let me repeat: with a bit of luck! At critical moments it often takes particular constellations of institutions and individuals to succeed. One has to have one's ears and eyes open and seize opportunities when they present themselves. And let's be wary of getting caught up in sectarianism.

LIPPARD I think Chitra's ideas about the length of time to sustain an activity or a group of activities combined with a lot of people involved, not only one or two artists, is someplace to go, something to go forward with…

ROSLER Speaking of which, I should speak for Artists Against the War again and remind you that maybe the projects that we do are not earthshaking, but we have a sustained effort. I am also involved with a tiny online group that has a person in Australia and a couple of former Germans now in the U.S. and somebody who used to live on a farm in Wisconsin, but has moved to Madison, and the last member is in San Francisco. Every once in a while, we work on something we consider political. It's all done via the Internet, but we're in touch and we have been since January of 2002 when we did a workshop together in Florida for three weeks.

America Starts Here: **Kate Ericson and Mel Ziegler**, organized by Bill Arning and Ian Berry as a joint project of the MIT List Visual Art Center (February 9 through April 9, 2006) and the Tang Museum (October 1 through December 30, 2005). During a decade-long collaboration, from 1985 to 1995, Ericson and Ziegler produced conceptual art projects that used poetic language and wit to highlight social issues. Their works included public projects, site-specific installations, drawings, and mixed media sculptures.

And again, 16 Beaver is a model that has a sustained engagement with a community they have created. We talked about audience production, but you not only address an audience, you build an audience. You build a constituency and you build a group of people who feel implicated in that constituency.

PHILLIPS I would like to return to ideas of success and failure and how we define those terms. I am thinking, as an example, of the retrospective of the work of **Kate Ericson and Mel Ziegler** organized by Ian Berry and Bill Arning. The artists did a performative project called *Loaded Text* (1989) where they wrote out every word of the pending sixty-five-page Downtown Durham Revitalization Plan on the cracked sidewalk adjacent to the U.S. Post Office that was scheduled to be replaced. Kneeling side-by-side, the artists wrote one page on each section of sidewalk, rendering an inaccessible document and process more visible. They then used their art project budget to hire a contractor to replace the sidewalk.

I wrote an essay about the project for the exhibition catalogue and, in many respects, it was one of their most successful projects—and also one of their greatest failures. They were represented by the media in Durham, North Carolina, as opportunistic New York artists who came and squandered their artists' fees and took advantage of the community, and so forth.

So I think this entire issue of success and failure is a very interesting topic because I think it's often ambiguous and often temporarily based. We succeed at times, but we don't know it until the future comes.

I guess the other thing that I think really struck me at the beginning of this conversation, Doug, was when you were talking about your student at Federal Plaza photographing and then having his camera and film impounded. Then he actually developed another sort of tactic or strategy to deal with that incident. So, there is this kind of recursive way of being in the world and thinking about our practices— something happens and you come up with a thoughtful, but effective response to it. And I found that very interesting and very hopeful.

Beauty and Its Discontents

Conversation 2
December 5, 2005

In the planning of "Beauty and Its Discontents," the organizers focused on ways in which aspects of contemporary art are affected by socially-based criticism that is still mistaken for a "denigration of beauty," alongside the role that industrial standards of glamour continue to play in reducing the political potential of even the most poetic moments of daily public interaction. In the following discussion, participants respond to the growing institutional isolation of art from historical process and political urgency in the context of reactionary ideologies associated with beauty that took shape during the mid-1990s. For many of the participants, the divide between beauty and politics is ironic at best; a number maintain throughout the discussion that they do not consider separations between aesthetics and social transformation in their practice.

Some argue that there is currently less variety in art sponsorship and publications than there has been in previous decades, leading to fewer outlets to express contesting points of view. Others voice their concerns about the effect that the strong art market is having on issues of beauty and social action in contemporary art making. Still others contribute examples ranging from art that explores the emancipatory moment and a shared solidarity in a social or collaborative practice to the "situationist orgasm moment"—a complete rupture with reality that offers subjectively radical results. During the discussion, artists offer heartening evidence of engaged group practices, strong artistic presence in urban spaces, and alternate models to reactive modes of critique.

Marlene McCarty, *Looking for the New World*, 2005–06

participants
DOUG ASHFORD, moderator
JULIE AULT
PAUL CHAN
PETER ELEEY
COCO FUSCO
BYRON KIM
MARLENE McCARTY
ANNE PASTERNAK
HEATHER PETERSON
PAUL PFEIFFER
MICHAEL RAKOWITZ
AMY SILLMAN
ALLISON SMITH
KIKI SMITH

DOUG ASHFORD The agenda tonight is to discuss what some of us understand as the false dichotomy between art as a form of social transformation and art as a form of aesthetic enlightenment, of aesthetic contemplation. The context that we find ourselves in as producers is often institutionally split between these two roles: (1) art that's organized around the idea of subjective interaction as an object in a gallery or a museum and (2) art that's organized in and around the idea of something that's discursive and that's engaging political action.

I'm starting tonight with a story. Sometime in the late 1990s, the artist Harrell Fletcher was working on a public project that involved a large park. In order to garner audience participation in the project, Harrell asked a boy in the area to tell him what kind of sculpture the park should have. The boy said, "You should make a turtle and that turtle should be, like, turtle-sized." Deciding that was a pretty good idea, Harrell asked the boy what the work should be made of. "Oh, it should be wonderful," he said, "so it should be made of gold." Harrell said, "Great, but here's the problem. If you have a gold turtle and it's part of a public work, then people would take the gold or want to take the turtle home." The boy said, "Yeah, I understand that. So you need to paint it green." As someone who's been involved in dialogic projects from the street to the university for twenty years and has tried to rethink the needs of audiences, I find that much of the discussion about public art is centered on social effect, on culture as an instrument.

When do we get to talk about the way things look and why they look that way? I'm hoping that people will freely speak about things that didn't work, the quality of failures, and aspects of public practice that are not working. Let's brainstorm about tactics.

At the last dinner conversation, David Levi Strauss reminded me of something else, which Byron Kim and I spoke about a little on the phone before this evening. A lot of times when artists get together we end up talking about how institutions are inadequate to artists' needs. They're not doing enough work or they're not doing the right thing. And I think that's often true, but I also wanted to remind everyone of a quote I read by Andrea Fraser in *Artforum* just a little while ago. She wrote, "Every time we speak of the 'institution' as other than 'us,' we disavow our role in the creation and perpetuation of its conditions." So, I just want to remind us that we're all beautifully and barbarically inside and outside of institutions all the time.

ANNE PASTERNAK As you all know, Creative Time has had a history of presenting art that is timely and directed towards social change. But for years, we haven't been getting stimulating, socially progressive proposals. The reasons are many, including the pressures brought on by the strength of the art market, and so I thought this was a good moment to sit down and talk about this changed environment in which we are all working.

Harrell Fletcher is a Portland-based artist who creates socially engaged, interdisciplinary, site-specific projects exploring the dynamics of social spaces and communities. He often engages with a group of individuals— schoolchildren, gas station attendants, older people in retirement homes— asking their opinions, getting their viewpoints, and documenting their experiences. Image: **Harrell Fletcher, *I'll Follow You*, 2005**

Andrea Fraser, "From the Critique of Institutions to an Institution of Critique," *Artforum*, September 2005, p. 278-283.

COCO FUSCO But the market was even stronger in the 1980s when a lot of activists worked and political art was being made.

PASTERNAK Without a doubt, the contemporary art market is stronger now in terms of the dollars pouring in and out, its influence on media, etcetera.

FUSCO I think the stock market was stronger in the 80s. Artists were making millions, collectors were buying a lot more, museums were a lot stronger, and tax laws were much more favorable to museums in the 80s than they are now. So, this idea that the current market is so strong is baloney. The market is strong in that you can sell work for under five thousand dollars. And who does that effect? People under thirty. It's a myth.

 I think there's a perception about political art that is a product of the blackout of intellectual discourse and the rise of certain kinds of reactionary ideologies associated with beauty in the mid-90s.

PAUL PFEIFFER But does that mean you think there is currently more art selling for lower prices than in the 80s? In the fashion world, couture designers still produce fifty thousand dollar gowns, but it's no secret that they stay afloat by mass-producing thirty dollar bottles of perfume.

FUSCO There's a lot more turnover of artists. There are people with a certain amount of money who are buying, and so there are all these galleries that keep turning over in Chelsea. And they keep on raiding art schools to find cheap merchandise to sell to people who want a step up from IKEA.

PASTERNAK We could argue about the strength and influence of the market all night, but let's not. I think the more fundamental issue is what artists are being fed in terms of their roles and how they matter in society. There are new cultural myths at play that shape the opportunities, even the identities, of artists and force into question the roles of the artist in our society today.

ASHFORD So, then is that a question about schools or is that a question about the larger context for how art is promoted and discussed?

FUSCO It's about schools, but it's not only about schools. It's also about a reduction in the number and the variety of points of view represented in publications. So, it's about how the art world represents itself to itself. I think that we now live in an age in which *Artforum* is our *Pravda* regarding the art world. We don't have the same variety of publications that we had in the 80s. We don't have the same number of outlets to express contesting points of view. We don't have a kind of space in which to publicly air dissent. And that gives an impression to the young that there is no dissent.

PASTERNAK Coco, you are making an interesting point, because the truth is, I think there's more media coverage of artists than there has ever been before, but that doesn't mean it embraces artists' freedoms and their dissent from popularly accepted "norms."

FUSCO It's not about art; it's about fame. Okay? It's about fame.

ALLISON SMITH And about money.

FUSCO It's about fame. It's about celebrity. It's about personality.

This is not just a symptom of what's happening in the art world. It's also a problem for university publishing, which has had to direct itself towards what is commercially viable, which means fewer books are published on a smaller range of topics.

A great indicator of this shift was the show, *COUNTERCULTURE*, that Brian Wallis did at Exit Art in 1996 about the history of the alternative press in which he saw that the number of underground publications, which were available in the United States in the 60s, 70s, and early 80s, dropped off after that.

COUNTERCULTURE: *Alternative Information from the Underground Press to the Internet,* curated by Brian Wallis, was held at Exit Art in New York City from February 24 to April 20, 1996.

DOCUMENTS magazine, a journal of art, culture, and criticism, was founded in 1992 by five friends and Whitney Independent Study Program alumni Christopher Hoover, Miwon Kwon, Jim Marcovitz, Helen Molesworth, and Margaret Sundell. Published from 1992 to 2004, the journal was named after a short-lived journal by Georges Bataille, which was published from 1929–31.

Electronic Frontier Foundation (EFF) is a nonprofit organization dedicated to preserving free speech rights in the context of digital technology. EFF was founded in July 1990 by Mitch Kapor, John Gilmore, and John Perry Barlow in response to the search and seizure of Steve Jackson Games in early 1990.

Heresies: A Feminist Publication on Art and Politics was a journal published from 1976 to 1996 by the Heresies Collective, Inc. based in New York City. The Collective consisted of a group of about twenty-four feminists from a variety of disciplines ranging from visual artists to anthropologists. Twenty-seven issues were published.

ASHFORD This is something we talked about during the last dinner, not in terms of publications, but in terms of the scarcity of contexts in which artists are in conversation with each other on a formal and informal level. I mean, there were artists' meetings all over that generated space and generated discourse. As a younger artist, especially in the early 80s, social collaboration was a constant part of my visual practice. I remember in any given month moving from reading groups and tenant meetings to PADD, A.I.R. Gallery, and Printed Matter. We organized shows in Coney Island and Club 57. Personnel and projects changed, but the notion was consistent: art provided a context for social forums.

So, I guess the question would be: Is there anything that we're doing now to change this predicament of a culture drained by the market? Can anyone bring up some examples so that we can talk about tactics to generate those kinds of conversations or publications again? There are examples today, as in publications like DOCUMENTS magazine. It's such a hard thing to run a publication.

MARLENE McCARTY I agree with what you're saying about publications dropping off, but in my naïveté and isolation in my studio, I thought, "Oh, it must have been absorbed by the Internet." There must be forums and opportunities to really voice your opinion and say what you think.

FUSCO That's exactly what people thought in 1994. That was the discourse of the information highway. That was the promise made by the rhetoric of the Electronic Frontier Foundation.

McCARTY So then, I'm asking, is there something out there that I'm naïve to?

FUSCO Well, I think some people thought for a while that the digital domain was going to be the alternative. And it promised that in the mid-90s. But then I think that a lot of people involved realized that the promise could not be sustained, because the digital domain became increasingly privatized. And museums lost interest, because they couldn't figure out a way to capitalize on the next phase enough.

AMY SILLMAN I was working on Heresies in the 70s, a feminist magazine. And I definitely remember hanging-out as being a crucial part of the political environment in the 1970s. If you were a young art student, then you would definitely meet people and hang out with them. I couldn't have understood the politics of feminism as a student without actually meeting older artists and going to their houses and seeing how they lived.

I actually have a different question tonight. I don't know whether the question of beauty has any relationship to what I do. In fact, I actually don't think it does. I'm not particularly interested in aesthetics. I'm not interested in the creation of beauty. I'm actually interested in other things.

I am a person who works in a studio most of the time and although I haven't exactly formulated a strategic way for my work to be distributed differently from the traditional way, I still don't think about my studio practice as being some sort of retrograde, old-fashioned thing. My studio practice is not a search for beauty.

FUSCO But at least, you need to recognize that with the rise of people like Dave Hickey in the mid-90s, a discourse was reintroduced into the art world that was politically designed to destroy another kind of discourse. It was designed essentially to completely destroy any kind of practice that engages with the social, because his argument negates the value of many socially-based arguments. He rescued all those people who didn't know how to react negatively to the onslaught of post-structuralist theory, to the introduction of institutional critique, to the popularity of collective practices engaged with the political. Suddenly, there was a language that wasn't negative, that wasn't overtly racist, that wasn't overtly sexist, and that was reconstituting the aesthetic. And all these very powerful institutions and people latched onto it. Remember this guy appeared out of nowhere from Vegas.

McCARTY You're coasting again on the institutional level. All I can do here is think, "As a working person, as an artist, I don't give a shit about that stuff."

FUSCO You can not give a shit about it, but it completely changed the way that the art world operates.

McCARTY That's true. But it's out *there*. That's out *there*.

FUSCO It's not out there when you're a professor and you go into the classroom and your students, who have never cracked a book, tell you that they don't want to read anything because they care about beauty. It is not irrelevant when curators, who have also never cracked a book, ask you endlessly about beauty. It is not irrelevant when people have absolutely no generalized understanding of the history of the relationship of art to the social, and yet they come up with these completely banal criticisms about work that engages with the political. That's when you see the fall-out repercussions of that discourse. It's not about whether I read Dave Hickey, because I don't. It's about my recognizing the political impact of a series of texts that were appropriated for political reasons by art institutions, which then had a fall-out effect on all our practices.

ASHFORD Coco, it's a good example, but it's an example that's being presented in a way that's a bit reductive in relationship to the artistic practices that are trying to redefine this dichotomy. The emphasis on aesthetics as oppositional to politics in art production seems to me more about academics protecting their turf than what artists actually think about.

Amy Sillman, *Big Girl*, 2006

Dave Hickey is a writer and cultural critic. His collection of essays on art, *The Invisible Dragon: Four Essays on Beauty* (Los Angeles: Art Issue Press, 1993), called for the "return" to beauty in art making and art criticism. A second collection of essays, *Air Guitar: Essays on Art and Democracy* (Los Angeles: Art Issue Press), was published in 1997.

FUSCO Doug...

ASHFORD It's true. And I think everybody here understands the didactic capacity of that guy's writing, but...

PETER ELEEY Isn't there a post-Hickey way...

Omme Kolsoum

ASHFORD Coco, many of us are also invested with ideas about how we associate with each other publicly around the idea of aesthetic contemplation and epiphany. We have had experiences with Omme Kolsoum, with Patty Smith, with the ecstasy of a shared experience of music, often developed formally with an eye toward social practice: "Jesus died for somebody's sins, but not mine." Right? Even those of us invested in direct social activism have had those experiences where we felt emotionally engaged. We have empathy with other people when identifying with the collective effort to make our subjective selves feel different. And that collectively felt difference is a political moment!
I want to go back to what I said in my introduction. The idea of exporting these problems to some other institution that we're supposedly not participating in, to me, is not the point of this conversation.

PFEIFFER I've been doing a lot of looking online at a site called Flickr recently. It's a photo blog. People upload their photographs, give them keywords, and then they link to friends. If you go to the Flickr home page you can search by any kind of subject category, like cat, and you get a whole list of people who have cat photographs.

FUSCO That's database art!

PFEIFFER And it's visual, and it's a social space, or a space where the like-minded can swap information, at least. In many cases, it's all about art, like blogs where people compile images of their favorite artists' work, or the ten favorite shows they've seen this month. There are lots of young artists out there with their own photoblogs, too.

ASHFORD So?

PFEIFFER Exactly. My point is that there are plenty of opportunities these days to create your own social spaces. We've never had more opportunities. But do they matter if they're not on the radar at *Artforum*, or the Columbia MFA program, or a big gallery, or with powerful curators and critics? If we're in information blackout mode, it's also self-imposed. I'm not trying to cast blame here. I'm just saying that's how control works in an information economy. Too many MCs, not enough mikes.

SILLMAN There are so many markets right now. There are shops dedicated to skateboarding, to robots, to the underground art that's going on that's related to Japanese

anime, and to the whole zine world. All of a sudden, it starts to feel really commercialized. Then there are all these different frameworks like Flickr. But, Marlene, you were saying that's not what influences you when you're in the studio, or that's not what impacts you in the studio. What is informing you when you're in the studio?

McCARTY It's not to say that those things are not present, but they are so obfuscating and they can shut one down so rapidly. I'll tell you what's really at work in the studio is a total fuck-you attitude. It's just like, "Fuck it. I don't give a shit." Otherwise, you don't get anything done and you don't get anywhere. It's a downward spiral when your thinking starts cycling: "Oh, it's so horrible in Chelsea. Galleries have just become big boutiques. And that damn psychedelic-like pattern shit." You know, you can't go there.

AMY SILLMAN I was actually asking because I was curious if beauty was of any importance to you. I don't really think it is necessarily of importance to anyone I know.

ASHFORD But don't aesthetic innovations and formal exper-iments model emancipatory moments? Shared concern happens when people appreciate things that move them. Those moments have happened to all of us. I know I'm not alone. Those moments have moved us to collaborate together on projects to try to transform institutions, museums, and markets. Those moments have moved people to **pray in front of paintings**. Right, Byron? Those moments have moved us to make acts that have tried to dissemble the social relations of art.

ELEEY I think the idea of an "emancipatory moment" is interesting in this broader discussion. I think that Allison Smith's work explores this kind of emancipation, the kind of liberating social sublime that we get from collaborative practice of a certain sort. I think that's part of it.
 But I also think, Amy, that we might be misunderstand-ing each other's definition of the word "beauty" because I definitely think of your work in terms of a kind of beauty and, also, *against* beauty. Even when we were talking last week and you said you were trying to work towards an almost purposeful ugliness in the work, that is a part of this dialectic. Maybe you're thinking about something differently, but I think that counts.

A SMITH I don't know if I've really been thinking much about "beauty" specifically, but I have been thinking about "making" a lot lately. And, in reading over the notes Doug provided for this evening, I found myself transposing the notion of making onto that of beauty. Some of the more interesting aspects, to me personally, that emerged from my recent *Muster* project had to do with issues of craft. There are an enormous number of creative and politically motivated people working right now in the D.I.Y. spirit to generate

Byron Kim with Assembly of the Buddha Sakyamuni at the Metropolitan Museum of Art, 1996

Performance by Coco Fusco and Guillermo Gómez-Peña, *Two Undiscovered Amerindians Visit the West*, 1992–1994

The **Whitney Museum's Independent Study Program** (ISP) was founded in 1968 and consists of four interrelated parts: Studio Program, Curatorial Program, Critical Studies Program, and Architecture and Urban Studies Program. The program encourages the theoretical and critical study of the practices, institutions, and discourses that constitute the field of culture. Alumni include Andrea Fraser, Felix Gonzalez-Torres, Jenny Holzer, Glenn Ligon, Julian Schnabel, Roberta Smith, Richard Armstrong, and Lisa Phillips. For an analysis of the ISP see Howard Singerman, "A History of the Whitney Independent Study Program: In Theory and Practice," *Artforum*, February 2004, p. 113+.

collective art practices—radical quilting bees, renegade craft fairs, and collaboratively printed artist zines, for example— that propose alternative economies and communities around the handmade. These interestingly call to mind other art historic movements that have emerged in times of national division and turmoil. Through my work, I'm interested in investigating the role of craft in the construction of national identity, and I find the social histories of many craft practices to be an incredibly rich source of inquiry from a political point of view, one that is consistently underestimated in the art world.

I came to New York in 1990. And just to give you a little bit of background, I'm thirty-three, so I think I'm one of the youngest people here. Both Coco's and Kiki's work were really important to me. I came of age at a time that was really vibrant in terms of active dialogues about identity. I felt personally called to respond to that. I knew that it was going to take me a long time to articulate what I wanted to do, and I feel like I'm still doing that.

So, one of the things I wanted to say, Coco, is that you shouldn't feel like your work is lost on a younger generation of artists, because I'm part of that generation. Not all younger artists are in this for celebrity.

I went to graduate school at Yale and was considered the feminist artist of my program. I was basically told by a faculty member, to my face, that art had no social relevance whatsoever and that essentially I should get over it and work on something else. So after Yale I went to the **Whitney Museum Independent Study Program** and I had a friend, a fellow participant, who came into my studio almost like an intervention saying, "Allison, we just don't understand why you're making things." Neither of these attitudes were helpful. I felt really out of place. In both places, I was trying to find community. I was trying to find that dialogue, which I felt my work was emerging from, and to contribute to it. One of the things that I learned from art and theory of the 90s was that political art is always necessarily temporary and local, which is perhaps why some of that art, though effective at the time, lacks long-term staying power for a younger generation of artists. Many of the ephemeral, performative, or highly conceptual strategies used then, in their effort to avoid commodification, leave little to engage with in the physical sense, and I'm not sure it's sufficient to suggest that today's art students just don't read enough. Another lesson of the same art that I have always carried with me is that new strategies of creative political engage- ment have to be reinvented constantly. In my own work, a reconsideration of the notion of making, in the broadest sense, is key.

And regarding the idea that political art lacks currency today, things do work in cycles. The fact that this meeting is happening right now suggests perhaps that the tides are turning.

HEATHER PETERSON What do you think allowed you to stick to your guns when everyone was telling you, "This isn't relevant?"

A SMITH I don't know how to answer that besides a belief that it was. I think a lot of people here tonight are also teachers in different programs. Amy and I have talked about this before. There are so many students, young women students for example, who don't want to identify with feminism. But then it becomes our job. I mean, I remember my experience as a student, so now I'm in the role of trying to advance that dialogue with younger artists. If you think that all your students just don't care, maybe that's not true, and it is up to you to engage with them in new ways.

SILLMAN We were talking about this because it's really hard to find someone who will say that they're a feminist under thirty.

FUSCO They don't need to be feminists, that's what I tell them. They don't need to be feminists yet. What the feminist movement has essentially done is pushed the glass ceiling back so that they don't really feel the effects of gender and equity until they are thirty-five. [Laughter]

I get these blank stares. I tell them, "Come and talk to me after you're thirty-five, when your tits have fallen, and you're no longer a second grader. Then we'll talk about it, when you're arguing about equity with men your age, dealing with the job situation, and not having parties all the time." Things change as you get older. I've seen it. I have students from ten and twelve years ago who now address me in a totally different way.

PASTERNAK Maybe this is too far off the "beauty and its discontents" subject, but what kind of power does art have today?

FUSCO Well, I can think of some really great examples of situationist orgasm moments in the last couple of years involving art.

PASTERNAK Situationist orgasm moments?

FUSCO Situationist orgasm moments. When The Yes Men were on the BBC World News apologizing for Bhopal and the BBC actually believed that they were from Dow Chemicals that for me was a situationist orgasm. That was one of the things in art that made me happiest last year.

It is when there's actually a breakthrough and when there's actually a moment of complete rupture that is productive. It doesn't happen every day. And I think one of the most interesting things that came out of The Yes Men example was that survivors of the Bhopal disaster, family members who lost their relatives, at first were really pissed off at The Yes Men. Then they decided that this was the

The Yes Men's Andy Bichlbaum appeared on BBC World news in the guise of a Dow Chemical spokesman, "Jude Finisterra," to take full responsibility for the **Bhopal** disaster. The appearance coincided with the twentieth anniversary of the tragic event, a chemical release that killed thousands and seriously injured over 100,000 people. Image: **The Yes Men, *Twenty Years Later, Dow Does the Right Thing*, December 3, 2004**

In April 2001, the anti-globalization movement held a People's Summit and organized protest marches against the **FTAA** summit in Quebec City, Canada

Henry Darger (1892–1973) was a reclusive artist who lived and worked in Chicago and posthumously became an important name in the world of outsider art. His major work was a twelve-volume, 15,143-page manuscript called *The Story of the Vivian Girls, in What is Known as the Realms of the Unreal, of the Glandeco-Angelinnian War Storm, Caused by the Child Slave Rebellion*, along with several hundred watercolor paintings and drawings illustrating the story. Image: **Henry Darger, *Untitled (Battle Scene During Lightning Storm. Naked Children with Rifles)*. Collection American Folk Art Museum, New York, Gift of Nathan and Kiyoko Lerner.** ©**Kiyoko Lerner**

Denis Diderot (1713–1784) was a French philosopher and writer. He was a prominent figure in the Enlightenment and was the editor-in-chief of the famous *L'Encyclopédie* (1750-1765). His art criticism was also influential. He wrote accounts of the annual exhibitions of paintings in the Paris Salon, the *Salons, critique d'art* (1759-1781). Diderot's other major writings on art, include his *Essais sur la peinture* (1765) and *Pensees detachees sur las peinture* (1775).

only way to make their issue known on a global scale, so they agreed to meet with The Yes Men.

PAUL CHAN I think you've brought up an interesting example. I have my own examples of moments where there's a formal point in which everyone becomes confused. You know a protest is going well when newscasters don't know what to say, they're just sort of dumbfounded, like during the **FTAA protest in Canada**. The idea is that art provides an opportunity to radically disperse power. Politics of anything is about power—who has it, who wants it, and who benefits from having it.

For me philosophically, art may be antithetical to questions of power. There is something within a **Henry Darger** painting that gives me the opportunity to realize there's a radical powerlessness there. And it makes me feel a little inhuman, which opens me to the possibility of something else happening. And I think these moments become incredibly personal and ethical.

We make dead things. So, at what point do you realize that you're basically making Frankenstein. And, for me, the question of how far do I want it to go on living becomes important. I think power becomes sort of a dynamic.

ASHFORD It's like **Diderot**'s idea of an emotional community that arises out of the aesthetic moment of looking at a picture. I believe that those things do happen. I am trying to understand this historically and theoretically, as an Enlightenment concept and also understand how that concept has been corrupted by hypermarket culture.

BYRON KIM I totally agree with Paul. I sit in my studio looking at this thing and regretting that I am dealing with this mute object and that I'm having an exclusive conversation with myself or with only a few other people Often, I make work in an atmosphere of disappointment. I feel backed into a corner and, finally, begin to sense some possibilities. Something beautiful arises out of the intimacy of the disappointment or the regret or the loss or the lack of being able to communicate. I'm always sitting in my studio comparing my work to some other thing and wondering whether this work might be beautiful because I learned this kind of thing is beautiful. I'm thrown into utter confusion when I do this and that is exactly the reason why I keep doing it.

SILLMAN I don't understand what you mean, Paul, when you talk about dead things. I wouldn't be able to walk through a museum and be interested if I felt like it was a mausoleum. Do you just think that about your own work? Or do you think that about everything you see?

CHAN I don't think we should make a normative value judgment on things that are dead. I don't necessarily think that dead things are bad. In fact, I think that's a whole problem, we think dead things are bad. But it helps me

to focus on the idea that there are certain things I do for the living and then there are certain things I do to remember and to articulate the dying and the dead. And so, art becomes one of those ways in which I help to formulate a discourse around what it means to be dead or dying. And I think for me that ultimately comes down to a very fundamental idea that these things that we work with, whether computers or pigment, are inanimate things. They're not a baby.

SILLMAN I just don't understand this death thing in regards to the idea of making because I don't separate the thing that I am touching and moving around all day from being alive. The making, the phenomenology of it, I don't separate that from my own body. My body is there still in the work!

FUSCO But once you're done Amy, it's done.

SILLMAN But it's not. It's actually not done…

FUSCO The thing about the majority of art objects, with the exception of those objects that purport to initiate yet another process of disintegration, or decay, or entropy, is that they are finished. And in that sense, they become dead things.

ELEEY But let's talk about active things. For me, there's a very distinct and clear definition between art and activism. Activism is oriented towards a very specific goal and is measured and evaluated on its effectiveness at achieving that end. Whereas art, on the other hand, is generally not oriented around a specific goal, and is less often evaluated on its ability to achieve a singular kind of purpose.

SILLMAN But I could give you counter examples. I could give you examples of activism that doesn't have a specific goal, and of art, that has a very specific goal.

FUSCO I'd like to go back to Doug's question about the hypermarket culture. Over the last ten years, the market has infiltrated spaces of dissonance. The market has subsumed all alternatives. When I was in school, it was opposed to the market. School was an alternative to the market. The artists who were my teachers developed their anti-capitalist, anti-market aesthetic orientations as artists—as performance artists, as anti-object artists—because they worked in schools not only as teachers, but they also presented their work in schools as artists.

Schools were the spaces that allowed Chris Burden to start, Living Theatre to survive, and a lot of the minimalists (who are now idolized by these people who are in love with the market) to have a beginning and to have a life. Over the last fifteen years, the market has taken over the art school and the alternative space, so that spaces that began in opposition to it have become spaces of collusion.

Today both schools and alternative spaces participate in the market. So, when people say, "I don't know anything else."

The **Living Theatre** was founded in 1947 by Judith Malina and Julian Beck. It was one of the first troupes in New York to break away from traditional theatrical restraints towards a more sociopolitically aware, reality-based theater. It became one of the best-known street theater groups in the United States, especially for its confrontational approach to audiences in the 1960s. Its political defiance led to participation in sit-ins, Vietnam War protests, and peace marches.

I say, "Well, I'll tell you why you don't know anything else. This is what has happened."

ASHFORD There was a time in which artists were encouraged—encouraged by themselves, encouraged by each other, or encouraged institutionally—to be re-invested in relation to dialogic forms of practice. One of the things I notice about my students is that they feel so professionally specialized. They have a relationship to the school. And they have a relationship to an idea of patronage, public or private. When you try to bring up a political or a social movement, even in a philosophical moment, they don't see it as fitting into the continuum of the institutional placement of the work.

I'm wondering, isn't it possible that there could be, with small amounts of money, a sponsoring context in which artists would be put into situations where they would have conversation with people and audiences and collaborators…people who are doing other kinds of work? Could they then see their work as related to other kinds of work? An anti-art school?

Cram Sessions, organized by Chris Gilbert, was a series of four experimental month-long exhibitions held at the Baltimore Museum of Art: *01 Collective Effort* (March 3 to March 28, 2004); *02 Dark Matter* (November 3 to November 28, 2004); *03 Sound Politics* (April 6 to May 1, 2005); and *04 Counter Campus* (November 2 to November 27, 2005). Image: **Installation view of Cram Sessions 04: Counter Campus, featuring Bohemia Research Garret by Stephan Dillemuth/Nils Norman**

Nils Norman and The Exploding School: See his Web site: http://www.dismalgarden.org/pages/exploded_school_contents.html. Facing image: **Nils Norman, The Ecology/Art Expedition Survey, Phase 1 (oyster lunch), Sonoma County, California, March 17, 2002**

SILLMAN I definitely feel like there is a way of being challenging in a classroom that might not be possible in a marketplace. You go into a classroom and encourage the students to talk about something in an open, questioning, curious, or critical way.

I feel like everything I have learned, I have learned by teaching. I talk to people that I don't agree with. I teach with people who I don't necessarily understand. I articulate ideas in books that I've read to people who don't know them. Teaching, for me, is the middle space between having work in a gallery and making something for a protest march or a magazine. Teaching is the front line. I still think teaching is the most ethical part of my life.

I try really hard to make students think about how their ideas about form need to be challenged and to be challenging. Because I think form is the vehicle by which their ideas come across. So going back to your proposal, Doug, in a way I think the most radical thing that we could do is start a new school.

MICHAEL RAKOWITZ Starting a new school is a focus of conversation where I teach in Baltimore, at the Maryland Institute College of Art. Part of it is in response to a series of exhibitions called *Cram Sessions* that was organized and curated by Chris Gilbert, who was the curator at the Baltimore Museum of Art for a while.

The last in a series of four exhibitions, *Cram Sessions: 04 Counter-Campus* was looking at alternative educational institutions. So, it looked at places like 16 Beaver Street and people like **Nils Norman** who champion the notion of radical pedagogy along the lines of those presented in *Streetwork: The Exploding School*, which was a very popular book in the 1970s about how education can't happen in the classroom. The exhibition takes it that much further

Nomads and Residents was founded in New York City in 1999 as a forum for visitors in the arts. The group's mission was to help make connections and support networks.

Parasite was a New York-based, artist-run organization formed to support, document, and present project-based artwork with a focus on projects committed to political and social causes. Parasite created projects at "host" organizations in order to develop a discursive context.

and recognizes that these spaces have existed. I imagine Nomads and Residents and Parasite have provided this type of space. And now, 16 Beaver Street seems to be a model and has been cloned in different places around the world.

I think we're in this healthy moment at the Maryland Institute College of Art where students are getting pissed off with the administration. There's a sense of distrust for the institution. But then the onus is on them to start to make discoveries about how they want to be taught and how they think about these ideas, which I find the students in Baltimore hold in very high regard and find important. Students need to look at these alternative educational projects and look at updating them so they're pertinent on tactical levels as well as in terms of subjectivity.

Students are fascinated with these projects. And I don't find the students so affected by market in Baltimore, but that might just be a geographic disconnect.

PASTERNAK Well, the problem is that the safest place to deal with it is in school, but the question remains: What happens once they leave school?

McCARTY The ideal place to do it is in the real world. It's not about going to school, going to graduate school, going to more graduate school…

SILLMAN I agree with you guys, but at the same time, I'm not telling my students that this will be how to make a living. I'm telling them how to stay together. The people from Skowhegan now show and teach in the real world, and the conversations that started at Skowhegan are now out in the real world. School is crucial.

ASHFORD I've been thinking about the pyramid scheme of art schools. The eight thousand MFA students a year is absurd. But I also feel that there's an idea about the training of the artist that is not about professionalization. It's about a combination of what Amy and Coco were both talking about. I hope to train someone to be a skeptical and creative citizen. There's a value in that.

FUSCO There's no space in that.

ASHFORD Many of my students end up resisting the professionalized role of the artist as it is organized at this moment in history, because they can't or won't cope with this boutique world of galleries and collectors. They often end up doing multiform practices, which maybe don't fit into received ideas of art in terms of the making of things, but they definitely are invested in creative practices. Unfortunately, there are few spaces or contexts for this work.

SILLMAN I'm curious, Coco if you're saying that it's not happening in the schools and it's sure as hell not going to happen in the marketplace, where do you see opportunities for artists?

FUSCO I think artists have to decide where they want to make those opportunities happen. And I think a lot of my peers are more interested in making a living, they don't want to work on making opportunities or changes. It's not the students. I'm not trying to rag on students all the time. This is a reality that I have to face everyday among my peers. People who used to be much more engaged with the social decided to focus instead on making a living. And that's a reality.

If you want to make something happen, you make it happen. You find the people who will work with you. You find a way to do it. You change your methods. You experiment. You look for an audience. You find a way. Lots of people go through all kinds of changes in their practice in the course of their careers. They end up channeling their work into lots of different areas.

But there is a lot of complacency out there that isn't about the market. It's also about an individual decision that it is too hard to think hard. It's too hard to make an effort to do something else. Many people don't want to challenge things. That's real.

ASHFORD Allison and Michael, you both have practices that started off in different ways, with *The Muster* on Governors Island and with the *paraSITE* shelters and other projects. What are your experiences? You were able to make this work in a time that was completely different from the history that many of us here at the table are talking about. There was no...

A SMITH Well, that's what I keep thinking. I feel like we've gone full circle in this discussion back to the idea that it's the responsibility of the artist to seek out new forms of engagement and critical dialogue. And there are examples out there for the younger artists who want to work in those ways. There are examples that could be shared by many of the people who are here right now; you are role models.

ASHFORD I say it all the time, "Make your own scene. Don't accept the scene that's there. Make your own scene."

A SMITH I connect to the title of this series, *Who Cares*. *The Muster* was a project inspired by a genuine desire to know what, if anything, people in my artistic and queer communities are fighting for. "Muster" is a military term meaning an assembly of troops for the purposes of inspection, critique, exercise, and display. Using references to Civil War battle re-enactment to metaphorically suggest a kind of relentless infighting, I wanted to create a space for ecstatic proclamation, for expression and dialogue, to frame a polyphony of ideas and voices. My experience

The Muster was held on May 14, 2005 on Governors Island in New York City, and centered on the question, "What are you fighting for?" Created by Allison Smith and inspired by Civil War reenactments, it featured over one hundred participating artists in approximately forty tents. *The Muster* was sponsored by the Public Art Fund.

paraSITE is a project begun by Michael Rakowitz in 1997. The artist describes the work as, "[T]he appropriation of the exterior ventilation systems on existing architecture as a means for providing temporary shelter for homeless people...Since February 1998, over thirty prototypes of the *paraSITE* shelter have been custom built and distributed to homeless individuals in Cambridge, Boston, New York City, Baltimore, Ljubljana, and Berlin. All were built using temporary materials that were readily available on the streets, such as plastic bags and tape." Image: **Michael Rakowitz, *Bill Stone's paraSITE shelter*, 1998**

Dennis Adams, *MAKE DOWN*, 2004 (video still)

with this project has been incredibly rewarding and cathartic. Over two thousand people attended *The Muster* on Governors Island, and it was not the same people you would find at a Whitney Biennial opening.

RAKOWITZ I came out of a situation where, as an undergraduate, I focused for the first two years on graphic design, because of parental fears about not having any kind of economy afterwards, and then I sort of segued into sculpture. After becoming disillusioned with where the work would potentially end up, I went into a graduate program at MIT that was a public art program that existed in the Department of Architecture. And the people who I was influenced by in my graduate work were clearly, I think, involved in teaching as a means for generating income. It's something that kept the discourse critical and aware of this countercultural moment. It was also a survival mechanism for me, purely pragmatic. I think that in studying with people like **Dennis Adams** there was a sense of emancipation in regards to not always focusing on market, which I know nothing about really. It showed me that there is a kind of steady income available that allows you to focus on the ideas that are not necessarily attached to something profitable. When I'm teaching courses, I'm coming from that. I try to show students that you can create your own scene or come up with a franchise of students that find the same things important, regardless of the market. I think this is starting to reveal itself in Baltimore where there is a group of students that are starting to stay in the city and deal with its issues. They are really integrating themselves into the urban tragedy that is Baltimore.

PASTERNAK I'm seeing this in mid-sized cities around the country. And I think this is important. Besides, it's hard to come to New York City—you just can't escape from the horrors of the economics. Perhaps you go to graduate school and you're tens of thousands of dollars in debt in student loans. The cost of living is outrageous here. So, it's great that artists stay in other cities and make their own scenes there.

A SMITH Must there be a dichotomy between the notion of marketable art and a more socially engaged practice? I mean, do they have to be polar opposites? Aren't there ways that you can work within a given situation, i.e., our market-driven art world, and still do work that is socially meaningful and relevant? Participating in the market affords visibility, and with visibility, you are part of a public dialogue in which you can effect positive change.

PASTERNAK For sure this is possible and it happens, but rarely. I wonder how much positive change is really put into motion…

CHAN May I just interject something? Whenever I get a chance to talk about this, I do, because I think it's incredibly prophetic. The writer Mike Davis, who wrote *City of Quartz*, has a new book called *Planet of Slums*. In this book, he discusses how the future population of the world will live. He says that for the first time in humanity people will predominately live in urban environments, specifically mid-sized cities. And you can actually see this trend. For example, in the U.S. immigrants now circumvent the metropolises where immigrants have traditionally gone— New York, Los Angeles—and instead they go straight to the suburbs because obviously the cost of living is cheaper there.

The other thesis Davis talks about is how by 2050 the world will be a planet of slums because the explosion of population growth in these cities are not and cannot be sustained by the usual suspect of job growth. So, cities growing in numbers, but not growing economically become slums. And who's organizing these people? It's not the Left, it's not the Right, it is Pentecostal Christians, populist Islam, and Hindu fundamentalists.

Actually I'd like to bring this back to beauty, because I think beauty is still really important to me. That is why I became a painter. I think the discourse about beauty may have something to do with Dave Hickey, but, frankly, for me, it has a lot to do with this return to religion. I think it's directly connected with this idea. And since religion isn't going to go away any time soon, I don't actually think that the discourse of beauty is going to go away anytime soon. Our Western notion of what beauty comes from a very theological background.

PASTERNAK Would you explain this a bit?

CHAN I think Western art is inextricably linked to cultic objects. Once upon a time art functioned as objects that where supposed to embody the unknown and the invisible, for instance, God. Over time, though, something changed, such as the advent of modernism. But I see the return to this idea everywhere.

I saw this in **Vieques, Puerto Rico.** I was hanging out with the people who were resisting the naval bases. They were eight- and twelve-year-old kids and eighty-year-old grandmothers, and they were climbing naval fences to put their bodies on the line. And in this charged political space, they had art: this plastic figurine of a Virgin Mary. And they would keep it clean! The Virgin Mary plastic statue provided the opportunity for seeing this sort of terrain, of a future time when the Navy would leave.

Same thing in Iraq. Iraq had a huge art market. And they loved Giacometti. Basically, Giacometti provided the existential form of how Iraqis saw themselves. So, if we take the history of art seriously as a history of cultic objects then I think this discourse actually goes beyond the market areas in New York and Los Angeles. I think there is still an

Mike Davis, *Planet of Slums* (New York: Verso, 2006). *Publishers Weekly* writes that, "Davis paints a bleak picture of the upward trend in urbanization and maintains a stark outlook for slum-dwellers' futures."

Vieques, Puerto Rico

aura of the museum and the gallery providing objects that can better us as human beings.

ASHFORD That's what I was trying to get to with the idea of the emancipatory moment. And I also think that your comment about religion is particularly important in terms of social organizing, because those collective aesthetic moments that I had as a kid—in relationship to rock 'n' roll or in relationship to fashion or in relationship to club culture—are experiences that many kids are now having in relationship to highly organized religious institutions. I think those are aesthetic experiences. People identify with each other around those experiences.

SILLMAN Whether they are from the suburbs and went to Harvard or from the slums and worship the Guadalupe Virgin, beauty is not a static universal. I don't want to treat it that way or think of it that way.

I learned to expand and transform my idea of what was beautiful by going to art school and I'm really glad that I did. I feel like that is the thing that interests me about modern art. I don't think that there is "Beauty" that exists independently. There are practices around beauty and fetishes around beauty. I came to New York from Chicago, where I grew up. In Chicago, in my baby artist, baby feminist social circle, we didn't care about gestural painting. I thought those paintings were hideous. When I came to New York to art school, I was told that they were beautiful. And I was like, "This gray shit?" Because of my background in Chicago, I didn't understand. But then I changed my mind.

So, that was transformative. To get out of one kind of aesthetic and into another aesthetic was very valuable to me. It challenged my notions of what was beautiful. I wouldn't leave beauty in a hallowed space.

FUSCO One of the problems that I've had as a professor in an art school is that there is very little criticality in the discussion of what constitutes the beautiful in the classroom. Now, that is the fault not only of the students, but of the professors who use their personal definition of beauty to determine what should reign in a classroom as opposed to any kind of historically, theoretically, or politically informed understanding of beauty. As a result, it ends up being about this personal epiphanic moment.

You know, when you empower adolescents that way, they end up just kicking each other in the stomach. They have no way of being analytical about their tastes. I think that is extremely dangerous in that it feeds into a reactionary idea that beauty is just about what I think and not about what history thinks.

SILLMAN I don't think it has to be reactionary if you describe it as being a bodily experience, a sensate phenomenological experience, which we all are having all the time.

FUSCO You know what, that ends up just being "whatever makes me feel good." When you tell a twenty-two-year-old, beauty is "what makes you feel good" they don't…

SILLMAN But there's a language of critique for that. That's what modernism was. It was the news delivered in a new form, a radical challenge to what was previously assumed to be meaningful—a total transformation of form, content, and delivery all in one.

ASHFORD That was the anecdote I was going to start off with. I had a lecturer in my class three weeks ago who said that in this period of war culture, with this level of disenfranchisement, and with the idea of globalization running rampant, anybody involved in an aesthetic, self-motivated practice is "self-indulgent." There were two weeks of discussions…

FUSCO Well, why not have a counterpoint to what students are being told constantly, which is that an aesthetic, self-motivated practice is wonderful? Why not have somebody come in and tear that down? At least having one person come in and tell them that isn't a bad idea.

ASHFORD I'm trying to get back to this question: Who gets the advantage of this false dichotomy between epiphany and participation?
 It doesn't affect my work. It doesn't affect my teaching. I'm always teaching aesthetics and politics as intimately related, not just form and content, but aesthetics and politics. Inquiry into the idea of engaging bodily with somebody and inquiry in terms of engaging with social issues have been connected since Beckett, since Breton, since Höch. This was understood fifty years ago.

PFEIFFER I also came to the conversation today questioning the dichotomy between beauty and politics. When I hear stories of people bad-mouthing the social or bad-mouthing beauty, it reminds me of the way people sometimes talk about communism today. People reference it as if we were living in the Cold War era, as if the subject was being beamed to us with a capital *C* from the 50s or something. I think we often use terms as though their meanings are more stable than they really are. I mean, it wasn't so long ago that the aesthetic categories of Clement Greenberg were the only option. To argue over beauty and politics today is to me like arguing over communism and capitalism as such in 2006. The terms of discussion have already been transformed, if not rendered obsolete, by larger social shifts.
 One formative reference in my own thinking about aesthetics and politics comes from the cultural studies movement. It's something that Stuart Hall wrote about in the essay "New Ethnicities," where he looks at the state of black British cinema in the late 80s and calls for practitioners and critics to acknowledge a kind of end of innocence.

Stuart Hall, "New Ethnicities," in Kobena Mercer, ed., *Black Film, British Cinema*. (London: BFI / ICA Documents 7, 1989), p. 27-31. Reprinted in David Morley and Kuan-Hsing Chen, eds., *Stuart Hall: Critical Dialogues in Cultural Studies* (London and New York: Routledge, 1996), p. 441-449.

Mysterious Object at Noon

Paolo Virno, *A Grammar of the Multitude* (Cambridge, MA: Semiotext(e), 2004).

The RAND Corporation (the name is an acronym of Research and Development) is a nonprofit think tank that conducts research for decision makers in government and commercial organizations. Founded in 1946 by the U.S. Army Air Forces, RAND initially worked on issues of national security.

He writes that it's not tenable any longer to say, "I'm black, or I'm coming from this or that ideological position, and therefore whatever I say is right or true." Instead, there's a need to recognize all language, particularly visual language, as inherently contestable. Looking at art making this way there's always a political dimension involved. To me, beauty and the contestation of meaning are one and the same thing.

The film *Mysterious Object at Noon* by the Thai director Apichatpong Weerasethakul is an excellent example. The film is absolutely beautiful, partially because of the way it's shot in black and white, but also because it plays with the language of ethnographic filmmaking in a way that totally fucks with your expectations and takes you to a place that's very different from where you expected to go. The capacity to communicate in ways that escape the traps of reductive thinking—that's the definition of beauty.

I think there's a white elephant in the room that needs to be reckoned with, and that's the increasingly central role the creative fields play in society these days. A lot of what used to be considered progressive, innovative thinking among artists and activists has been swallowed up and turned into a standard job description among creative types in general. I mean, thinking outside the box is what Apple commands designers to do now. Maybe the political dimension of art making seems less urgent to a lot of young people today because that urge is being sated in other places.

ELEEY When you say that aspects of political practice or thinking have become fully absorbed by these other fields—a kind of institutionalization of politics within industry, I guess—it makes me curious to hear why you think that's occurred. Is it because those other fields have more power than the art world or the activist community has to keep them separate and resistant to co-optation?

PFEIFFER I think that in today's information economy, the model set by the culture industries, which used to be thought of as a set of relatively marginal practices, has become the central mode of production in society. Surplus value no longer comes from mass-produced objects; it comes directly from people's brainpower. I'm taking this idea from Paolo Virno's book *A Grammar of the Multitude*. The promise of art as a scene of revolutionary thinking hasn't been abolished, it's been flattened out and subsumed within the current modes of information-based production. Mao and Che are the favored subjects of ad campaigns these days, in case you haven't noticed.

FUSCO I think to claim that the art world has lost its power is really disingenuous. **The RAND Corporation**, which is a think tank for the military, has done three reports in five years on the arts. They obviously think that there is something very significant about what the arts do. They've done one on performing arts, one on digital arts, and they just came out

this year with a report on visual arts. The military spends more on image culture than they do on supplying computers for real information gathering. So, somebody with a lot of power has figured out that visual culture and the culture of the image is incredibly powerful. They are basically interested in harnessing the power of the visual arts.

McCARTY But I think they're also frightened by us. I mean, did you read Richard Florida's *The Rise of the Creative Class*? There is actually redemptive power in the fact that the creative class is growing faster than any other class within the United States. And, of course, the military is going to cotton onto that and be like, "What's going on here and how can we control it?" The thing that I came away with from that book was the fact that there is massive power amongst those of us working with ideas and information if people could just connect.

PFEIFFER Yeah, that's the thing that the design industry can't do and the fashion industry can't do—it can't create a political community. I'm holding on to the idea that art doesn't have to be mainly about creating a marketable stylistic identity. Otherwise, I'd be bored to tears. One of my oldest activist friends now works in an advertising firm. The stories she tells about the corporate working environment make her job sound just awful. But sometimes I feel like things are not much better in the art world. Then other times, I think it's equally tedious to bellyache about such things and much more interesting to just stay engaged and make art. Whatever the mood, at this point it's questionable whether art can muster a political community, or if it's losing that capacity quickly.

FUSCO Yeah, and I think that as long as the training that artists get is so geared towards individualism, intuition, and the personal epiphanic moment you will not have it.

ASHFORD There is a schizophrenia between the making of things and the idea of social transformation that's reflected in lots of institutions.

PASTERNAK Two years or so ago I got involved with a political action coalition, called Downtown for Democracy (D4D). This group of young artists, graphic designers, writers, and editors came together to use their creative intelligence to raise money for progressive political candidates. I was so excited that here was a PAC for the first time in my life that was started by the creative industry. But I also wish they weren't using their resources to only raise money—instead, I wish they used their creative skills, intelligence, and connections to actually shape information and a wider public consciousness.

Richard Florida is best known for his work on the creative class and its ramifications in urban regeneration. He is the author of the bestselling book *Rise of the Creative Class* (New York: Perseus Books Group, 2002) and *Flight of the Creative Class* (New York: Collins, 2005).

Downtown for Democracy (D4D) is a political action committee founded in 2004 by professionals in the arts, music, fashion, film, publishing, advertising, design, and other creative media. Their goal is to mobilize America's creative community to engage new voters and elect progressive candidates.

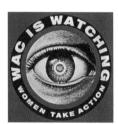

McCARTY I had a conversation with a few of the members; it was just brainstorming about things to do. The sensation I left with was profound disappointment. They had skills, they had access, they had everything, but it was all about communicating with other cool people. My point of view was, "For this election, you gotta get out. You gotta get out to the people. You gotta get to the ladies in the Laundromat in Ohio. It's not about getting to the other cool designer across the street on Broadway."

PASTERNAK Marlene, Julie, and others at the table remember the Women's Action Coalition. D4D has thirteen people organizing big national fundraisers for progressive causes, whereas WAC had thousands of us organized and impassioned in a matter of weeks with no money and yet there were franchises all over the country. WAC had a great impact. It had power. By the way, WAC was actually started by a group of women who were primarily artists and its earliest meetings were at The Drawing Center in SoHo. It seems that at this current moment, we don't come together.

SILLMAN Well, I don't know that we all agree about this personal/private thing necessarily being an evil.

ASHFORD But we do agree that there are not those same social moments in which we are put in a position of forming coherent communities. The idea of privacy needs to be changed publicly.

FUSCO To bring in another student anecdote, when I try to counter this in the classroom by bringing artists who do work with the social, my graduate students' immediate response is that any artist who engages with the social is engaged in exploitation. They believe that if you dare to think of something other than your private space, other than your little room, you run the risk of exploiting somebody. You're exploiting the people you're working with, you're exploiting the poor people you photograph, you're exploiting the social issue that you're dealing with, you're exploiting the insane person in the insane asylum you made a film about. And so, that becomes their moralistic high ground on which to basically retreat back to the studio.

SILLMAN I understand that. You don't have to argue that with me. There are a lot of different ways to see transformative activism or the transformative personal understanding of what is possible. The cutting edge of that is not going to be "I'm alone" or "I'm together." You can work together with people and still be an asshole. And you can be alone and still be really ethical.

FUSCO It's not about working alone; it's about an ideology of individualism. I work alone most of the time, but it's not in the service of an ideology of individualism. Whereas I do think that we have to recognize what art schools are doing. Name

me an art school that doesn't put everybody in their own room. Name one. There isn't one.

ASHFORD I agree, Coco, with the idea of the art school being something that's creating this ideological moment, but only in part. I think that ideology existed when Group Material started and that it existed when WAC started. It has always been in existence at different levels of dominance and in different kinds of forms. But artists have historically been the people that have taken down the Vendome Column. I mean, it's 150 years of history. And the idea—at this particular time in a context in which there is an international crisis—that artists don't have a cohesive political moment cannot be blamed only on art schools.

FUSCO In the past there were interdisciplinary dialogues. Artists talked to people who had knowledge from other fields. There were so many conferences with anthropologists, sociologists, geographers…

ASHFORD …or with labor unions.

FUSCO Now artists talk to artists, and then they talk to more artists. They don't talk to anybody else. I mean, it wasn't like that twenty-five years ago. It was not. And if you're lucky, you get to read Slavoj Žižek in an art magazine.

A SMITH People could share more. I'm really proud of the fact that I took my grant from the Public Art Fund and basically gave it away. The gesture was to share it with anyone and everyone who wanted to participate in *The Muster*, to use that money to create a very literal platform with a lot of fanfare for people to say what was on their minds. And whether or not *The Muster* really created a community or whether or not it was anything radical, that's sort of beside the point for me. I wanted to make a portrait of something beyond "us and them." It was a gesture toward opening up a potentially unwieldy, incoherent, and cacophonous dialogue, and…

ASHFORD It was more than a gesture. It really did open it up.

A SMITH One of the interesting things about *The Muster* was that it revealed how hard it is for people to imagine an alternative. There is so much protest. We're all comfortable talking about protest. We're all comfortable critiquing our current administration, the art world, other artists, students, etcetera. Wherever you are on the spectrum of art theory and critical discourse, we all know how to criticize something. So I disagree with Coco's earlier point about there being no public space for the airing of dissent. There is a whole industry centered on criticism. Maybe what is needed now is not more critique, but a profoundly radical creativity.

 With *The Muster*, I wanted to do a project that would give people the opportunity to imagine something that they would

Vendome Column is located in the Place Vendôme, Paris. Napoleon erected the column to celebrate the victory of Austerlitz. During the Paris Commune in 1871, the painter Gustave Courbet proposed the column be disassembled and re-erected in the Hôtel des Invalides. The column was taken down, but when the Paris Commune fell the decision was made to rebuild the column with its statue of Napoleon. Courbet was financially ruined when he was condemned to pay part of the expense.

Slavoj Žižek is a Lacanian-Marxist philosopher and cultural theorist. He is well known for his counterintuitive observations on a wide-range of topics including fundamentalism, opera, globalization, human rights, Lenin, cyberspace, David Lynch, and Alfred Hitchcock. He is the international director of the Birkbeck Institute for the Humanities and the author of many articles and books including *The Fragile Absolute* and *Did Somebody Say Totalitarianism?*

Democracy, a project by Group Material, was held at The Dia Art Foundation, New York, in 1988. During the project, installations on education, electoral politics, cultural participation, and AIDS were tied closely to round tables and town meetings.

Marlene McCarty, *Looking for the New World*, 2005–06

proclaim, rather than protest. And what I found was how difficult it was for people to answer my question, "What are you fighting for?" I think even this conversation is evidence of that, how difficult it is, no matter how many times you say, "Well, let's think of some new ideas." It's so difficult to get to that place.

SILLMAN I had an idea once. I haven't implemented it, so I'm at fault for not having done it, but I think it's a good idea. I'm friends with lots of filmmakers and video makers and they don't make any money. I thought that every time I have a show I should be in charge of having my gallery open one or two nights a week to show the work of time-based artists. Every time I have a show, I could do this because I have the whole month, and it's only from 10 a.m. to 6 p.m., Tuesdays to Saturdays…

ASHFORD It's a lot of time, right?

SILLMAN I know. I don't think I really use it properly in some ways. In my show in 2003, *I am curious (yellow)*, I made T-shirts and that was my political action. I hawked them during the opening. They said "Pussy Against Bush" and had a small drawing of a cat leaning against a bush with its arms folded, and the names of three women artists having solo shows on the back. But my idea is that if every gallery artist-type would open the gallery to a different kind of practice one night a week…well, I just wonder if those of us who do have these gallery positions are using the galleries in the right way.

A SMITH I like this idea. It's almost like imagining that there are as many town halls as there are galleries. And they're pretty much empty and dark at night.

ASHFORD I remember turning the Dia Foundation into a town hall meeting for a night during the Group Material project *Democracy*. It was great. However problematic the social use of museums may be, I still try to see them as truly public places.

McCARTY I have a specific thing, too. It's just something very small that I participated in this year, but it was so invigorating. And it does fall into the design realm for all those who are feeling bad about that.
I was asked to do this workshop in Maine, this summer design retreat. They wanted me to mentor these young designers and do their kick-off talk. And I was like, "Ugh." But I was desperate for the money, so I said I'd do it. And then I started to wrap my mind around it and I thought, "I am not going to do this unless I have a good time." I kind of went crazy. I dressed in a Pilgrim costume and did an entire super-political presentation.

A SMITH Alone?

McCARTY All by myself. And it was so inspiring. We did this whole pamphlet based on Thomas Paine, pamphleteering, and the Declaration of Independence. And it was this really spontaneous, activating thing. The people left saying, "Oh, my God, that was so easy and so fun." And it happened that there were some people from Cal Arts and Cranbrook there. And they were like, "Oh, my God. You have to come do this at Cranbrook. You have to come do it at Cal Arts."

JULIE AULT In your Pilgrim suit?

McCARTY I've got my mother making a Pilgrim outfit. I went into that workshop thinking, "Fuck the conversation about, 'Oh, you can't be too feminist. You can't be too political. People will get turned off.'" I just thought, "Burn me at the stake. I don't care. I'm going for it." And it was so transformative.

There were twenty people in that class, and those twenty people walked out saying, "Oh, my God, that was so easy. And that was so cool, and I feel so engaged, and not disconnected." And now I feel like, "Just say it. Just say it."

A SMITH There is such a developed theoretical language around socially motivated art practice. They don't know the "language" or they think their work isn't going to really change anything. I'm just trying to imagine my students in conversation with you, Coco, and I just feel like they'd think they were being set up to fail, which is a shame.

FUSCO Well, there are plenty of other art students in digital media at schools like Rensselaer Polytechnic Institute, Carnegie-Mellon, and the School of the Art Institute in Chicago who are enamored of the idea of tactical media. They read Critical Art Ensemble and Guy Debord and others, they fuck around with Wal-Mart, and they have a blast. They're not intimidated by me or anybody else who comes to talk to them, because they're not at all concerned with being artists in a traditional sense. They're interested in being tactical media practitioners.

Unless there is a recognition of the moment—and I mean that really in a Marxist sense—where we are institutionally, where we are economically, and where we are politically, we can blab all we want about what we like or the wonderful things we are doing, but we still have to recognize where we are, and what we're doing in relationship to what's happening in the world. If I can't make my students understand that then the rest is just BS.

KIKI SMITH In my experience, I've learned most through making and doing and listening, from having a relationship to a material through my body and being here.

ELEEY I was going to say more or less the same thing. I'm all in favor of book reading, but I think that there could be a similar amount of awareness of one's place in the world

Thomas Paine (1737–1809) was a revolutionary and radical pamphleteer. His writings helped guide the American Revolution. His most famous pamphlet, *Common Sense*, was a treatise on the benefits of personal liberty and limited government.

Tactical media is the appropriation of mass media in order to oppose and criticize a powerful person or organization. It uses technology and hit-and-run tactics to put forward an often short-lived activist agenda. By generating information and creating a reaction, tactical media attempts to reverse the one-way-flow of communication and power. Organizations that have used tactical media include ®™ark, The Yes Men, and Critical Art Ensemble. See Wikipedia contributors, "Tactical media," *Wikipedia, The Free Encyclopedia*, http://en.wikipedia.org/w/index.php?title=Tactical_media&oldid=58219095 (accessed July 10, 2006).

that could come from being alone in a studio, not reading anything, and just making stuff. It's hard for me to despair to the point of thinking that's impossible. I think there's a lot of work that's made under those circumstances that does have that awareness.

CHAN I came to this country in 1981 and I realized that one of the things that was markedly different from Hong Kong was that in Omaha, Nebraska, where I grew up, I was increasingly pin-pointed as a target market. And you can easily see how this has progressed: first, it was selling boutique clothes to 16-year-olds, then it was 14-year-olds, then 7-year-olds, and now even toddlers have their target market. As I was teaching I realized that one of the reasons people go to art school is that it is a radical escape. If you're constantly being told that you are a consumer, of course, one of the models for being in the arts is to become a producer.

A beautiful thing for me about Henry Darger was that he provided a radical escape. And that escape was incredibly important to me. And so, in a way, the escape becomes an essential component of my engagement back into the world.

I was swimming in Foucault and Derrida at the School of the Art Institute, and I loved it. But what I realized within Darger was that the sexual anxiety and the connection between image, body, composition, and form provided a new horizon, it provided me with a new language to talk about things. I couldn't get there until I realized that escape was an essential part of how to understand what real engagement is.

And so, I think when we complain about students, what we don't realize is that perhaps the lack of critical imagination comes from us, the teachers. We have not found a language to re-describe this form of escape so that they can escape from what they're feeling, which right now at 18-years-old is horrifying. It is horrifying as a consumer and as a person living through war. Frankly, today's 18-year-olds will not have the same social welfare net that we'll have. And this is frightening. I think art school, as a form of escape, is incredibly valuable. And I think, in fact, that if we don't re-describe this sense of escape within art so that students can see it as an opening, as a form of engagement, we've lost the opportunity to realize what being-in-the-world means for us today.

SILLMAN I think there's a new description of the primitive in what you're saying.

CHAN I hope so.

SILLMAN I have to play devil's advocate and contest that, because I've seen so many cycles of finding the primitive who really describes what art is about. The one who wasn't part of anything, the one who was outside the culture, the one who was insane, the one who was trapped in his office, the one who wore a grass skirt. Those are myths. They are myths about art that…

CHAN It's a funny thing. It doesn't make me want to go into an apartment in Chicago and draw for myself. Strangely enough, I had the opposite reaction. It's too simple to believe that human beings simply identify things by seeing them. There is something that we all know as children called reaction formation. You can react negatively and you can react positively. Art provides the horizon of freedom from which that can come about.

SILLMAN I agree with what you're saying, but I also think that the important idea is that of transformation. It's not about imitating an escapist, and it's not about imitating Darger. It's also not about imitating Foucault. It's about transformation.

There's a lot of Marxist writing that doesn't consider making from the inside of that experience or from the beginning, from the non-cognitive unknowing space of making something and through an idea or object as it materializes. Psychoanalytic theory might be a little closer to what we might want. And then there's a lot of aesthetic theory that is also of no interest in terms of describing the cultural or the process of making.

Most writers don't want to address issues of a synthesis between mind and body, because most people don't want to address a transformative synthesis between mind and body.

CHAN I think for me Adorno provides that space as a philosopher who writes about art and the making of art. His writing provides the opportunity to re-describe what it means to make something and how this thing transforms me. No matter how brutal or how beautiful that thing is, and this is just an example, it doesn't leave me until it leaves me speechless in a way. I mean he described it as essentially a space of speechlessness.

ELEEY It seems like the most engaged and interesting part of what we've talked about tonight has been around epiphanic ideas or thoughts that people have had about what makes things or might make things different, not necessarily around this specific dialectic of beauty and its discontents or around these larger problems, but on a smaller scale. In the time we have remaining, I'd like to encourage everyone to share more of those smaller things.

FUSCO For me, the anti-Republican National Convention week in this town was a moment of collective engagement in the utopian good that involved many artists, thinkers, and activists working together. It was an incredibly invigorating and wonderful celebration. I don't see why we now have to retreat into personal epiphany when we have that very recent moment as an example of social cohesion.

I think that the immaturity of that moment was in only conceiving of getting rid of Bush, and not imagining an actual political future. What is left to be done is to take those Downtown for Democracy people and all the other people

Theodor Adorno, *Ästhetische Theorie* [*Aesthetic Theory*], ed. Gretel Adorno and Rolf Tiedemann, *Gesammelte Schriften*, Vol. 7 (Frankfurt am Main, 1970). Reprinted with translation by Robert Hullot-Kentor (London: Routledge and Kegan Paul, 1984; repr., Minneapolis: University of Minnesota Press, 1997). The *Art Journal* writes that, "*Aesthetic Theory* contains the stubborn insight—rarely offered by cultural critics today—that redemption may be glimpsed only by means of the most difficult and determined artistic ciphers of negation."

Anti-Republican National Convention

Daniel and Philip Berrigan were
two brothers and Catholic priests who
became internationally known peace
activists after taking non-violent actions
against the Vietnam War. For a time,
they were on the FBI Ten Most Wanted
Fugitives list for actions against war.
In 1980, they founded the Plowshares
Movement.

Facing image: **Coco Fusco, *A Room of
One's Own: Women and Power in
the New America*, 2006**

who were involved in trying to get Kerry elected, and actually
get them to imagine what an alternative politics would be and
how to engage with it.

PETERSON I think as artistic language gets co-opted by
many different forces, artists need to think differently about
how to communicate. It was very interesting to hear about
these ideas of escape and to hear specific examples from
both Marlene and Allison who used costume and fantasy,
in a way, to break through to audiences. Marlene, you talked
about how the Pilgrim get-up worked and it seems to have
made it easier for the people who engaged in that with you.
And then Allison talked about creating a platform for public
expression through *The Muster*. Both of these are interesting
and specific examples that help us think concretely about
this notion of language and how to communicate differently
to break through.

CHAN Can we be honest? What do we want to break and
where do we want to end up through? What exactly do you
want the visual or the aesthetic to do? Do we want to shut
down Army recruitment centers? Do we want to get Bush
out? How much consolidation of power and identity are we
willing to bear on the aesthetic in order to change things?
And how much are we not willing to, so that the aesthetic
retains a utopian space for us and for anything that longs to
escape the punishing reductionism political discourse must
exercise in order to ascend toward power.
　　After tonight are some of us going to go the Army
recruitment center to shut it down like the Berrigans did
in the 60s? Are we willing to step up to the plate with the
twenty-five people who are on the plane right now going to
Santiago, to walk to Guantanamo to do the hunger strike?
I mean, are we willing to do that?

FUSCO I'm working on militarism in my projects right
now, but I don't think one needs to be so reductive or
re-appropriate the strategies of the 60s. I think there's a
lot of work that can be done artistically about the military
invasion of American culture. It isn't directly related to being
in the hunger strike, but it is about exploring the way in
which fascism is our present reality, not something from
the past. I believe that we do actually live in a militarized
fascist state that people don't want to recognize. And I
don't think the answer is to focus on one thing, but instead
to look at the ways in which the culture of militarism has
disseminated itself into our lives, and has normalized itself,
and made itself so invisible to many, but incredibly powerful
to many others.
　　For me, pushing people to the edge isn't productive.
It's about thinking, "Okay, here are these social, political,
historical, economic, cultural, and artistic phenomena.
Now how do we begin to work on them, if we're interested?
And if we're not, what other aspects of the contemporary
reality are we interested in working in?" There are other

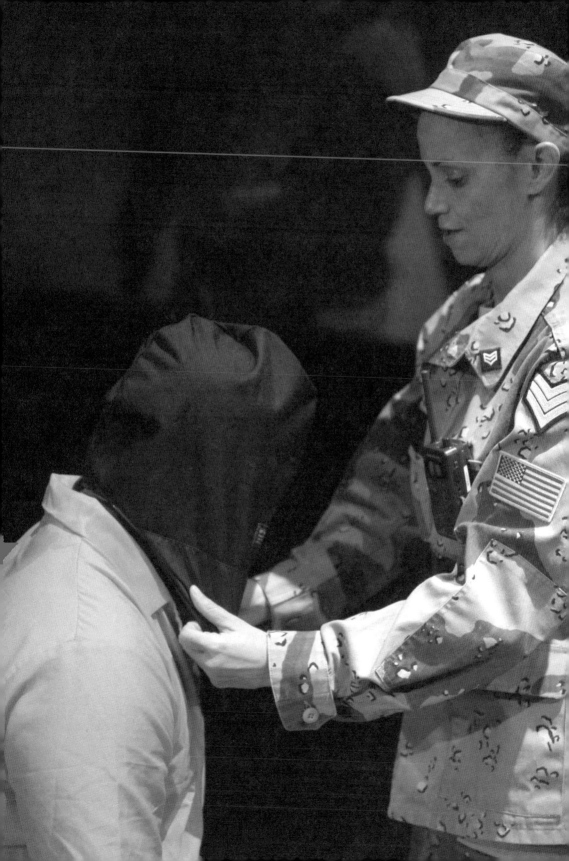

artists who are interested in other aspects. For instance, there are the guys who do Killer-Cola in Colombia. Right? They do great graphic design against Coca-Cola and their implication of Colombian workers and the way in which they bust unions, kill organizers, and all those kinds of things. And I'm totally one hundred percent with them.

Killer-Cola

CHAN I think today when there is an aesthetic intervention it is easily consumed as simply an aesthetic "intervention." We have lived through an industrial economy, a service economy, a knowledge economy, and now I think we can say we are in the midst of a spectacle economy. We consume the information and imagery of a spectacle like war, for instance, the way we choose and buy coffee: right, left, or center. What I'm fanatical about are things that "escape" this economy. Aesthetic interventions function quite legitimately in this economy, which robs it of the kind of transformative force needed to break through these overwhelming exchange relations.

FUSCO I'm very critical of a need to impose a barometer and a measurement that we can quantify. On this project, you're going to yield this result and it's going to get people to do this thing. You can't do that with art that actually has any kind of lasting value. You don't know what it's going to do, because you can't measure its effect over a long period of time. And so there has to be some space for that opening, because if you just push people and say, "Are you going to go to Guantanamo?" Of course, most of our friends are not going to go. And then you're going to lose them. And that's the problem that my generation had with a lot of people. So, we learned to know better.

AULT That is a feature of this conversation, I think. I don't want to demonize Creative Time, but you're asking, "Well, what's next? How do we do it? What are our strategies? What should we be doing?" And then we shoot out a few things and they become the basis for codifying a public culture that doesn't necessarily emerge from considered desire or need or process. This is one of the reasons for my silence here tonight. I have trouble relating to the general, latent agenda of this conversation. I'm sympathetic to the notion that there is a generalized crisis that we feel that we're in. But to talk about that in terms of coming up with strategies over dinner, at least in this case, doesn't seem to work, and isn't personally productive.

These are really complex, massive situations and questions that we're thinking about. I find it hard to be articulate about what I want to see happening within culture. What do I think artists should be doing? What is the power and potential of art? These are questions that I don't expect to answer in my lifetime. And frankly, I'm not really interested in generalizing these kinds of things either.

ASHFORD The necessity for open-ended discourse evolves into specific value and example.

PASTERNAK Julie, I respect what you are saying, but as the leader of a public art organization, I have the opportunity, even a responsibility, to help artists engage with the world. So I think there can be value to open discussion, for those who may feel isolated or frustrated. If nothing tangible is gained from a conversation such as this, so be it. But I do have a related question. I have been wondering what it would mean to start a fund for artists who want to create a timely, socially progressive project. On one hand, it might sound attractive to some artists to help them realize their projects on their own and not be limited by an institutional voice. But then you could argue it's a cop-out to just offer cash and not provide full organizational resources. So I wonder how best artists can be supported in these efforts?

CHAN I heard this crazy statistic of how the U.S. military is spending a billion dollars a week in Iraq. And the insurgency is spending around $200,000. And so, I always sort of do a mental experiment: How much is the U.S. government spending domestically to quell dissent? And how much do we need to spend in order to resist and transform? I think it's about $200 on our end.

So, I don't think it's actually money. It might be something else. I'm not sure what it is, but I don't think it's money.

The groups that I know of that are working aren't looking for any kind of institutional connection, because it diminishes their capacity to break through. It becomes a very easy way to say, "Oh, this is just a creative thing." What they're looking to do is to break something.

PASTERNAK For sure, Paul! They would be right. At the same time, plenty of artists want the support of an institution and hope to benefit from its networks and resources.

ELEEY But then at the same time we were hyper-aware going into this of the limitations and restrictions that come with institutional affiliations, of the restrictive effect our presence can have on work of this nature. That's not exactly this kind of thing, the way Paul has described it.

PASTERNAK Absolutely.

FUSCO But I think something did happen to cultural funding. A lot of the individual artists programs have been eliminated in the last fifteen years, and some artists think, "If only I had money," because a lot of the money that was available is no longer there. Even though there are people, like Paul says, who are not interested in it, there are many others who are very interested in it.

But I think there's something else. There was this pressure that was not only put on individual artists, but also on small-scale cultural organizations to become more

Creative Capital is a New York City-based nonprofit organization that was founded in January 1999 with the idea of combining innovative ideas from the commercial sector with the integrity of purpose of the nonprofit sector. It helps support artists' projects in performance, visual arts, film, video, and emerging fields by providing funds, advisory services, professional development assistance, multi-faceted financial aid, and promotional support.

like businesses, to become more fiscally responsible, and that killed a lot of them after the 1980s. Creative Capital is that way. I mean, it's basically teaching artists to be capitalists. You have to meet with all these entrepreneurs. You have to have a business plan. It's insane. If I wanted to be an entrepreneur, I would be an entrepreneur. The nonprofit sector has been severely damaged by the insistence on entrepreneurial return.

SILLMAN Well, think tanks don't just have three dinners, you know. I feel most people have expressed how they approach things. That's it. Nobody is going to be able to do more than that over dinner, although it's still interesting to have this conversation. It is worth it to me to find out how people are thinking about stuff and not get distracted by other discussions.

ELEEY At the same time, coming out of the "culture wars," many in our community assumed government and private donors would recognize and support the kind of work we did based upon economic, quantitative terms, rather than qualitative ones. We said, "Okay well, fine. You were going to reject us on aesthetic terms. We're going to force ourselves upon you on your terms." And so we end up with Christo and Jeanne-Claude's The Gates discussed primarily in terms of the amount of money involved in realizing the project, and by extension, the "generosity" that's associated with that when the artists are paying for it themselves. The artists seemed to talk about this more than they discussed the work itself. Of course, City Hall regularly defended the project on economic terms, even offering predictions of positive economic impact on the city at the initial press conference announcing the project. That is largely a problem of our own making that we continue to perpetuate. We have trouble making arguments for art on its own terms, even though the experience that most people seek from art has nothing whatsoever to do with economics.

ASHFORD There's so much more funding if you're providing a service than if you're doing a small-scale art presentation along the lines of Creative Time, Trans, White Columns, or Participant. The number of foundations that fund this kind of work is miniscule. You can really count them on two hands. And in the sort of service world, there are tons of people who want to help you grow.

AULT And you can't downsize.

ASHFORD You can't go down. You can't go back.

FUSCO You can't go down, because the only way to get more money is to be bigger, and bigger, and more stable, and more business-like. It's madness. It kills the heart of a lot of freaky artistic practices.

K SMITH I think as a person, one is whole, but it's a whole
of parts that have different aspects or facets. As an artist,
I want my heart and my work to reflect that complexity, and
as a citizen, I want my life to have an active relationship to
society. Not all those things have to fit together or be evident
all the time, nor are they dispersed all the time.

Art has many possible manifestations. I'd like the art
world or the art community to be as multi-dimensional as is
its changing truth. Obviously different things have dominance
at different times and it is a continuum that is constantly
disrupting and erupting new. This evening, we have been
superficially pitting beauty against social content. I would
never say beauty is in conflict with social content. They aren't
in conflict nor is there historical evidence to support them
being seen as antithetical.

Art is one of the few open spaces in society, so it is not
in my interests to try to constrain or control other artists'
necessities.

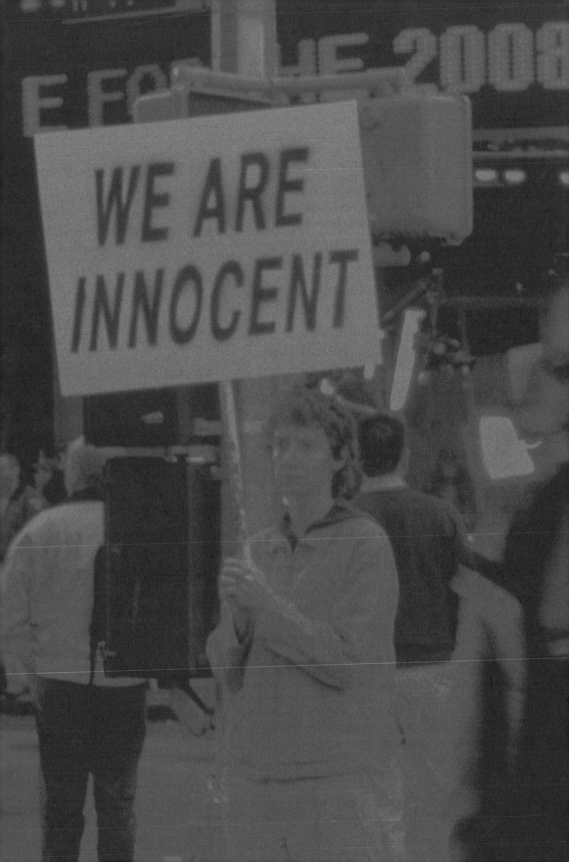

War Culture

Conversation 3
December 14, 2005

The last conversation of *Who Cares* was the first planned. It was conceived
in response to the most urgent social issues of our moment: the wars fought
against "terror" and in the name of "freedom," including those in Afghanistan
and Iraq, and the varieties of cultural upheaval they have fostered. The dominant
question following 9/11 and the invasion of Iraq was how we, as artists, critics,
teachers, and organizers of art projects and exhibitions, could create cultural
narratives, events, and effects that would contribute to the conversation around
the wars in more advanced, profound, and truthful ways. At the core of this
internal discussion is the question of how artists find ways to continue to work
critically in a historical period overwhelmed with ideological manipulation,
violence, and despair. One dominant issue emerges throughout the dialogue:
How can creative practices respond to war culture and do so in an increasingly
repressed public sphere? As we were reminded by President Bush's spokesman
a few weeks after the 2001 attacks, "Americans need to watch what they say,
watch what they do."

The discussion begins with participants highlighting their experiences of
certain cultural shifts and the effects they have had on their individual practices.
The fluctuating role of New York City within the broader matrix of national
countercultural activity is discussed. Calls are made for changes in strategy—
through the creation of alternative emotional landscapes that offer opposition
at the level of mood, rather than just information; through different models
of intimacy that change the current war-inflected notions of affect and sensation;
and, through a reframing of situations that inverts the ways in which we think
about such concepts.

The conversation also identifies a number of disturbing trends, including
the privatization of knowledge and the use of fear as a tool of oppression and
censorship; the ways in which the institutions that form public opinion deny
artists their critical roles by pushing them to the periphery; and the undermining
effects that corporate models—foisted upon nonprofit organizations beginning
in the late 1990s—have had on radical art practices. But constructive ideas
emerge as the participants take a look at the resistant capacity of emotion,
tactical media responses, and the creation of collaborative art spaces that build
communities committed to critical thinking and social action over the long term.

**Sharon Hayes, from *In the Near
Future*, commissioned by Art in
General, November 2005**

participants
DOUG ASHFORD, moderator
GREGG BORDOWITZ
PAUL CHAN
PETER ELEEY
DEBORAH GRANT
K8 HARDY
SHARON HAYES
EMILY JACIR
RONAK KAPADIA
STEVE KURTZ
JULIAN LaVERDIERE
JOHN MENICK
HELEN MOLESWORTH
ANNE PASTERNAK
BEN RODRIGUEZ-CUBEÑAS
RALPH RUGOFF
NATO THOMPSON

DOUG ASHFORD I want to set a tone for the evening by quoting two texts. The first is a poem, "The Dawn of Freedom, August 1947" by a man named Faiz Ahmad Faiz. The great public intellectual and anti-war activist Eqbal Ahmad, who was an influence on my childhood, used this to help explain his own work:

> These tawny rays, this night-smudged light
> This is not that dawn for which,
> ravished with freedom,
> we have set out in sheer longing
> so sure that somewhere in its desert
> the sky harboured a final haven for the stars
> and we would find it.
> We had no doubt that night's vagrant wave
> would stray towards the shore
> that the heart rocked with sorrow
> would at least reach its port.
> But the heart, the eye,
> the yet deeper heart still ablaze for the beloved
> their turmoil shines in the lantern by the road.
> The flame is stalled for news.
> Did the morning breeze ever come? Where has it gone?
> Night weighs us down.
> It still weighs us down.
> Friends, come away from this false light.
> Come, we must search for that promised dawn.

Another quote I want to read is from an aide to the vice-president of the United States as quoted in *What Happened Here: Bush Chronicles* by Eliot Weinberger. He told his listener, a journalist, the following:

> You are members of the reality-based community—those who believe that solutions emerge from the judicious study of discernable reality. That's not the way the world works anymore. We're an empire now. And when we act, we create our own full reality. We'll act again, and again, creating other new realities, one after another, which you can study, too. And that's how things will sort out. We are history's actors. And all of you will be left just to study what we do.

Very modest. Tonight we're going to try to have a conversation that speaks towards doubts, failures, and more complex understandings of how public expression in the United States has been compromised in recent years. I am hoping in this informal setting we can speak honestly in capacities that may contradict our professional lives. We're focusing on war culture and, while I see the first two conversations of this series as more abstract, tonight's conversation is more of a case study.

I guess I want to start by going around the room and having everyone share a thought that you've had about the

Faiz Ahmad Faiz, "The Dawn of Freedom, August 1947." Translated by Agha Shahid Ali. See Faiz Ahmad Faiz, *The Rebel's Silhouette: Selected Poems* (Amherst: University of Massachusetts Press, 1995).

Eqbal Ahmad was a journalist and anti-war activist. He was strongly critical of the United State's Middle East strategy for what he saw as the "twin curse" of nationalism and religious fanaticism. See David Barsamian, ed., *Eqbal Ahmad: Confronting Empire* (Cambridge: South End Press, 2001).

Eliot Weinberger, *What Happened Here: Bush Chronicles* (New York: New Directions Publishing Corp., 2005).

way this war in Iraq has influenced or impacted your work or your life.

BEN RODRIGUEZ-CUBEÑAS In response to your question, I have two initial thoughts. One, on the practical level, I'm involved with an organization called the Cuban Artists Fund. Its mission was to bring artists from Cuba to the United States, and we can't do that anymore, because it's impossible to get a visa for artists from diverse countries. And yet, I am familiar with a lot of organizations that still bring artists here, but they're not coming from Third World countries, they're coming from Europe. They're coming from countries whose governments can afford to send artists to the United States. So, that's something that I see on a practical level.

Two, related to my work (and my work is varied), at some point during the war I just started to feel as though I was powerless. That everything I had done and everything that I could do was not going to make a lot of difference in this huge world that we live in. So, I could get really depressed, but I don't. However, I think philosophically it's caused me to think deeper and to think more long term and to think about what we can do to make a difference even though things are so complicated and so difficult.

RONAK KAPADIA I live in Crown Heights, I'm twenty-two, and I started college a week after 9/11. I feel like in a lot of ways I don't know another world other then the one we are in. I came into my politicization as a queer artist of color and a performance scholar after 9/11. It's hard for me to think of an unsullied moment in a lot of ways. I am now doing a lot of uncovering of previous periods in history and finding that a lot of stuff that I'm seeing now is nothing new. It's a continuation of a larger project in this country. It's kind of disheartening to realize that you're coming up in a moment, in an age, where Bush is really the only president and that it is this culture that I have had a stake in during the last four or five years while I've been developing my own consciousness as an adult.

So, I don't know what we'll look like in three years after this current regime falls. And I'm not particularly optimistic. It's hard to think of an art practice without thinking of current events and that kind of immediacy. I'm not feeling victimized, but I am realizing that a critique of militarism and xenophobia is always central to my work. That's what I'm in. That's my moment. And I don't have a previous moment to compare it to. So, that's the one thing that I think about when I think of this war—I don't remember a previous moment in terms of my own consciousness.

EMILY JACIR It's hard to respond to your question without considering the profound impact the previous Gulf War and the sanctions, as well as America's full support of Israel's apartheid policies, has had on many of us in terms of politicization and activism long, long, long before 9/11.

This war is a continuation of those policies. Also, being Palestinian, I am coming from a situation in which our country has been under brutal occupation for my entire lifetime. So it is hard to address your question in terms of the impact of this current administration's war simply because coming from a war zone and dealing with being in a war before this one started puts me in a different contextual frame. Also, this war was not a surprise to me. It's part of a longer Euro-American project in the Middle East to destabilize the region and to divide Iraq along religious lines. I guess that's my main concern right now: the victory of America/Europe in dividing what was once a secular country along religious lines and the effects of that on the region in terms of religion and religious extremism.

But hand in hand with that, during travels in Europe (and I'm not defending America), I see that many Europeans refuse to take responsibility for their collaboration with America in this war and that is very frustrating. Also, I was in Europe during the Hurricane Katrina disaster, and I found that people were really surprised by the poverty they saw on their television sets and my response was, "Who the fuck do you think lives here? I mean American people are working one hundred-plus hours a week. They don't have health care. They don't have vacation time like in Europe. People are barely making ends meet in America." There is a great misconception about who lives in this country and how they live. I think people actually believe the image America exports of itself vis-à-vis television programs like *90210*!

And then there's Abu Ghraib and the torture camps, which the Europeans are also collaborating with as well as some Arab countries like Jordan. So, these are my fragmented initial responses to your question.

JOHN MENICK The last five years has been a real learning experience, to say the least. All the rules of thumb I brought to American politics have been thrown out the window. I mean, 9/11, two fishy elections, two dirty wars, the erosion of civil rights, etcetera. I can't say my work has been able to deal with Iraq in a direct way, or whether that's even necessary. I don't know, I am probably as cynical, pessimistic, despondent, and pissed-off as the rest of you. So, I'll just turn it over to Julian.

JULIAN LaVERDIERE I actually have found the war rather inspiring; after all, it's given this round table a renewed *raison d'être*! I don't mean this to sound inadvertently provocative; actually, I believe it's important to afford enough gallows humor to recognize that the only virtue of the war, or our government's hubris, may be the consequent revivification of America's dying counterculture.

When I was an art student in the early 90s, I struggled with the anxiety of influence that my Marxist professors had over me. My class developed nostalgia for our teachers' Cold War fear and Vietnam War era angst. Seminars on

institutional critique and politically correct protest strategy were virtually mandatory. Yet, we were rebels without a cause, just students conditioned with a longing for the bygone ferocity of the 60s protest movement. We were taught to feel guilty for not being situationists, Black Panthers, or members of the Weather Underground; and so, ironically, we learned to lust for that symbiotic relationship that exists between an oppressive government and the activists who rally against it.

Perhaps this is indicative of why there is an American youth-culture desire for apocalyptic unrest, and at this rate we may just get our wish. Hollywood certainly caters to it, with popular disaster flicks depicting the end of Western civilization. Freud would probably diagnose films like *The Sum of All Fears*, *28 Days Later*, or *The Day After Tomorrow* as evidence of a pop-Thanatos, a mass media death-drive.

The "oil wars" have instigated a new battery of fears to hold our attention hostage: dirty bombs, bio-hazardous attacks, and a renewed interest in global warming. The cultural appetite for a History Channel brand war with black-and-white battles between good and evil is now being sated by full-color, live simulcast war coverage in high-definition.

GREGG BORDOWITZ I don't know how to answer the question. I'm agitated in all sorts of ways. I'll try to answer your question specifically regarding the war. Since last spring, everything that I have done publicly has been against the war. So, every lecture I've given has been an anti-war lecture, and I've given a lot this semester, because my book, *The AIDS Crisis is Ridiculous and Other Writings 1986-2003*, came out last spring. So, all last spring I gave anti-war lectures. I was asked to do book events, and I would show up and do anti-war lectures. Every class I taught was an anti-war class. Opposing the war is a problem of counterculture. It's not only about informing people about alternative historical narratives, or arming people with alternative facts.

I think that the problem at the moment is finding a way to produce an anti-war culture. That's a larger problem than simply protesting the war. We need to find a way to foster a counterculture, which means fighting the battle at the level of mood, not just giving information. How do we create an alternative emotional landscape?

The manipulation of panic and public moods—the ways that sensations are marshaled to induce complacency and inactivity—must be understood. Is it possible to produce new emotions? It seems to me that the job of making art at the moment is to understand the political role of affects and the different ways that art making participates in the cultural production of affects.

SHARON HAYES It's nice to follow you, Gregg. It makes things a little more alive in my head.

I think that in a way, I echo a lot of what other people have said. My first reaction is that, to a certain extent, the war changes everything and nothing. There is this way that it repeats and provokes our accumulation of other events. It's interesting that these other events become part of how people answer Doug's question.

By the same token, I agree that it is a different kind of moment. A lot of my time is spent trying to figure out, on a small, immediate, local level, what the conditions of this current moment are. Maybe one way I could answer that, to get towards this issue of mood, is descriptive. When I walk around these days, I feel like my senses are a bit peaked. It feels more urgent and important to look for moments, even if fleeting, where there can be a collective address of a social and political situation and its impact on us. I don't know if that's really helpful, but I feel like I'm in a slightly… agitated state.

ASHFORD It's like a social anxiety?

HAYES Yeah, it's an anxiousness, but it's also like a porousness, like taking a lot of things in. There's a way in which I'm really urgently looking for something. It doesn't necessarily feel productive, but it's something.

K8 HARDY This whole time I've been thinking that all I can do is sum up my feelings by saying that I'm really agitated by the war. And I feel that has affected my practice and work. It's rather simply put at the moment—coming off of what Sharon just said—but that's how I'm going to leave it.

HELEN MOLESWORTH I recently organized an exhibition called *Part Object Part Sculpture*, which, at the time I was organizing it, didn't seem to have much to do with the war. Although I'm reminded of something that Lee Krasner said about her paintings, that they were intensely autobiographical if anyone would just look at them.

The exhibition is a reconsideration of the legacy of Duchamp for transatlantic sculpture made after World War II, which takes very seriously his interest in the erotic and the bodily and how he tried to think of that in tandem with his interest in commodity. In the organizing of this exhibition, I found that it suggested different models of intimacy, which in my mind, harkens back to something that Gregg was talking about. My own sense of how the exhibition ended up being a profound anti-war statement is, in part, because of the models of intimacy it proposed. And that's partly why I was interested in coming here, not only to talk about very overt forms of thinking against the war, but also to talk about trying to re-gauge notions of affect and bodily-ness and sensation, which seem to me very important to do right now.

PAUL CHAN I think the war has made my work more desperate. I think the war has made my work more inhuman. And I think, in a way, it makes it better.

Part Object Part Sculpture was an exhibition curated by Helen Molesworth at Wexner Center for the Arts, Columbus, Ohio, and was on view from October 30, 2005 to February 26, 2006.

Henry Ford received the "Grand Cross," German's highest honor for a non-citizen, for his financial backing of Hitler's party. The "Grand Cross" was also awarded to Mussolini that same year.

DEBORAH GRANT I've come to understand that everything that is conspiracy is fact, and everything that is fact is conspiracy. I'm beginning to understand that the things I have been thinking about or trying to understand regarding the idea of corporate war have actually been decided and presented in a particular way. I think it goes back to when Henry Ford received a medal on his seventy-fifth birthday from Adolf Hitler. Everything I was thinking about when I was in graduate school—this idea of random, yet selective that I was trying to understand for myself—is basically happening in its own way. In fact, everything is more selective than random.

STEVE KURTZ I'm a member of Critical Art Ensemble (CAE). Since it began, the group has been dedicated to anti-authoritarian activities. And what we are most interested in are the issues that are off the public radar or are generally only mythically, rather than historically, understood, yet have a profound effect on everyday life. Consequently, I always thought, "You know, I hope I get through this whole project without ever having to do a work about war—it's so obvious."

But sure enough, about a year or so into Iraq, CAE came to believe, "We have to do something about the war whether we like it or not." And that's when we started investigating

germ warfare. We thought, "Well, let's go to one of the problems that's transparent due to false consensus, and is having a terrible impact on society. Let's reveal the economic and social consequences of 'biosecurity' that aren't readily accessible by the public." And in this particular case, we looked at the linkage between the war economy and global healthcare, and it's an unfortunate relationship. We began looking at the losses of finite resources in the military for research on diseases killing millions of people every year. Instead, what interests the military are minor occurrences, like the 2001 anthrax attack, a one time event where five people died. I don't know what that translates to exactly, but it's approximately the same number of deaths that happen in forty-five seconds every day from HIV. But "threats" like Anthrax is where billions and billions of dollars go, along with other limited resources. It competes with the emerging infectious diseases that people are really dying from like HIV, malaria, and multi-drug-resistant tuberculosis.

It was in the context of this kind of horror show that CAE thought, "We have to address the war. We have to address the hyper-reality of this war and how the neoconservatives are constructing hyper-realities that keep people focused on the places that are of little risk to their lives." So, we started thinking about how we could reframe this situation, to use a trivial example, like the way the Atkins diet reframed dieting and brought about a complete inversion of the dieting process. It's that type of tactic that we are trying to engage in regard to this war. How can we find ways to take manageable, consumable bites of it, reframe them, and chip away at this dark mountain, because we obviously have the time. It is going to go on for years, so we can think about this as a long-term process. And it needs to happen on all levels, as Gregg and Helen were pointing out. It certainly has had an effect on how the group thinks and how we're going to pursue our tactical responses.

NATO THOMPSON You know, I was really into the anti-globalization, anti-WTO movement. And the war put a break on that in a profound way that mystified me. When Bush came into office, it was a very rainy day. I remember that day so well because that gloom never left. But what was so profound to me was that I knew—as soon as Bush came into office everyone knew—a war was coming. A lot of people at the time said, "That's going to up the stakes." Everyone assumed that radical culture was going to get more intense once Bush got into office. In fact, some anarchical friends of mine, particularly malice-leaning types, said, "Oh well, you gotta vote for Bush, because it's just going to be the end all, be all. It's going to really push it to a head."

But, in fact, what we didn't expect was that Bush coming into office would put a mental block in people's minds and that the level of radical participation would drop off dramatically. That was a very profound kind of moment

Critical Art Ensemble (CAE) is a collective of five artists dedicated to exploring the intersections between art, technology, radical politics, and critical theory. Image: **Critical Art Ensemble, Image from** *Flesh Machine*, **1997-98**

Anti-WTO movement

Free Trade Area of the Americas (**FTAA**) is a proposed agreement to eliminate or reduce trade barriers among thirty-four countries in the Americas and the Caribbean. The FTAA has been criticized and opposed as a tool of United States' economic imperialism.

in my opinion. People were still operating under this Clinton era, neo-capital framework and to see the stakes change freaked people out. There was so much inertia after Clinton and then things shifted to straight-up state fascism. It is a hard thing to adjust to.

The good news is the rest of the world is still really going for it. Like Argentina was blowing up with the **FTAA** situation over there. Stuff is still going on around the world. Over in Hong Kong, the WTO protests are huge with the Korean farmers leading the charge. So, it's not that things are down and out with this war globally, it's mostly in the U.S. and I think particularly in New York City. I always think, "Oh, man, New York City's really depressed." Because my friends in Chicago are more active than New York. And my friends in Los Angeles are more active than New York. I always feel like New York suffers a social capital malaise. So, I'm always like, "Yeah, New York City's got some stuff to work out."

And one last thing that's on my mind is how we can support those people in this country that are doing radical art practices, because they're not gone. There are great spaces doing cool stuff that could use funds. We could all lend a hand to help those who are doing really good work, like using our own writing prowess to force magazines to publish legitimate forms of practice and producing radical culture ourselves. I think it's really out there, it's viable, and I think it's important to back it up.

PETER ELEEY I've been thinking a lot recently about the personal level of the war, because my cousin is going to Iraq next month, and I don't know many other people with relatives in the service. It has been interesting mostly in terms of how difficult it is to discuss within my family, most of whom are opposed to the war, though there are a number of people who have been in the service. Some of them seem to be at least partially faithful to the war effort, perhaps because it may feel like not supporting it would demean the value of my cousin's life, should anything happen to him.

My cousin enlisted out of high school not long before September 11th, and shipped out for basic training the week that the attack happened. For him, I think it was the classic story of not feeling like there were other options and thinking that military service was a viable job with good training. Even though lots of other people in my family have gone to college and done other things—seen the world in a bigger way—those examples weren't enough to keep him from enlisting.

This is a hard thing to discuss, and the difficulties of trying to talk about it within my family has made me think about how hard it must be on a broader level for us to talk about the issues of class and privilege and the aspects of hopefulness or hopelessness that underlie attitudes towards military service. The ways we conceive of what's possible for ourselves is of course tied directly to the success of

recruitment efforts, the success or failure of which has
a direct bearing on the continuation of this war.

ANNE PASTERNAK This gathering was, in part, inspired
by my cynicism and anger over the war. As we went to war
in Afghanistan and then Iraq, it struck me that we could
walk around the galleries and museums and never know we
were at war, that our country was divided, and that countries
around the world were infuriated with the United States.
In talking with artists, I recognized it might be a good idea
to come together and share our views—as diverse and
even oppositional as they might be—about the relationship
to art and war at this moment. And it has been my hope that
in some ways our individual practices might be inspired
tonight—I truly hope so, at least, because I believe profoundly
in the power of art to inspire consciousness and even
social change.

RALPH RUGOFF I have two very different reactions to the
war. One was in the days before the war when there were
protests around the world, and there were maybe ten or
fifteen or twenty million people in different parts of the world
protesting. There was a big protest here in New York. In
San Francisco, of course, there was another one. And I felt
very uplifted that there were that many people out there who
felt that it would take extremes to oppose this war around
the world.

Six months later when that initial will to oppose the
war was no longer visible, I felt a lot of despair and also
estrangement. I felt I didn't really recognize the country I had
grown up in. I think my despair wasn't only about the war
in Iraq. It was the war on democracy, the war on healthcare,
the war on the impoverished rather than a war on poverty,
and the war on the free press and our civil liberties.

And I think that now in retrospect, there was also
something slightly depressing about the fact that there
had been this enormous mobilization before the war and it
had dropped dead. There was a sense that we had rehearsed
this form that people knew and that had worked in the
past. But it wasn't working anymore. It wasn't enough.
People somehow had this almost ritualistic belief in public
demonstrations, we would do this ritual, and then things
would get better. There wasn't a connection to what you
had to do beyond that.

So, one response I had was to curate a show called
Monuments for the USA where I invited seventy artists
to make a proposal for a monument for the United States,
to whatever they thought was appropriate to commemorate
about the United States. Paul Chan did a wonderful piece
for that show that suggested renaming constellations after
core democratic rights and principles. One of the things
I thought might happen, as people were thinking about what
they would commemorate or celebrate or criticize in the
United States through the making of a monument to it, was
that through this process the artists would somehow create

Monuments for the USA was an
exhibition curated by Ralph Rugoff at
CCA Wattis Institute for Contemporary
Arts, San Francisco, California, from
April 7 to May 14, 2005.

Paul Chan, *A free press (formerly Ursa Minor)*, 2005

a different and more accurate profile of where the country was right then.

I do think there is a great role for art to potentially play in all of this. I agree with a lot of things Gregg was talking about. I don't think we're living in an Enlightenment Age where the public is swayed by reason and they make their decisions based on reason. You have to go beyond just reiterating the right reasons to do the right things. You have to find ways to create a mood or a sense of a horizon that people are moved towards. And you can do that through images and art.

There is a Mexican artist/designer group called Torolab and they have a saying that this is no longer a time for protest; it is a time for proposals. And I try to take that as a challenge when I think about these issues, because it is too easy to react against what's going on. Instead I try to think of a proposal that's going to counter that effect.

ASHFORD I want to talk some more about what Nato had commented on, the lack of a counterculture. I think it was also reflected in what Ralph was saying about the way that protest movements need something else happening around them or through them. I tend to disagree a little bit; I think that a happening with people on the street every weekend protesting against the war would be a great thing. And I think that it would lead to other kinds of work. It would lead to those countercultural moments that Gregg was describing, and it's related to the idea of intimacy and rethinking intimacy, which Helen was talking about. I might be asking

too big a question, but I'm wondering if someone can figure out why New York, as Nato said, is displaced? Why has it become a desert of countercultural work of both the intimate and the explicitly political kind?

GRANT Economic plight. I remember, growing up in Coney Island in the 70s and all the abandoned lots that I used to play in from Surf Avenue all the way to Neptune Avenue on West 36th Street. What I remember about these abandoned lots is that they were specifically left that way, either from burnouts or as land speculation. It made more sense to leave them abandoned than to have anyone in them.

Now I feel like that same thing is happening again, but in this case there are buildings. Gentrification is everywhere; it's in Chinatown, Harlem, and all these different places. So, I feel like everyone is caught economically one way or the other. I feel like New York is caught in that place of economic strife, of not even understanding where it's going to turn next. Harlem is growing. Brooklyn's growing, too. It becomes a weird thing where you are barely able to make it, where you realize that you have to come up with next month's rent. At one point during the late 80s or 90s, the idea was come to New York, make money, and send it home. Now it's becoming a situation where you're almost economically trapped in New York.

I also disagree with the idea that we're fighting against the corporation. I feel like we are the corporation. And what I mean by that is that we vote everyday with our dollar for products and things. So we're the corporation through our constant dollar-voting or through just the way we deal. In most cases, an individual may have a political viewpoint one way or the other, but an aspect of being a part of the corporation is that the corporation was indoctrinated a long time ago. So, we cling to corporations, our corporate sponsors. Sometimes we are supported by people who have the money who are thinking in the direction that we're thinking. But we work hand in hand in one way or another with corporations. I mean, eventually we are holding the devil's hand.

ASHFORD The economic re-organization of our world into "all against all" is clear.

BORDOWITZ I want to bring this part back to Nato. Why do you think there's less counterculture here than elsewhere? What gives you that sense?

THOMPSON Okay, I'm going to be quite frank. In cities like Chicago, there's a different feel. I talk about this with my pals. It's weird when you go to New York, because the social capital game is so high. People are very ambitious here. Activism feels like a career move in New York City, but it doesn't feel like that in other cities. I'm serious. Because in Chicago no one thought they were going to be in the Whitney Biennial. No one went out on the street and got it

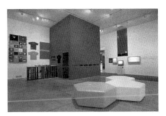

Torolab, established in 1995, is a Tijuana-based group of artists, architects, and designers who focus on concrete action to social issues in the urban spaces of Tijuana. Image: **Torolab installation at the San Diego Museum of Contemporary Art**

Group Material, active from 1979–1996, was a New York-based artists' collaborative who mounted provocative temporary exhibitions around social and political issues such as the U.S. involvement in Central America, AIDS, and mass consumerism. Image: **Group Material, Timeline P.S. 1, 1983 (organized as part of ARTISTS CALL Against U.S. Intervention in Central America)**

documented, because they thought, "Someone might see this." You know what I'm saying? But here it feels like all culture is part of someone's career. I swear to God it does.

It's nothing against the good folks here. I'm not saying that, but there's ambition here. There's a lot of money in New York City in ways that, I think, ten years ago there wasn't. I mean, call me crazy, but I feel like this is the center of the art world and these terms of the culture industry, of cultural production, is important in how you delegate your radical practice in a cultural space.

ASHFORD Nato, you and I have had this discussion before, and I have trouble with it because of my own history. The market dominated the early 80s, it was a gigantic art sale, it was the junk bond world—a market explosion. But there were also artists taking over buildings, there was Group Material, there were artists working dialogically in the Bronx and Brooklyn, there were people going to Cuba and Nicaragua and working with unions and activist groups and coming back and starting formal experiments, there was public theater, grassroot health campaigns, and client-based "educational movements." I'm not saying it's great right now, I'm just saying I think it's a little bit too easy to blame this lack of cultural activism on market domination. We had a junk bond art world in the 80s and there was experimentation. There's experimentation now that goes undocumented.

BORDOWITZ The counterculture—or whatever has announced itself as counterculture—is stymied around the idea of countering "wrong" arguments and information with reasonable ideas and facts. That cannot be the limit of our activity. Making a counterculture has to do with producing enough heat and light around a moral equivalent to war. You can't be just anti-war. You have to be *for* a set of positive principles and ideals and it is very difficult at this moment to be for something.

I am very afraid. I think this is a proto-fascist moment. I am concerned about something more than the media domination of information. I want to understand how the Republicans successfully operate on so many different levels, including the level of emotions. They have created a worldview—that the good life some people are living in this country, and the promise of a good life most people are laboring hard to achieve, will disappear if we don't dominate and control resources at this moment when there is no opposing superpower. This is the worldview they've produced, without saying it directly. This is justification for U.S. aggression that most people believe, whether they can articulate it or not

People are willing to protest. Some people are. But when I talk to young people about the anti-war protests—and of course, this is just anecdotal—they make comments like, "Well, I protested and the war continued anyway." For young people, there is no place to drop out into, there's

no supporting structure for dissent. There is no sustaining alternative culture. So, people who oppose the current regime get discouraged. They participate in dissent episodically, for a day, for an event, for efforts not anchored in a sustaining alternative.

Right now I'm forty-two and I feel irrelevant to the dominant culture. I feel so marginalized. And it's painful. It's not romantic; it's not bohemian. But I'm willing to do this. I'm willing to come here and do difficult intellectual work for the price of dinner. I am literally singing for my supper here, because I respect a lot of people at this conversation.

ASHFORD I think that a lot of people at this table are in a very similar position. We're calling it different things, we may call it "aesthetic innovation," we may call it "reinventing intimacy," we may call it "searching for the irrational," but a lot of people at this table are realizing the way that historical countercultural narratives are now quickly consumed and put to rational effect and we are looking for other kinds of ways of working. My interest, as a teacher, is in how public agencies can help inspire and motivate those kinds of practices that resist both instrumentalization and decoration.

HAYES I did read the letter that Doug wrote inviting us here and I thought it was interesting. The whole discussion about supporting projects and artists and activists, for me, is bound up in what you were pointing to, Deborah. I think there is a change in New York, which is sweeping across a lot of places internationally, that has to do with real estate and this certain kind of privatization. And it's an internalization of this same kind of proto-fascism you're talking about, which is this feeling that I have to get what I need now. And if I don't get what I need now then I'm locked out or blocked out. So, I have to find a space. I have to grab what I can with whatever resources I have.

One of the absences I was thinking about is this desperate need for space. And that is something that reverberates. It's not only physical space, but it's very connected to physical space. Because there's a different relationship to space in Los Angeles and Chicago. I think that's also one of the blocks, how do we struggle in a city where we cannot grab a ground. There's been temporary occupation of buildings, but it's like we're constantly being moved around the city.

PASTERNAK There is the very real issue of access to space, as you point out, but there also is a critical issue of having time. I'd guess that for most, if not all, of us, our days are filled with an onslaught of demands on our time and the pressures of responding to hundreds of e-mails, cell phone calls, etcetera. How are we to even consider working on a much greater scale of time? The religious Right started its conservative agenda on shaping the country's political and social sphere with a long view of time, taking a multi-generational approach. Yet our concern is with the next,

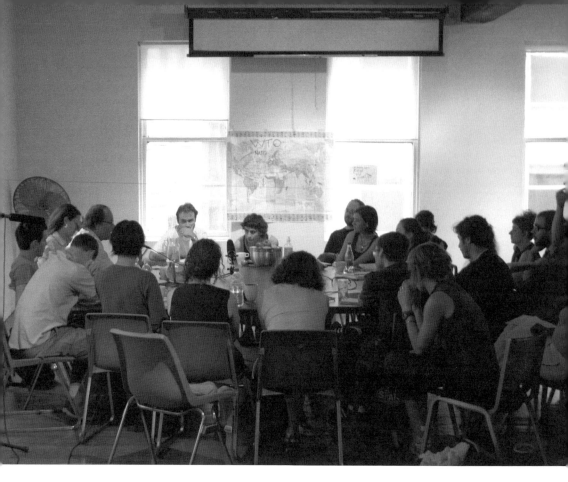

16 Beaver Street

most immediate need and it is increasingly difficult to integrate a long-term view into our work and into our lives.

THOMPSON Just in terms of space, it would be so nice in New York if there was a space that wasn't afraid of mixing art and activism in some sort of clean way. Fund a radical, anarchist community center in Manhattan—that would be big. That would be a great fund because it seems like it would be nice to have a place that would have the rent paid and that would be grassroots and on the ground, as well as doing more conceptual projects. A place where people could come together and hang out. I mean, that's kind of what 16 Beaver does, which is really nice. It just could use a little more square footage.

MENICK Yeah, but 16 Beaver didn't get any funding. Maybe that has changed recently, since I haven't been closely involved in the space in the last year or so. I think that's still true, though.

ASHFORD John, maybe you should describe the beginnings of 16 Beaver.

MENICK Well, I wasn't there in the beginning, but the space was started by Colin Beatty and Rene Gabri, two artists who came out of the Whitney Independent Studies Program and started a space downtown at 16 Beaver Street. I think this was around 1999 or 2000. Colin has since left to pursue other projects. The sort of financial genius and simplicity of Beaver was that they got a fairly large space, sub-divided it into studios, and the studios pay for the general rent. Then there's a common space that people share, and that's how most of us know the space since the majority of the participants don't have studios there. And over the years there's been a reading group, artists' projects, a Web site, publications, and all kinds of other stuff that has come out of the space. People come and go. There's a turnover. Every year it seems you get a new crop of people, but a lot of people have stayed on. Nato's been involved in it, and I think, Steve, you spoke there the other night.

I've been a grant writer and raised money for other spaces, and I know how difficult it is to raise real money for an operation like this. Most young nonprofits will maybe make a few thousand dollars if they try to raise funds, but they're not going to get operating costs covered. Nobody gets a salary at 16 Beaver. They're not going to get healthcare through the space. They don't have a CFO. In short, they've actively resisted the nonprofit structure, even though they may have some form of sponsorship now. And for a while I thought it was kind of silly of them to do so, but now, after working in nonprofits for a number of years I realize that's absolutely the perfect thing to do, because the foundations don't have enough money to go around. You've got to figure it out yourself.

ASHFORD But it's also something, as we discussed at the last meeting, that is part of the problem with getting professional. One can end up having a kind of bureaucratized practice that can no longer speak to or act on the counter-cultural moments that are being described in this room.

MENICK So many large, bureaucratic nonprofits have lost any sense of immediacy because their legal counsels increasingly govern their decisions.

ASHFORD Historically, many autonomous groups have not been organized as nonprofit organizations. I don't think that the creative work that many here have done is organized that way. Critical Art Ensemble is not registered as a **501(c)(3)**.

KURTZ We fought that from the very beginning. People always asked us to be nonprofit, and we'd say, "No."

THOMPSON I want to be on your board. [Laughter]

HAYES Now that I'm thinking about this, yeah, okay, there could be a space, but it's a space I can't even specifically define. It's not only about an anarchist community center

501(c) is a subsection of the United States Internal Revenue Code, which lists twenty-eight types of tax-exempt nonprofit organizations. 501(c)(3) organizations are prohibited from lobbying to influence elections and legislation. However, they are permitted to educate individuals about issues.

LTTR (a shifting acronym that initially stood for "Lesbians to the Rescue," but has also stood for "Lesbians Tend to Read," "Listen, Translate, Translate, Record," and "Let's Take the Role," among others), founded in 2001, is an artist collective that produces art journals, performance series, events, screenings, and collaborations. LTTR is dedicated to highlighting the work of radical communities whose goals are sustainable change, queer pleasure, and critical feminist productivity. Image: *LTTR #4 DO YOU WISH TO DIRECT ME*, 2006

and it's not only about space for us to work as artists. It's also about a space for a drag show at 12:00 am and for the proliferation of a drag community. I mean, 16 Beaver made me think a little bit about **LTTR**. I think one of the things that LTTR does really well is to work without that anchor of architecture. It works to carve out something else and to try to have a presence that doesn't rely on that kind of ground, the ground of a "home". This is something that I think is a good strategy to think about, too.

BORDOWITZ I think LTTR is one of the hottest things going at the moment because it can function without a building and without bureaucracy. I'm really excited because of the ways they organize gatherings. They are enormously capacious and eclectic. And LTTR understands that the counterculture problematic is about providing a new ground for intimacies, and different intimacies formed along new lines.

There are no politics except the politics inside the room. Politics manifest in what we are doing now, among ourselves, the worldview we produce and perform together.

The politics of any work of art unfold in the present-tense moment of the work's presentation. That's the politics of the work: What mood does it mobilize? What mood does it capture? Does it create a new ground for emotions, or the ground for new emotions? What discourse does it produce? These are the political questions of art.

Counterculture is about stripping away illusions. We must give up the illusion that we're going to make decisions here about what we can perform somewhere else to make things better in some imagined future. In direct opposition to that, counterculture is about producing something here, now, together, that's real—something that we can take away and spread to other encounters. This is my experience.

I formed these ideas through my ACT UP experience. Although there was measurable social change achieved through our work, the most radical thing I experienced in my life was being part of the movement itself. The most radical thing I experienced in ACT UP was being in a room with five hundred people, where we all tacitly agreed to change the world for each other. That's what counterculture is. We looked at each other and said, "We're going to change the world for each other, here and now."

MOLESWORTH Often when you talk, Gregg, I feel very inspired, but tonight I don't. I feel like what is happening around the table, and one of the things that's in this room, is a profound sense of failure. The affect in this room is one of failure. I used to romanticize failure—it was good, because to be successful was a problem.

ASHFORD But in your work, Helen, I have always read that art's constructed failures, its laziness, are key aspects of a critique of rationalized labor.

MOLESWORTH Yeah, but failure is as hard to romanticize now as marginality. So, I really like LTTR, too. I got magazines from K8, and read them in my living room and thought, "God, those kids in New York make these great magazines." And then I think, "Okay, so who cares?" I'm really torn between these feelings. And the affect for me often at the end of the day is a kind of a failure that I can't surmount.

ASHFORD Failure to do what?

MOLESWORTH Failure to have relevancy. Failure to gain traction. Failure to somehow negotiate for myself the insanity that one feels around the state murder of Tookie Williams with the "Christmas shopping that simply had to be done."

Stanley "Tookie" Williams, cofounder of the street gang the Crips, was executed in California on December 13, 2005 for murders he was convicted of committing in 1979. Image: **California State Prison System Booking, 2000**

CHAN I think there's a grand failure in recognizing—or maybe not owning up to the fact—that there is a cultural presence within the last ten years that we refuse to recognize as counterculture. I think one of my examples for a large counterculture presence is the Falun Gong in China. I think in terms of the criteria we're talking about, the Falun Gong has done more than anything in the world to make the Chinese government insane, crazy, and afraid. They have created a huge alternative to a state-run market driven society, and provided a moral equivalent to what it means to live in a community. Whether or not we want to accept them as part of what we consider to be the counterculture is one question, but this connects back to what Gregg said: What are you for and what are you opposed to or against? They're obviously for a kind of radical, politicized yoga, which they use as a touchstone to engage the world with.

Falun Gong, a form of *qigong*, is a practice of refining the mind and body through meditation introduced by Li Hongzhi in 1992. China began officially suppressing Falun Gong in July 1999 after the group came to their attention through peaceful protests.

Catholic Worker Movement is a Christian anarchist organization founded by Dorothy Day and Peter Maurin in 1933. The group provides social services, campaigns for nonviolence, and demonstrates against the unequal distribution of wealth.

The megachurches in the United States can, by all accounts, be considered a counterculture even though we may believe that they are mainstream culture. At the execution of Tookie Williams, the people who were protesting were all more or less from the religiously oriented anti-death penalty movement. I know twenty-five people right now, nine miles out of Guantanamo Bay, staging a hunger strike in solidarity with the people at Guantanamo. All of them have roots in the Catholic Worker Movement. Everyone I went to Iraq with was Catholic, Quaker, Buddhist, or Mennonite, except me.

So what are the oppositional modes for this commodified culture? One of the things that people have found is religion. Let's not say religion, let's say Christianity. Let's say populist Islam as well. If you believe in a counterculture, how do you believe in a secular counterculture that opposes not only capitalism, but also religion? Or maybe not opposes religion, but seeks to transform it in a way, so that it becomes a moral equivalent to what those megachurches believe when they look at those large screens and believe that God is speaking to them, so that they can work together.

MOLESWORTH bell hooks admonished us in 1988 that our inability to grapple with religious movements would be our downfall. She turned out to be right.

ASHFORD But, Paul, it's not possible to separate these religious movements from their formation in capitalism. The religious Right is not a religious movement, it's a political one and a very repressive one by self-definition. I think it's a false linkage to say there's this religious counterculture. I think it's a parallel culture rather than what I would call counterculture. Parallel in the sense that the status quo needs an extremist wing.

CHAN Yeah, it's not a hard and fast distinction, I agree. I mean, obviously Christianity has been used in collusion with state power. But I think in this country there's definitely a religious civil war going on between neo-Protestant groups about what it means to believe in Christ and what it means to have religion sleep with state power. But for me, the people who increase my room temperature are those religious folk who believe that it's God's purpose for them to burn down military recruitment centers or to stage hunger strikes against wars. And in a way, that becomes the moment where my shit is called: "You think you're brave, look what else you can do." And I think perhaps that's what we're always longing for with these communities that we create that somehow we become braver by being together so that we can do more things.

ASHFORD For me those are moments of the emancipatory identification I spoke of in the beginning. My neighbors in South Brooklyn associate with each other in outrage over issues they find in church. People in this room have found emancipatory moments, but not necessarily within religion. For me those emancipatory moments can happen with art. I've found them in identifying with fellow activists working on social movements. I've found them in the camaraderie and affinity with artists who have been involved with Group Material projects. I've found them in political movements. I've found them in the Great Hall at Cooper Union working for ACT UP. I am interested in when, as a public, we're at the point where we are willing to make associations, identify with each other, and make decisions collectively. When we can determine new public needs.

I'm not saying that religion isn't important. I'm just saying that the act of identifying with other people in suffering and in action is something that happens to all of us. This is what art does. Isn't it? I mean, this is where art took us in the first place as kids. It moved us to search for different ways to live and different ways of relate to each other.

THOMPSON If you combine Thomas Frank's What's the Matter with Kansas?, with his other book The Conquest of Cool on the commodification of counterculture, they're pretty profound. Because he really talks about populism, spectacle,

bell hooks is a writer, intellectual, and social activist. Her work looks at race, class, and gender and focuses on their ability to perpetuate oppression.

Thomas Frank, What's the Matter with Kansas?: How Conservatives Won the Heart of America (New York: Henry Holt, 2004). And Thomas Frank, The Conquest of Cool: Business Culture, Counterculture, and the Rise of Hip Consumerism (Chicago: University of Chicago Press, 1998).

and political subjectivity in a tangible manner. I think Paul's really right about this kind of movement or religion, but I think it's mistaken to say to yourself, "Well, then I just got to get religious." I mean, that's a problem.

What it really points to is the total effect that the rise of spectacle and the commodification of counterculture have had on us as cultural workers and the profound effects of cultural activism or movements, and their ability to inspire belief. I think that's a really important thing to navigate.

Tom Frank talks about the fact that Kansas voted Democrat up until 1992. And then it just shifted. You might think, "Kansas, my God, it's always been Republican." But no, it's actually always been a backbone of the Democratic Party. According to Frank, it has a lot to do with the disappearance of unions throughout Kansas. The meaning production that used to happen through union halls now takes place in churches. Which leads to another question: Where is meaning produced in this country and who is producing meaning? Religion is definitely producing meaning in the culture of alienation from capitalism. Religion does the trick as counter to something that exists in the state.

MOLESWORTH Peggy Phelan, a brilliant theorist of theater and performance studies, recently made an argument that might be germane to this discussion. She said that the society of the spectacle has given way to the society of performance and she locates that in 1980 with the election of Ronald Reagan as the first actor-president. Phelan thinks that strategies of countercultural performance are something that can be brought to bear on our political moment. Further, she thinks that the problem with the burlesque of most left wing aesthetic culture is that it's still fighting this battle against the spectacle culture. That is, it actually hasn't moved toward an understanding of performance culture. It seems to me one of the things the big churches have is performativity and participatory culture in their spaces. They've left spectacle culture behind for a version of intimacy with each other and God that comes from an embodied performance of faith.

ELEEY This goes back to that Neal Gabler book called Life: The Movie from the late 90s. I think the subtitle is How Entertainment Conquered Reality. It's a short American studies book that similarly locates why America is the locus for this kind of media dominance and the rise of a very spectacle-saturated culture, but particularly why Americans have come to see our own lives as spectacle. It situates this in the history of evangelical practice and performative practices within the church. This book was incredibly prescient—pre-Monica Lewinsky, pre-Bosnian televised war, and pre-everything else that's come since. It's badly in need of a reissuing with a new foreword.

Peggy Phelan is a leading theorist whose essays have been cited in the fields of architecture, art history, psychoanalytic criticism, visual culture, performance studies, theater studies, and film and video studies. Her books include Unmarked: The Politics of Performance (New York: Routledge, 1993) and Mourning Sex: Performing Public Memories (New York: Routledge, 1997).

Neal Gabler, Life, The Movie: How Entertainment Conquered Reality (New York: Alfred A. Knopf, 1998) New York Times Book Review called Life: The Movie, "A thoughtful, in places chilling, account of the way entertainment values have hollowed out American life."

Guy Debord, *La société du spectacle*
[*The Society of the Spectacle*] (Paris:
Buchet-Chastel, 1967). Reprinted with
translation by Donald Nicholson-Smith
(New York: Zone Books, 1994). Available
online in an unauthorized translation by
Ken Knabb, http://www.bopsecrets.org/
SI/debord/ (accessed July 10, 2006).

RUGOFF I don't have such a romantic idea of the church. For me the church was one of the early models of spectacle culture. If we think about it, spectacle is not about controlling thought or restricting thought, it's about shutting down thought. And the spectacle of church performativity, or whatever you want to call it, is about shutting down thought. So, I don't see us living in that post-spectacle moment.

This leads to a really important issue for public art: If you live in a spectacle in which thought is being shut down, what tool do you use to address that culture? I think there's been a nice argument made that the U.S.'s response to 9/11 had to take spectacular form, because the destruction of the Twin Towers was a spectacular event. And so, we had to come back with shock and awe. We had to launch a Hollywood war that was also going to be a spectacle.

I think for artists and people working with artists it's a question: Are you damned if you try to use spectacular tools to somehow counter this spectacle? Or are there other ways? Helen, you brought up the idea of intimacy. Maybe there's a different mode of intimacy. I think of intimacy as something where you have options and choices, and you're not shutting down thought. But I also was talking to somebody recently about the architecture of the Tate Modern. My most intimate experiences there weren't in the galleries, but in this huge public space, the Turbine Hall, where you have a much more dynamic interaction with the works of art. So, ideas of intimacy don't have to be limited to one-on-one situations. Maybe they can be a kind of mass event, but there's an intimate construction in how it's organized.

BORDOWITZ The term spectacle is often used with varying definitions. Its common meaning refers to a public show or ceremony. We often use it to refer to some kind of dazzling display. In *The Society of the Spectacle*, Guy Debord taught that the spectacle is not any particular image or event. Rather, the spectacle is the means by which images and public displays are used to mediate social relations. Following Debord, I understand the spectacle to refer to the ways that representations organize society.

The spectacle has reached a new level today. For example, consider how the most recent bombing raids on Baghdad were televised. We watched the bombing in real-time and most of it appeared as a lyrical abstraction. What we often saw was a fuzzy, digitized image of a light foreground against a dark sky. Occasionally, a burst of light would illuminate a distant cityscape. The burst of light was followed by the sounds of bombs exploding and episodes of gunfire. Then silence. There was little information presented, or rather, the real-time events were allowed to unfold with little commentary for long periods of time.

I felt a mixture of panic and excitement. It's difficult to admit this, but the horror I felt was mixed with the kind of excitement associated with cinema or theater. I was on the edge of my seat, watching the scene of war in a way

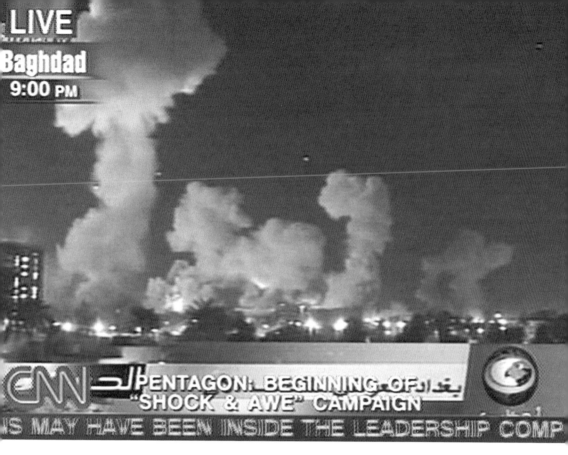

LIVE
Baghdad
9:00 PM

CNN ‏حرب‏ PENTAGON: BEGINNING OF ‏بغداد‏
"SHOCK & AWE" CAMPAIGN ‏كما‏

IS MAY HAVE BEEN INSIDE THE LEADERSHIP COMP

that wired me directly into the fighting. I was participating as a witness.

 Media is now working on the level of affect production. My encounters with historical events, no matter how geographically distant they are, are produced as a set of sensations on my body.

 We experience affect over information. To some extent, we have experienced the partial defeat of semiotics. While it remains important to listen to the broadcast commentary by hosts, like Wolf Blitzer on CNN, to hear how the reportage is being shaped ideologically, we must also consider how the news is embodied. This is why I have shifted my attention to emotion, feeling, and affect production—the ways that sensations play a role in building a worldview. That's why embodiment, as Helen was talking about, is also a significant term within certain lines of thought. In queer theory and culture, the term "embodiment" refers to one of the more radical tendencies of thought right now.

 I would like briefly to address the issue of religion. We shouldn't presume that no one here is religious. I believe in God. I don't allow a certain portion of the United States, fundamentalists specifically, to claim exclusive purchase on one of the oldest founding documents of Western civilization—the Bible. Personally, if you want to get into it, we can have a theological discussion. I'm very interested in a negative theology. I only trust people who say they could

Bombing raids on Baghdad

119

Emile Durkheim, *The Elementary Forms of Religious Life* (1912). Reprinted with translation by Joseph Swain (1915). Reprinted with new translation by Karen E. Fields (New York: New Press, 1995).

Dromological pollution refers to Paul Virilio's theory that the speed of technology makes the world a smaller, and thus more claustrophobic, place. In a 1997 interview Paul Virilio stated, "…I believe that there will be for future generations a feeling of confinement in the world, of incarceration, which will certainly be at the limit of tolerability, by virtue of the speed of information. If I were to give a last image, interactivity is to real space what radioactivity is to the atmosphere." [James Der Derian, "Interview with Paul Virilio," 1997, http://proxy.arts.uci.edu/~nideffer/_SPEED_/1.4/articles/derderian.html (accessed June 8, 2006).]

never describe what God is. I DO NOT trust people who claim to know God's will. God doesn't know, doesn't feel, doesn't judge. We can't imagine the verbs of God. There are many differing views about the nature of God within the long-standing history of theology. I think secular intellectuals—and I am one of them, as I am not an observant Jew—must take religion seriously. If you go back to Emile Durkheim and his book *The Elementary Forms of Religious Life*, you can talk about how religion was, and continues to be, the basis of social organization. That's a much larger discussion than we can entertain here. However, we shouldn't make presumptions about the beliefs of anyone at this table.

KURTZ Paul Virilio has a phrase for what you're talking about: dromological pollution. The idea is that we have a First World time, which is a constant presence—that we're constantly in contact with everything that's around us. And he sees it as a form of pollution. He also talks about a Second World time and a Third World time. I guess Third World time would just be reading newspapers or weeklies, where you don't get your information instantaneously. He thinks that a new ethical culture comes at a point where we help ourselves filter out the dromological pollution. How do we not become so immobilized by the presence of the present all around us, either from the Web or this constant terrible connectedness that comes from everything from cell phones to IMs to e-mails?

ASHFORD It seems this fragmentation has real effects on multiple communities. Emily, do you want to share thoughts on any of these things?

JACIR Regarding the beginning of this discussion about the lack of activism in New York City, I would just like to add that pre-9/11, the Arab community was very active and on the streets; a movement was really growing in connection with WTO protests and other actions around the world. But after 9/11, all that energy and work practically disappeared. People were scared to speak out, scared of losing their jobs, of being detained. All of a sudden the community was under attack and suspect, so the energy shifted and we were on the defense trying to deal with the devastating effects of people being hauled off to detention camps, questioned by the FBI, visited at random by the FBI, discriminated against and attacked in schools and businesses, as well as trying to deal with the way the media twists our history, our religions, our words, and so on. It has almost completely shut down an entire segment of the American community.

ASHFORD In terms of all public expression, including art and civil disobedience, right?

JACIR Yeah, in terms of protest, in terms of being able to speak, or going on the street. This whole group of people was completely silenced, because they want to survive. They don't want to be in detention camps or be deported.

THOMPSON But how much of that is actually true because I hear that from activists all the time. They believe police resistance stepped up after 9/11. But that's not true either. I mean, don't get me wrong, I think there is a perception that it has stepped up. But how much did it actually step-up, in terms of arresting protestors? A lot of these protests that have happened since then, like the anti-war stuff, a few people have gone to jail, but on the level of any of those other European ones, it's fairly small. I feel like the perception that police presence is huge is bigger than any of the actual demo-presence. Sometimes I think the perception that we're in a police state is bigger than the attitude, "Get out in the streets and just do some shit."

JACIR Yeah, but it's easier for some people to get on the streets without having to worry about being taken to a detention camp or deported than it is for others. And there is a risk especially if you are coming from one of the at-risk communities (Arab or South Asian).

ASHFORD After I had Naeem Mohaiemen speak at Cooper, I realized the problems of public expression are much worse than I thought. As a member of the VISIBLE Collective, he was able to represent how national identity is being used by the state to police behaviors. The U.S. Department of Homeland Security, as an agency, is able to link together all aspects of our relationships to public life and examine them. And punish us. It's like the Red Scare of the 1920s.

JACIR Even those of us who have passports are not safe.

ASHFORD And the physical danger of governmental abuse of power brings us back to society and the spectacle. I wonder if Steve wanted to say something about tactical media? It occurs to me that there are different strategies here: one idea invested in *affect* as emotion and one in *effect* as influence. On one hand, a painting is an anti-war painting because it models subjectivities that won't fight, that defamiliarize us from the nature of war. On the other hand, you have the notion of tactical media as it's developed over the last twelve years: visual intervention to achieve a counter-spectacle, from culture jamming to protest art.

JACIR Can I just interrupt for a second with a crazy, political painting story? I went to the Venice Biennial this year and there was no hint or whisper about the current situation. Nothing showed that there was anything going on in the world, that there was even a war. Nothing. A month later I was in Rome, Italy, and I accidentally ended up going to a **Botero** exhibit where he did these paintings about

Forty-eight paintings and sketches from Fernando **Botero**'s Abu Ghraib series were shown as part of *Fernando Botero: The Last 15 Years* shown at the Palazzo Venezia, Rome, from June 16 to September 25, 2005. The exhibition traveled to the Würth Museum, Germany, and to the Pinacoteca, Athens. Image: **Fernando Botero, *Abu Ghraib 46*, 2005** ©**Fernando Botero**

Abu Ghraib, and that was the most political thing that I'd fucking seen. I couldn't believe it. I'm serious. Especially after Venice. His Abu Ghraib paintings were put in the larger context of his life's work, so you see all that, and then you go in this Abu Ghraib room and it was shocking.

ASHFORD I want to know if his regular collectors are buying them.

JACIR He won't sell them.

ASHFORD He won't? Now that's tactical media.

CHAN He's funding his own exhibits.

ASHFORD Making his own scene. So, Steve?

KURTZ All right. It's hard because you and I have gone through so many issues.
 The first thing I want to mention is that I'm not invested in New York. I don't really care about it. I don't think New York leads the world. I don't share that kind of centering. If New York's in a down phase on activism right now or on politicization, it's okay. Things will come around again. One thing that I've been sitting here thinking the whole time is: "Folks, let's not forget our history." If inspiring ideas and tactics of resistance are happening in Berkeley, that's fine. If it's Olympia, Washington, that's fine.
 Where I am, in Buffalo, there's an incredible amount of solidarity, organization, people helping each other, and the public intimacy that Gregg is speaking about. These radical reinventings are happening worldwide, all the time. It's going on and I think this process of refitting activist practices is taking care of itself. I'm not as worried about the affect part. I think it's there and takes its own course in non-rational ways.
 The reason I have this bit of optimism is because I believe history is on our side. I don't think a proto-fascist state can reach its endgame under the neoconservatives. And I don't think that this new rise of nationalism and old-fashioned imperialism can reach its endgame again. We're going to go back, sooner rather than later, to where we left off when Bush came in. He's just this horrible historical hiccup that has been a massive pain to all of us. But there will be a historical correction and we will return to the struggle catalyzed by the Bush Sr./Clinton style of global neoliberalism—a horror in itself, but a much less ferocious and militaristic brand than we have gotten from the neocons.
 Maybe part of my optimism is because I don't have the option of talking about failure and the triumph of neoconservatism or fascism. If I do, I may as well lock myself in a jail cell, which I'm not going to do. I do feel more urgency about CAE's activity since my arrest. The interesting question for CAE is how to organize the intimacy we create when we're moving all the time. Our method of operation is a very nomadic kind of resistance where one moment I'm in

Serbia, the next moment I'm in Beirut, and the next I'm here in New York. How do we reach out to try and create the kind of micropolitics we need to go with the macropolitics that are underpinning the coalitions of global resistance? That's where I think the problem is.

The other historical lesson is that performativity entwined with spectacle (in the Aristotelian sense) is tactical media. A fully flowered model of cultural resistance bloomed in the 60s with groups like the Situationist International or the San Francisco Diggers and has continued in different forms every since. Take Guerrilla Art Action Group. They wanted to close the Museum of Modern Art until the war was over. What were the Black Panthers doing when they marched on the California Congress? That was performativity and spectacle working together. They weren't going to take over. They knew they weren't going to.

MOLESWORTH I don't know. Do the Panthers make pure performativity and pure spectacle one and the same? I'm not so sure that the Panthers are pure spectacle. I don't think that just because they made powerful images that were then disseminated by the media that they were involved in spectacle.

KURTZ You had to have them both going. One would not work without the other. Look, the Panthers at their peak had less than one thousand people under arms. Less than one thousand. Yet they were truly considered a threat to the stability of the United States. That's hyper-real. They explicitly understood and knew it, as did the Yippies levitating the Pentagon. This is how we as artists come out of these situations. We know these tactics. Some of them are still viable, some of them aren't. I think understanding performativity and understanding counter-spectacle helped to create effective practical models of resistance and that we can see them in action today, which is, again, why I'm a little more optimistic. I think we're accumulating models and tools, and adjusting the best we can to the dromological problems that were pointed out earlier and that Paul has summarized for us. I have a slightly different perspective, and so this conversation has made me agitated, too. I don't feel like I'm on the same avenue that I'm hearing so many people speak about tonight. I think we have agency. The greatest lie that we can ever internalize from authoritarian culture is that we are helpless to do anything. I'll be the evangelical here tonight.

ASHFORD Well, I think that means something coming from somebody who's been indicted by the federal government; illegally, improperly indicted, I should add.

BORDOWITZ I just want to be clear that when I say "mood," I mean the production of new emotions. I generally feel that novelty is possible, that our feelings are not our own, and that feelings are socially produced. And so, the terrain of cultural

The **San Francisco Diggers** were a street theater and direct action group active from 1966 to 1968. They took their name from the original English Diggers of the 1640s. Their most famous projects were Free Food (which took place each day in the Panhandle) and the Free Store (where everything was free for the taking).

Guerilla Art Action Group (GAAG) was an artists' collective cofounded by Jon Hendricks and Jean Toche in 1969. GAAG adopted tactics of labor and civil rights activists organizing protests that aimed to challenge and transform art institutions, most prominently the Museum of Modern Art, New York. On October 31, 1969, Jon Hendricks and Jean Toche, two of the artist members of GAAG, entered the Museum of Modern Art, removed Kasmir Malevitch's painting *Suprematist Composition, White on White,* and replaced it with a manifesto demanding that MoMA sell the equivalent of one million dollars worth of artwork from their collection to be given to the poor, decentralize the museum's management until directly democratic, and that the museum remain closed until the end of the war in Vietnam. Image: **Jon Hendricks and Jean Toche removing Malevich painting from the walls of the Museum of Modern Art, October 31, 1969**

production at the moment is to engage or create a ground for the production of new emotions. This is not about making people happy or hopeful. Mine is not an argument for hope. I'm not interested in simply making people feel better. I am interested in the ways that art can stage emotions and give viewers an opportunity to change the way they feel about situations. Ultimately, that's not a new aspiration. It goes back to Bertolt Brecht. It goes back even deeper in history than that.

KURTZ What I was taking issue with is where you were placing that argument. I can sit down with people that I'm intimate with, and even watch TV news, and all exclaim together, "Oh, that makes me so angry." There is a spectrum that emotion moves along that we can exchange and that exchange helps push the discourse. I'm with you.

 Where I'm saying our problem is, is that our real political/cultural fronts, like TV, the Internet, and other media that create the hegemonic political/cultural myths are nomadic structures and those types of nomadic structures do not lend themselves well to solidarity because they do not have a consistency of face-to-face and bodily experience.

BORDOWITZ I have the same question: Is public solidarity what we're looking for? What is the ground of intimacy now? We're not looking simply to get along or to share. We're not looking to establish some kind of Eden, or ideal communism. I'm interested in the kinds of intimacy that I think Helen is getting at in her discussion of erotics, when she's talking about her practice as a curator.

MOLESWORTH Not to personalize your situation, Steve, in fact, to depersonalize it radically and to follow up on some of Gregg's questions: Part of what is on the table is a notion of agency that comes from intimacy rather than a version of agency provoked by massive producers of authority. I hope we don't fall into that old transgressive model where the spanking is both the self-fulfilled motivation and the agency in and of itself. While I'm happy your sense of agency is reinvigorated, as a model of agency at this particular moment, I find it very troublesome.

THOMPSON I think Helen's point is one that has haunted those that are in a minority resistant position forever: How can we ever be anything but reactive? And as the speed of what's coming at us increases, we seem to get locked more and more into reactivity. I think you've got to give her that point.

ASHFORD Isn't that the role of affecting performative or any long-term creative practices? That they are not reactive? I mean, Steve, when I brought up Guerrilla Art Action Group this morning at breakfast I was talking about it as part of a tradition of performative, artistic practice. I believe that

The **Black Panther** Party was an African American civil rights organization founded by Huey P. Newton, Bobby Seale, and Richard Aoki in October 1966. The organization called for armed resistance to societal oppression in the interest of African American justice. Facing image: **From Stephen Shames, *The Black Panthers* (New York: Aperture, 2006)**

The **Yippies** were activists who came out of the The Youth International Party founded in 1967 by Abbie Hoffman, Anita Hoffman, and Paul Krassner, among others. They used street theater and politically oriented pranks to mock the social status quo.

Mess Hall is an initiative based out of a storefront space in the Chicago neighborhood of Rogers Park. It is an experimental site for exhibitions and events exploring visual culture, creative urbanism, sustainable ecology, and food democracy.

for GAAG, closing down the museum was an aesthetic, continuous affective idea. The premise of the *Who Cares* initiative is that Creative Time wants to develop a context in which people can respond to issues in a timely manner, to overcome the slow bureaucracy of most publicly funded production. I'm wondering, what about long-term durational performative and artistic practices? I mean, Guerrilla Art Action Group went on for seven years; they took a Museum of Modern Art owned painting, off the wall, and they read an ultimatum. They said, "Close the museum till the war's over." And then they got kicked out, and so they went back two weeks later and demanded the resignation of the Rockefellers from the MoMA board. You know what I'm saying? Part of the idea of a reactive technology of protest culture ignores the fact that you need to be able to go back the next day. Back to the museum, back to the studio, back to the union hall.

GRANT I feel like sometimes it's a mistake to think of individual practices. For instance, what is the practice we need to do to produce this? I really believe in thinking in terms of infrastructures. Like, what are the spaces or communities that we operate within that produce meaning? There's a space in Chicago called Mess Hall that I love. 16 Beaver produces a community of meaning because of its duration. The people move through it and it gains a lot of power, the longer it's around and people can hang on and move through it. Good spaces work because they've been around and people come through them with a lot of different practices.

BORDOWITZ There are things that do that, but they do it differently. I think LTTR rejects consistent durations in one single event or place. Their activities are wave-like. And LTTR's notion of diversity is radical because transgender theory and gender-queer practices are at the center of it. LTTR does something that very few groups have been able to do. They allow anyone to claim a queer identity through participation.

MOLESWORTH It sounds like you two have a much more developed conversation; the question of solidarity points to some kind of division that you already know about. But for me, what you're claiming for LTTR, which I could easily call "a kind of being together" or at least a "momentary being together" that isn't rooted in an essential identity, is extrapolated from the (older?) idea of solidarity. It is a moment for something to actualize; it's the ineffability of Gregg's idea of the "politics inside the room."

ASHFORD Yeah. Also, it is a moment to have an identity outside of yourself. That's what I remember experiencing over and over again about collaboration. There is never a cohesive singular idea of production; the work we needed to get done was a politics that we had to translate between

the street and the museum and university. I think we forget how beautiful this struggle for contextual meaning can be.

LaVERDIERE Is this group's intention to be a consciousness raising organization? If so, doesn't it need to have an awareness symbol, an icon, something universally recognizable like the red AIDS ribbon. Anne, you knew the artists that conceived that project, didn't you?

PASTERNAK Patrick O'Connell led the Red Ribbon Project as an initiative for Visual AIDS—it was a brilliant way to garner attention for HIV/AIDS and solidarity around the urgent need for compassion, education, and finding a cure.

LaVERDIERE I understood that it started as a public art project and quickly became a universal sign for the AIDS awareness movement, a symbol that the entire country learned to recognize. However, sometime during Desert Storm, patriotic citizens began wearing identical little yellow ribbons, in support for the troops. It's perverse, that a ribbon representing merciful awareness can be mimicked by another symbolizing war pride.

Yellow ribbons

Does there exists an anti-war awareness ribbon? I remember that there was a "Blue Button" project put together by some artists in 2003 that never really got legs. Have color-coded awareness merit badges just become politicized fashion accessories…ideological commodities?

Perhaps this objectivist "War Culture" dinner party's symbolic color should be black, in mourning the loss of our desire for anarchy. So my question for the table really is: whether this collective wants public recognition as a countercultural art movement, and if so does it need an awareness ribbon to identify itself? Maybe a simple black ribbon or armband would be an appropriate accessory?

Armband

ELEEY Before we get into that could we talk a little bit, just quickly, about LTTR?

HAYES As an audience, what I find so interesting about LTTR events is that often you don't know how you arrived or why you're there or quite what is happening. I mean, somebody asked you, or you knew about it, or you heard some hype about it. And then at the event you run into certain people who have been active and doing things in the art world for the last fifteen years, some of whom you've had a crush on or have inspired you over the years. Then you run into these young, queer people who you had no idea about, and they look crazy. They're outrageous. And then something unfolds and you can't necessarily even explain it. It's a new set of identifications between strangers. I'm not willing to grab onto it as a moment of emancipation yet, but something is definitely happening. Something that I can't fully describe. And that is interesting.

But one thing I don't want to do is claim LTTR as the only space that this has ever happened in or claim that LTTR

Black ribbons

is the only thing happening now. I think one of the things that I experienced, in New York in the early 90s as a younger person, was that I ran into these experiences all the time. There were thousands of different places for me to have them. One of the deficits that I arrive at is that I can't mark so many spaces or locations where these social platforms unfold anymore.

ASHFORD By "marking them," you're saying that they don't exist or that we're just not able to describe them?

HAYES No. I'm not willing to say they don't exist. I think they're more dispersed and that there's something that's shifting in the culture now. Counterculture is trying to find itself. And I may be finding myself too. I suppose I identify as neither hopeless nor hopeful. I'm just kind of waiting.

PASTERNAK This leads me back to Julian's desire for something that unifies us.

LaVERDIERE Yeah but "unifies us" sounds rather optimistic. I wasn't promoting a black ribbon specifically; my suggestion was meant to be somewhat ironic, because black ribbons are generally recognized as patriotic awareness symbols for POWs and MIAs. Although, it would be fitting for this post-modern collective to re-appropriate that iconography because we are all prisoners of war culture now whether we're being held captive by our fear of the enemy at home or abroad.

GRANT I was just going to say that I was looking at the new Kenneth Cole/amfAR ad campaign about AIDS. Zackie Achmat, the most influential AIDS activist in South Africa, was pushed way in the back, and there you have Will Smith and a whole bunch of other celebs saying, "We all have AIDS." And I just thought it was really telling that collective work gets pushed to the back.

ASHFORD Back left corner actually!

GRANT It felt like it was saying celebrity is the new power, this is the new conversation.

BORDOWITZ I just want to say "yes" to everything. What was great about ACT UP and why was it different than the Left? I participated as a very young person in ACT UP. ACT UP said "yes" to everything as long as it benefited people with AIDS. If you had an idea to do something that would benefit people with AIDS, you could present it to the entire group at a public meeting and people said, "Yes." "People who want to do a red ribbon, meet in that corner." "People who want to do an installation at the New Museum, go to that corner of the room." "People who want to pass out needles on Delancey Street, meet here." It was largely about "yes."

And there was a very simple, very loose shifting set of constraints on the group.

That's very similar to what Sharon is saying about LTTR and other collective moments right now. There are a lot of different things going on. Can you produce a space that has enough heat and light, a space of legitimation for practices that have very little constraints on what people can do? How does one engender an ethos of self-selection? We're back to the problem of radical participatory democracy.

THOMPSON Often the "yes" to everything approach and the conceptually tight (politically useless) desires of the art market are not in cahoots. And ultimately, this battle results in spaces not finding support due to a combination of lack of social capital and lack of finance. An infrastructure of resonance, that is a countercultural network of magazines, spaces, critic, producers, and activists can often compensate for this anti-political cultural climate. Spaces are good, but so too are magazines. We live in a land of magazines. I always focus on our little radical art culture thing.

What I mean is, there are a ton of political magazines, but I want to focus on our little cadre. Because that's some-thing we can work on at this table. We can do something about that. What we can do about political magazines, I don't know, but art culture magazines, like cool. LTTR, that's rad. Let's give them money then. Let's get them distributed. Let's talk about the mechanisms to get it out there.

LaVERDIERE You brought up an interesting issue. I can foresee a new reward-based funding mechanism for political-art. Being that activist-artists are engaged in an asymmetrical warfare of sorts, warfare fought between the public and the State, between a lesser and greater power. Perhaps activists should receive reward-grants from sponsor arts-organizations in the same manner that Palestinian martyrs are rewarded by their terrorist organizations? After joining in Jihad, martyrs are given a kind of life insurance policy and if they blow themselves up successfully, their families get the money. It's an after-the-fact, merit-based grant, like a Machiavellian MacArthur. Political art organizations could wait for splashy results before they give generous grants to their activists so as to inspire the initiative to make more sensational actions. Thus, if you're a successful political activist and you make a ripple, then you get your grant, and you don't get your grant…

THOMPSON Until the ripple. Yes. Ripple grants. That's a good idea.

HARDY We've been talking a little bit about space in a cultural light and saying that we can create spaces in different ways and that it doesn't have to be physical. But, in this city, do we have a desire for ample, real physical space available for gatherings and for practice and for

everything? I mean, we came here tonight to discuss how institutions can accommodate or help critical art practice and I think physical space is major. I know that for every single thing that LTTR has done, we have had to fight tooth and nail to get space. They gave us the windowsill and we took over the whole building. It's really difficult.

THOMPSON And not just arty stuff, but also stuff that's willing to be grassroots. You know what I mean? If art-funding culture could be okay with things sullied by pragmatics because it's not just a conceptual practice. You know what I'm saying? If a space could be grassroots and conceptual at the same time. If it could be flexible. If it could be trashed.

KURTZ There still seems to be an underpinning to this conversation that grounds it in the infantry of cultural workers. And I'm trying one more time to ask: What do we do about the cavalry workers? I think this is the ascendant demographic, which is, forgive the crudeness here, the dialectical opposition to the biennial culture.

On the one hand, we have those workers moving from political scene to political scene—following the global elite as they move. On the other hand, we have the biennial nomadic culture consisting of an international jet-set market elite who fly around following the big-ticket exhibitions. There is no longer a cultural capital anywhere. It's not New York; it's not Los Angeles; it's not San Francisco; it's not Berlin or London. It is where it is at that moment. One minute it's Amsterdam, and then it's Ljubljana the next minute. There's constant movement. And it's important to have that. So wherever you see a temporary site of global struggle, these resistant groups and coalitions are always there, whether it is in Genoa or Zurich or London or Mexico. A lot of the issues that we have been talking about aren't meaningful for this demographic. It's meaningful for a grounded coalition like ACT UP. That was chapter-based and there were neighborhood centers. Here the production of new forms of affect is very meaningful. We haven't even talked about that. Gregg, didn't you go as far as moving in order to better envelop yourself in that culture?

BORDOWITZ Yeah, I don't remember.

KURTZ There were these neighborhood-based nodes and centers that became very important. But for this other kind of struggle that we have—one that the CIA pointed to years ago—for nomadic contestation, what are we going to do to keep up with that? Those power vectors that have free movement that don't worry about borders or place or rootedness in any kind of center, and I mean that in the physical sense. What are we going to do to keep up with the issue of speed, with this new rate of becoming? I think the tactical is truly still the key discourse. It's all we've got that I can see.

HAYES What that seems to point to is also my biggest agitation. The people who I feel most engaged with politically and aesthetically, the people I can really have a conversation with, are spread across two continents and three thousand miles. And there's a way that is also a structure. That's a structure and a connection that is unfundable in a sense, because if we get together and we want some kind of support for getting together, then we have to have a project. And if we have a project or we meet at a symposium or we meet while trying to have some desperately needed vacation, then that's a very specific kind of coming together. I don't know how you keep the thing that has always been our base—which is friends, colleagues, comrades, etcetera—happening.

BORDOWITZ I always go into the realm of theory too much. And we can talk about tactics versus strategy at some point. But I'm just going to respectfully depart from what we're saying. I like the idea of a granting system providing spaces for groups. But the challenge institutionally—and, frankly, what I'm thinking is a challenge to the Rockefeller Brothers Fund and to Creative Time—is to fund spaces where no success is required, where no reporting is required, where things are allowed to happen; a space where individual practices can unfold alongside group activities. The test of a collective is what it allows individuals to do. That is the test of the democratic collective.

LaVERDIERE I can understand why you wouldn't want to give grants out for getting arrested, that's called "aiding and abetting" and probably is considered a sort of organized crime. I could also understand one's apprehension for wearing incriminating ID like a black ribbon to say to every cop, "I'm an anarchist, arrest me!" However, if you always stand anonymously and silently in the center, then how can there be a collective affect or movement to the left of center? I thought the purpose of this gathering was to cook up new, provocative proposals and concepts for change, not just discuss the status quo. Although the food's been great, I worry this dinner table's dominant countercultural message is frozen in the center.

BORDOWITZ When I started working at Gay Men's Health Crisis (GMHC) in 1988, there were about twenty-six people there. By the time I left in 1993, there were around two hundred and fifty people. I saw the history of the inherited grassroots model of the 70s change into the corporate model of the late 80s. Jean Carlomusto and I were creative partners at GMHC for five or six years. We were given video cameras and a video studio, and we were allowed to produce a cable program, plus an enormous amount of media as a means of direct action. We were charged with the mandate to provide potentially life saving information to people with AIDS. We understood that this mandate included an activist media practice to legitimate and document the efforts of the

Gay Men's Health Crisis (GMHC) is a not-for-profit, volunteer-supported, and community-based organization committed to national leadership in the fight against AIDS. It was founded in 1981 by Larry Kramer and Paul Popham in response to the large number of gay men who were falling victim to a rare cancer called Kaposi's Sarcoma, an early clue of the existence of the AIDS epidemic.

AIDS activist movement. In the early days, we were not asked to justify our activity by measuring how many people viewed our materials. (At that time one could approximate that three thousand people would see any cable program. That was enough.)

When GMHC grew and the corporate model took over, we were constantly asked to prove efficacy equal to the expectations of commercial programming—commercial products made with far greater resources and very different commitments. There was also pressure to produce revenue from our media for the nonprofit institute. That was all well over a decade ago. I have no idea what it's like at GMHC now. Certainly, they continue to provide valuable services to people with AIDS.

ASHFORD The community-based art movement of the late 90s is also part of this history. Even though public projects were already creating political agency on levels that we knew through intimacy and through affinity, artists were being asked to have an effect that could be statistically measured by funders, art agencies, and local government.

BORDOWITZ And can we prove efficacy now? No. But we can look back at the history. Sadly, we accepted quantification. We totally abandoned quality as a term. We accepted the corporate cultural incursion into the independent world and slowly gave over to the notion of legitimating our activity according to quantification, revenue production, and efficacy models that were totally inappropriate to emerging political activities or radical art making.

ELEEY I mentioned this in an earlier session, but I think it would be dishonest for us not to admit that those were active choices. In the wake of the "culture war," arts organizations said, "Well, you reject us on our terms and so we're going to legitimate our models and strategies on your terms." A whole variety of organizations have embraced evaluative methods based upon economic impact at various stages to defend to funders, and to other power structures, the kind of work that they do. It's undeniable. Artists bought in, too.

BORDOWITZ We faced a great deal of pressure to conform. Our funding was threatened constantly. Remember that Congress under the leadership of Jesse Helms was successful at limiting funding to groups that provided services to gay people.

Today we face new terrifying signs of repression. The conjoining of sexual politics to anti-terror politics is a horrifying move that recalls Nazi politics. We must analyze how George W. Bush and his people were able to win the last election by shifting the attention of a large margin of the electorate to opposing gay civil rights. By marshalling homophobia, the right wing can establish the fantasy figure of an internal enemy within the national borders. That fantasy figure goes far beyond the image of a terrorist. While we

are fighting a war-without-end against a largely phantasmic enemy abroad, the Right is using fear to construct a multi-headed demon in our midst. This development recalls the way that Red Scares historically focus on a combination of characteristics. In the fifties, during the McCarthy period the internal enemy was imagined as a communist, a Jew, or a homosexual. Perhaps, all three. Today, the structure of fear mongering is similar.

Today, as in other periods, a kind of self-mortification is required. One must be willing to risk one's own comfort, to risk losing the support and love of friends and social networks. Consider the risks gays and lesbians have to take when they come out. Even today, a young person risks being banished from the home for talking honestly about his or her sexuality. You go home, you talk to your parents, you don't agree with them. You risk them banishing you from the home.

Talking about the war is similar. You go into the classroom and you openly oppose the war. You risk the institution firing you for violating the supposedly value-neutral classroom. Yet, you take a stand now. You can't risk these things by calculating their efficacy on a broader scale.

How does this translate to funding institutions, like Creative Time or the Rockefeller Brothers Fund: Don't ask for the assurances of quantification. Fund risk. And be proud that you're doing it. And be willing to go out of operation if you're forced to. We are now facing situations that necessitate taking huge risks. The stakes are high.

ASHFORD Or, as discussed at the last dinner, don't be a funding agency that coerces artists into following the model of profitability and make them feel that they have to work within market constraints. There's an example with the NEA that I experienced personally. Group Material started as a room full of people with a project. After a few projects, the NEA would give us money. They'd say, "You want to do it. Go do it." The "culture wars" created a kind of microscopic examination of that process that shut future Group Materials down. What began as an inclusive agenda of artists, in line with democratic ideals of expanded public expression, became bogged down in a repressive agenda of responsibility. Censorship is then internalized as sponsoring organizations obsess on what serves their audience—now so easily offended. The right wing's fictionalization of the American audience for culture still needs to be challenged.

MENICK It's a lot deeper than that, though. It's even a problem for nonprofits that are membership-based. A financially successful, membership-based, nonprofit may do very little fundraising. But there are still the same sorts of problems, even if the organization in question has no one to respond to except a sympathetic membership. They're still corporate, almost by reflex.

National Endowment for the Arts (**NEA**) is an independent agency of the U.S. federal government created by Congress in 1965. The NEA's mission is "to enrich our Nation and its diverse cultural heritage by supporting works of artistic excellence, advancing learning in the arts, and strengthening the arts in communities throughout the country." In the late 80s and early 90s, a conservative contingent began attacking artists for creating "obscene" work. In 1990, the "NEA 4" (Tim Miller Karen Finley, John Fleck, and Holly Hughes) had their NEA Fellowships revoked because of political pressures. Congress eliminated NEA support for individual artists in 1995 and cut the NEA's budget by about forty percent.

The Interventionists: Art in the Social Sphere was curated by Nato Thompson and organized by MASS MoCA where it was presented from May 29, 2004 to March 31, 2005. Image: *The Interventionists* at **MASS MoCA, 2004 (installation view)**

By "corporate," I mean that the people who work in very developed nonprofits might as well be making widgets really. Like in for-profit corporations, which I've also worked for, there is a lot of alienation. People aren't involved in anything except a kind of day-to-day paper pushing. That's deeper than the "culture wars." That's the corporatization of everyday life.

THOMPSON When I did *The Interventionists* at MASS MoCA, I had to fight through so much internal self-censoring. There was a lot of fear that this would not fly within the given understanding of institutions. And then when things worked out, they all looked at me like, "Hey, are you crazy?"

I'm surprised just on a pure market level that people don't support more radical politics. There's even capitalist interest in radical politics that people still self-censor. Look around New York. I mean, it's absurd. There's good work happening in the world. Like the Istanbul Biennial. It's a great biennial. That was a great show. There are good shows. And there are good movements out there. What happened to ideas in contemporary art? I want to be relevant for once. These developed nonprofits might want to ask, "How about if we are all relevant now?"

MENICK Nato, your argument about relevance is not about one organization. I think it's about the trajectory of any successful organization. Meaning, if an organization hangs around for more than five or ten years, it begins to become bureaucratic. I believe very strongly that institutions have life spans and they should die at some point. They shouldn't go on forever. But going back to the case of, let's say, 16 Beaver, you have a very rare instance where there's an economic model that works. People aren't getting salaries, but it's gone on for six or seven years, and it can keep going as long as the lease goes on, I guess. I think you hang around too long, you fall into the trap of wanting grants. I've actually been in that situation a few times at other nonprofits. And incidentally, if you don't get the grant and you realize, "I'm living on handouts. I don't want to live this way." I think the best way to run a group is actually to come up with some sort of trick, outside of the foundation structure, to get the money you need so that you can continue doing what you want to do. You don't have to be a rabid capitalist to do that.

ASHFORD An extremely important moment for me in terms of cultural organizing was at the end of ARTISTS CALL Against U.S. Intervention in Central America where we raised $240,000 and had to distribute this money to solidarity and cultural organizations in North and Central America. After a year and a half of organizing, fifteen people were sitting around a table like this, people who were not necessarily tired. And Jon Hendricks, the same guy who went into the Museum of Modern Art and took the Malevich off the wall in 1969 said, "I'm sorry. We have to stop this organization now."

And although there was a lot of disagreement, in the end Jon won with the idea that the institutionalization of dissidence in general should always be revolving, that organizing should give way so that new things should come around again.

BORDOWITZ I just want to be clear. I don't think that people and organizations should be reckless without cause. I don't romanticize dissent. As an artist myself, I'm interested in getting paid. I try to get my work on television. It might be for lack of talent, but it's not for lack of trying that my work doesn't show on television. There are plenty of ways in which artists are marginalized. I'm not romanticizing marginalization. I just think now is the time to make a risk assessment and take big risks. And like Nato is saying, I don't think that you will necessarily lose, but I think that all the kinds of self-censorship put into place during the 80s and 90s within funding institutions was misguided. It went too far, and now is the time for a radical new risk assessment. If there's any time to take risks, it's now. Now is the time for activism to permeate throughout institutions. And people are not their institutions. Every organizer knows this: When you mistake people for their institutions, you give into an institutional effect. People are never identical with their institutions, and that's why you can go into any institution and organize, from IBM to any nonprofit organization. Now is the time to fund things that cannot necessarily be proven, to reaffirm the notion of art as an experimental field, and to allow for a great degree of uncertainty over what the people you are funding do.

PASTERNAK Paul, last time we were together you mentioned that the issue was not about money. What do you think about Gregg's very specific appeal for funding?

CHAN I think money is great. But I think of the people who move me. I think of the twenty-five people on hunger strike down in Guantanamo. They got their money together and just went. I think of the time when we made the RNC map, *The People's Guide to the Republican National Convention*. We weren't going to wait for it. We weren't going to wait for a grant. We robbed, lied, and stole for that money. But these are all very event-based things. I need an event to feel desperate enough to do something, and desperate enough to do something different. And so, money, for me, becomes secondary.

What is it that will break me? I think of Botero. Something broke him. Something broke him to make those paintings, to put up his own money. So, at what point will an event break me to a point where I think nothing else matters except for a kind of action.

I don't know if I can contribute that much to this idea of how the institution is supposed to think. Maybe it's not a matter of giving people money, but something else

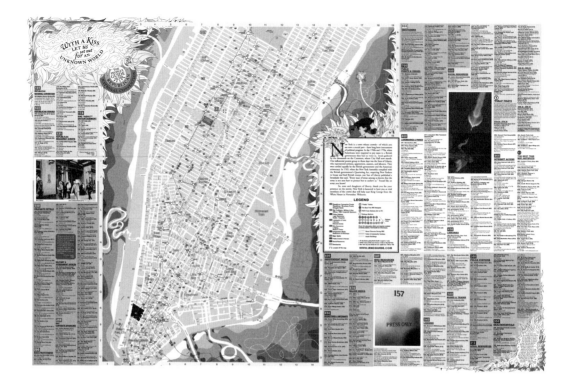

The People's Guide to the
Republican National Convention
was a map handed out for free during
the RNC in New York City in August
2004. Designed by Paul Chan, Nadxieli
Mannello, and Joshua Breitbart, it
offered information for protestors
including a list of hotels where delegates
were staying and contacts for bail
bondsmen. The New York Times said it
offered guidance "so that people have
enough information to get in the way or
out of the way."

Las Agencias (The Agencies) is an
informal collective based in Barcelona,
Spain, that has produced a number of
multi-disciplinary campaigns, counter-
information devices, actions, and
interventions that deal with issues of
nationalism, militarism, gentrification,
squatters rights, and migratory "guest"
workers' rights.

happening. Maybe people are looking for something else
that you can contribute to them.

THOMPSON But what about those guys—you remember
when MacBA gave Yomango a bunch of cash? Or gave
money to Las Agencias? These Spanish anarchy groups got
a bunch of money from the The Museum of Contemporary
Art in Barcelona. And Las Agencias made all these buses
that went to the WTO demonstrations. They looked like the
most unfundable organization on earth. But they took the
money and made critical work.

MENICK I think it's important to discuss money, because
I think a lot of funding organizations and foundations
are in the same situation as nonprofits. Technically they're
the same. But people have the mental image of the big,
bad, rich foundation and the poor, little nonprofit that's
got to beg for its money. In fact, there's actually a lot
in common with the two kinds of organizations. Not to
sound contradictory to what I said earlier, but it's those
longer-term projects that really need to be thought about.
And I just think the smaller institutions or the smaller
movements, although they're great, miss exactly what
needs tending to, which is the larger institutions that are
going to sustain people for longer periods of time. Those
are the institutions that give a lot of artists and writers
their salaries by employing them. Not everyone is going
to live by teaching or off the art market.

GRANT I think the smaller institutions sometimes, though, get threatened by the public in general. Recently I chose to take a painting out of a gallery situation. I chose to put it in a learning center, a place for people who look like me. But it got ripped off the wall, because the content didn't suffice with the people within the community. But, was it taken off the wall because some kid decided to rip it off the wall or was it the fact that the institution itself edited it and moved it out of the main space because of how people reacted to the work?

Deborah Grant, *Cast the First Stone*, 2003

PASTERNAK I don't think it's an issue of institutional scale. Small or big, it really comes down to fear. The PATRIOT Act, for example, is impacting the grant decisions and processes of foundations in ways that can have profound impact on providing opportunities to artists and public access to art. If a foundation supports a project that can, in any way, be linked to terrorist activity, the assets of the foundation can be seized by the feds. And so some foundations are asking their grantees to legally guarantee that none of the funding can be attached in any way to any kind of terrorist activity.

RODRIGUEZ-CUBEÑAS I spent eight months negotiating an operating grant for a nonprofit institution. I said, "Why is this taking so long?" The woman said to me over the phone, "Basically, it's the PATRIOT Act. We're afraid that you guys are going to give money to organizations that the PATRIOT Act doesn't like."

ASHFORD See, this is just not acceptable to me. I'm sorry. We have to let our institutions know that this is beyond humanity.

RODRIGUEZ-CUBEÑAS And I realize that the nonprofit and the foundation were both in the same boat at that moment.

PASTERNAK The problem is not just with the foundation and the grantee. The problem initially lies in our awareness, knowledge, and resistance to the PATRIOT Act in the first place!

HAYES I don't know where you go to and how you say that this is a problem that foundations are experiencing. But I think there's something about putting that on the table here where it becomes very real that it is untenable. I'm not sure what to do with that or how to respond. What can we as artists do with that except start to self-censor?

PASTERNAK Every citizen, including artists, must recognize how this can affect their personal freedoms…

ASHFORD At a certain point you may have to refuse to participate in the conversation.

The USA **PATRIOT Act** (Uniting and Strengthening America by Providing Appropriate Tools Required to Intercept and Obstruct Terrorism) was passed in 2001 in response to the September 11th terrorist attacks. Critics claim that portions of the Act allow U.S. law enforcement to infringe upon freedom of speech, freedom of the press, human rights, and the right to privacy. Section 215 allows investigators to look into personal records (including medical, financial, phone, Internet, and library records) on the basis of being "relevant for an on going investigation concerning international terrorism or clandestine intelligence activities," rather than probable cause as outlined in the fourth amendment. The law was renewed in March 2006.

The Mid-Kansas Jewish Federation is located in Wichita, Kansas. Their Web site (www.mkjf.org) states that their Community Relations Committee "foster(s) and manage(s) the relationship between the Jewish community and the greater Wichita community by monitoring and reacting to incidents which affect the security of the Jewish community, by reaching out to the wider community to provide information and education regarding the Jewish community, and by joining with other community groups to promote common goals." According to the Web site, there are approximately eight hundred Jewish people in Wichita.

THOMPSON On that note, *The Interventionist* show was actually the easiest show MASS MoCA's ever had to fundraise for. We raised tons of money. It was just funny to me. Our director had said, "We'll never raise money for this." And I was like, "Look at the funding coming in."

Anybody in the curatorial field that has problems with censorship should talk about Palestine and you'll deal with some real censorship in this country. Everyone's like, "Oh, you want to talk about anarchists. Great. You stole that? Awesome. Oh, it's religion? Fine. Palestine? Can't do it." That's where the real censorship goes down. As far as I can tell from the horror stories I've heard, censorship in the United States always revolves around the question of Palestine.

JACIR I could talk for hours about censorship in this country in regards to Palestine, Palestinian narratives, or basically Palestinian anything.

HAYES Emily, I don't know if I told you this, but I always thought that your decision to send a mass e-mail about the situation at the Ulrich Museum in Wichita was very smart.

You refused to be an individual in that situation. You immediately collectivized it. You immediately said, "This is our problem." And I guess that is what I mean about this situation. To a certain extent, I hear you say, "This is our problem." But to another extent I hear you say, "Well, this is the foundation's problem."

PASTERNAK I'm saying it's our problem—as artists, foundations, organizations, and as citizens.

JACIR I was invited to show my work in a museum, Wichita State's Ulrich Museum of Art, and they kept me in the dark about what was going on over there. They were trying to preempt what they thought were going to be protests in the community. So they started contacting all the local rabbis to make sure my show was kosher. One thing that was very problematic was that they decided one of the ways of dealing with my show was to have a panel on anti-Semitism in Europe! How that has any relationship to the work I make is beyond me, that's what they call being "even-handed." And then I was informed in December that the Mid-Kansas Jewish Federation had asked the president of the university if they could put up posters and a brochure talking about the Middle East from their perspective inside the exhibition with my work. And when the curator called me to tell me this he said, "We need you to make a decision right now. I totally support you if you back out. This is unheard of. This is a horrible thing."

Based on my prior experiences of censorship I knew that this was a tactic that they use so that you don't have time to actually think and have a response plan, because it had already happened to me previously where I was completely shut down. So, I said, "No, I need two weeks. Can't answer.

Won't give you a response to whether I'm going to be in the show or not. I've got to think about what I'm doing here." And then I sent out this e-mail and started contacting everybody I knew. Then the university got this barrage of e-mails from all over the world—from Tel Aviv, from everywhere—and the university actually went back on their decision and told the group that they couldn't put their brochures in. They were allowed to protest outside the building, which they did. When I arrived, I was handed a brochure that said, "Wichita State University is presenting this art exhibit by Emily Jacir that is defamatory to the State of Israel." And was full of so-called "facts" and "myths versus reality" in regards to my work.

So, in the end it actually ended up being a fantastic experience. It was incredible. There are three thousand Arabs living in Wichita that came to the exhibit. They talked about the piece in the Friday prayers at the mosque. They sent the whole mosque over. The museum didn't know this community existed out there. When I did the graduate visits I was also surprised to find out most of the graduate students were deeply affected by the war in Iraq. I mean, I had a grown man crying in his studio. Apparently that town has a lot of family military connections, so a lot of them had family in Iraq and they were anti-war. For me, going there and seeing what people were really thinking was important because people here in New York City have a tendency to imagine what people living in the rest of the country think, which is often really wrong. Anyway, I have many other censorship stories. I won't go into all of them except to say that New York is definitely the hardest state to show work about Palestine in and this is *the* place where censorship happens, so anyone who thinks that the scene in Wichita was because it was Kansas needs to wake up!

GRANT I want to talk about money. I say that specifically because, among a lot of black artists in general, resources are so limited. There's a pecking order. And a new generation of black artists are getting in a pecking order because the older artists say, "We didn't get money. We fought for the same conversation. And we were excluded. So, you too will be excluded out of that same conversation." And then we're saying, "No, we're not being excluded. We're a part of this dialogue."

I talk about money, because it is a new thing, very much a new thing, especially in the community I come from. So, it's hard to really understand, especially considering that you have some of the best schools in the country who basically have a dowry that's large enough to put every person in the United States through college at least four or five times, including anyone who's an immigrant. I mean, it's a weird thing to discuss. It's hard. In a weird way for me, it's a little hard to even be here, because it's something I'm working for. And at the same time the people who buy my work are Republicans and not Democrats or people who are liberal. That's the thing. Maybe it's because I'm preaching

to the choir, but in some ways I feel like when I'm doing the kind of work that I do, I get to infiltrate somehow. It might mean nothing, but I don't know.

ASHFORD The organization of money and the organization of war are not separate.

KURTZ Well, I'm not saying you shouldn't talk about money. In fact, that has dominated the past hour of conversation. But what I'm saying is, let's not talk about it at the exclusion of other issues, which I believe are of equal importance. What has come up in this conversation about money is access to knowledge, which I do rate incredibly high in my list of priorities. We've talked about censorship. We've talked about the PATRIOT Act and exclusion. We have even talked, in my case since my arrest, about the way that access to scientific knowledge is being shut down. The university is closing the doors saying, "No more amateurs in here." The distributors of materials are saying, "We're not going to sell anymore to amateurs." The knowledge and the materials we need to produce are disappearing. But what needs to be emphasized is the tremendous acceleration of privatization of cultural and knowledge centers. This is something I would like to talk about. I think it is one of the essential issues that burns every single one of us. We can't even get a production off the ground if we can't get the basic information to be able to talk about it intelligently. That concerns me. There are processes that should be a completely smooth passage from A to B regarding the flow of information and should be available not just in our universities and high schools, but through out the public sphere. That's problem one.

But problem two—and this is what makes it worse, where the clamp comes down and the censorship begins— is trying to talk about any scientific discourses through the filter of political economy. That is when we really get nailed. Authority will leave a little astronomy club alone if it will just talk about sciences as neutral, objective, value-free endeavors. The trajectory of so many knowledge initiatives are of course not value free, but are intimately linked to war economy.

THOMPSON I guess that is the way in which capital has taken advantage of the culture of fear. These systems can be taken advantage of through the guise of national security in a time of war. I remember being on a plane and the cabin crew said, "Economy passengers can't go through the first class cabin to use the bathroom because of security reasons." I want to do a whole litany of the baffling ways that security has been used to reapply oppression. It's classic. You've got to sit in the back of the bus for security reasons. And now you can't have this information. For security reasons…

HAYES Yes, capital takes advantage of authoritarian practices. And over the last ten years or so, this tendency seems to have an increasing relation to a shift in the balance between two distinct systems of knowledge or belief. Maybe it's too big of a tie to make, but I am referring to the discussion we were having around religion and the ideological battle about "knowledge" and "belief." Here I think there is also a deficit in our strategies. It seems to me one of the difficulties during the 80s and during the Reagan administration was the attempt to fight Reagan on his terms. His political narratives about Russia or nuclear war, or the economy even, were completely outrageous and absurd, but it didn't matter. His rhetoric couldn't be refuted by facts because facts weren't important. He was incredibly successful at organizing emotion and loyalty and belief. This seems to return in the "culture wars" of the 90s and again in this moment. And I don't think we're doing so well at counter-organizing emotion. Perhaps that's not the right tactic but I feel like we're at a point where there are huge and very real decisions to be made.

KURTZ But we can say that about anything. Trying to do something about the war. I don't know. It's not as though the president's going to ask me what I think. Invite me down to the White House, and ask, "What should we do here?" But with regard to the knowledge question, I think that's one that we just work out in practice. We find ways to get at these struggles through reinvention. For every lock there's a key. I really think that there are kinds of alternative and underground ways to ferret out the knowledge that is being kept from us.

I think the religious element, like Christians demanding the teaching of "intelligent design," is just a smoke screen. What is really foreclosing on the university or the library are the corporations and the military. That's who's invading campuses throughout the U.S. It's not some theocracy that's taking over there. The minute a university signs a contract with the military that lab is classified and closed to anyone not on the project or that engineering lab is classified and closed. What's shutting down access is the fact that all knowledge that is produced has to be proprietary. Knowledge is now organized around market niches.

But there are certain databases that are out there that still have to be made public domain and we can use those. We can take that information and use it to further our own interests in peace and social justice. The control of knowledge and the restriction of access to it certainly link to a proto-fascist state. That kind of privatization, to say that there is certain knowledge that cannot be public knowledge, is fundamental to the foundation building of a fascist movement.

GRANT But for many people, religion is becoming a new knowledge pool. If we look at the new conversation that's happening among youths who are part of these movements

there are obviously battlefields. You've got to look at it and expand your idea in terms of what you see. If you see it even at just the grassroots then it's obviously a part of the culture. And it is the culture. It's very much what you were saying, Paul.

CHAN Yep.

GRANT I know we talk about George Bush a lot, but we haven't talked about Condoleezza Rice and we haven't talked about Colin Powell who are very much part of this.

HAYES But I just want to clarify, what I was trying to link in this idea of the church foreclosing thought is that it's not the battle *for* those minds, it's the battle *with* those minds. What I'm trying to say is that I don't think the religious Right is made up of people who are duped, but rather people who hold fully formed ideological positions with which we are in debate. And that is something that requires a refashioning of our work.

BORDOWITZ Religion has always played a structuring role in kinship and the distribution of wealth. Religion also plays a vital role in the personal belief systems of millions. You can't judge someone according to his or her beliefs. How can you deny the veracity of what someone says they believe? If they believe it, then they believe it. However, you can and you must judge people by the consequences of their beliefs. What unfolds from beliefs? If the consequences of a particular system of belief results in the deaths of people from AIDS, from bombs, from repression, from privation, then the fundamental spiritual value of religion is sacrificed by the very same people who present themselves as spiritual leaders. A theocratic machine threatens us. The Bush administration wants to spend the majority of its international AIDS education budget on abstinence-only education. Abstinence-only education is an ideological effort that prevents people from having the full range of options necessary to protect themselves from HIV infection. This is an issue of knowledge management and the way that management affects all kinds of financial and social policy. Additionally and most importantly, this kind of management affects human behavior. People will die from a kind of knowledge management that secures the narrow beliefs of a very wealthy minority. The theocrat values his own fragile beliefs, and the well being of his intimates, over the lives of a vast majority. Knowledge isn't ever only symbolic; it's life or death. Knowledge is a kind of embodiment. We feel and we embody knowledge through belief. Belief is intimately tied to sentiments. Beliefs are affects.

ELEEY This is the sinister brilliance of Doug's quote from the White House that we began with. Their power stems from artifice. We think the creative world of art and art making is about artifice? Well, for the White House it's artifice on a

master level that focuses on the creation of a social reality for millions. They are basically challenging us to try to remake the world in our image instead of responding to theirs. At the same time, they are making the assumption that we're trapped in a responsive position.

ASHFORD But we're not completely trapped. I'm proposing next time you have an open space, or an auditorium, or a school, and you feel that you can make a social moment happen, make it happen.

Appendix

The casual atmosphere of a dinner party was the desired setting for the three preceding conversations. The organizers wanted the participants to feel comfortable, to think and speak freely, and to engage on an intimate and personal level. Although each gathering was given a theme in advance, a large part of the excitement was the unpredictable course of conversation. No one knew where the discussions would lead. As a result of this spontaneity, not everyone was able to contribute in equal parts, as is the nature of unscripted dialogue. Once the transcripts were in, the participants were invited to make further contributions to bring together a more extensive network of ideas.

Appendix 1
Original Draft Letter to Participants with Addendum Agendas
Doug Ashford

Dear _____

Who Cares, the series of discussions on timely public art practices that
we are organizing as part of a new Creative Time public arts initiative is about
to get started. The series of meetings, phone calls, and e-mails between
Anne Pasternak, Heather Duggan and Peter Eleey that began this process
have resulted in a remarkable set of conversations already, a prelude to
the project that I hope will model new forms of dialogic support for radical
public practices in New York.

It is clear with recent events going on outside our cultural sphere,
that the work we do as visual thinkers is going through an important shift
in its relationship to audiences and constituencies. The state's censorious
regime of expression management reminds us of the worst days of the
"culture wars." The exultant marketeering of artists, even while in school,
describes an artworld of decorative frenzy oblivious to radical meaning and
method. The visual spectacularization of any and every participatory moment
from elections to grassroots movements reduces democratic exchange
again and again.

Yet, our artworks and writings still ask the hardest questions.
The ideas that many of us have put into practice repeatedly over the years,
pushing against the definitional boundaries of audiences for art, inventing
democratic functions for museums and cultural display, re-designing the
relationship between identity and contemplation, reflecting communities
of concern, and reinventing the necessity for art—are becoming once again
a concern of artists of all generations. There are developments on the
horizon, both in the political economy and in the cultural practices around
us that suggest a period of change in our art world. A growing sense of
possibility to look beyond accepted forms of institutionalized visual practices
and their marketeering.

In the planning conversations I have been having with Anne, Heather,
and Peter, I have referred to these developments, this sense of possibility
as *counterculture*. I use the term excitedly today because there are so many
examples these days in which artists work to engage socially in the moment
they live. In organizing *Who Cares* I have tried to consistently respond to two
general understandings:

1. That we live in a particularly alarming social moment in which the
emancipatory effect of cultural is increasingly suppressed.

2. That recent art practice suggest a resurgence of critical artistic models
and methods; a growing desire among visual artists to see their work as part
of a counterculture.

And as countercultural practices suggest different futures, they also remind
us of a past that may already be forgotten—of the sense that we have been
through all this before and no one remembered to write it all down. The lack
of institutional interest in agitational art often means that the record of tactic,
strategy, and experience is often incomplete. As many have said—we seem

to have to re-invent the wheel every time we walk out of a gallery, every time we make a space of our own.

So, next month we will begin a set of three informal conversations about countercultural practices, comparisons of tactics and strategies, descriptions of failures and successes, discussion of the role of disciplines and institutions, the apparatuses of funding and audiences. Our conversation will be transcribed and act as part of a knowledge pool for a new set of Creative Time grant recipients. The idea, as Anne envisioned it two years ago, is to help artists create work that responds to timely cultural, social, and political issues that are of immediate interest to broad constituencies. Each meeting will be cross-generational and cross-disciplinary, putting you at the table with producers from different places in life and in the world. And every meeting will be informal, over a meal, with all of us in a context in which we can share speculatively—without concern for professional context and career.

The three meetings have been organized to provide a conceptual progression from studio to street; from contemplation to active citizenship. By using these discussions as steps in a progression of responses to political subjection, the foundation for an actual practices rather than mere theoretical interventions, will be emphasized. The idea is to be talking about what is being done and what can be done

Addendum 1: The meeting you have been asked to attend is titled "Anywhere in the World" and is the first conversation of *Who Cares*. Primarily I am there to help us get the conversation started and to keep it moving. Where we land with our concerns and hopes for culture is up to all of us and I am open to all subjects.

Among other things, participants in the "Anywhere in the World" conversation will be asked to critically address shifts in art institutions' understanding of place and productions that radically shift the working context for artists interested in site and social specificity. Expected to be everywhere and nowhere simultaneously, our work is often denied a productive relationship with audiences. Coherent communities of concern form themselves in political cultural practice everyday, in the street and in schools, but are diminished as models for public practice. The globalization of artistic display in festivalism and art fairs only adds to the problem, citing artworks as internationalist programs without local importance or extended discursive effect. If we would say that this is the stage of a globalized market coming home to roost in the art industry, we might not be far off. Artists traverse the globe as legal immaterial laborers, producing knowledge and legitimating urban renewal—while armies of unemployed migrants follow to maintain the profits of a international ownership class. In a way the problems of narrowing public function for art are pre-written in the market plans and strategies of a global economy.

I am hopeful that this conversation, in comparing the experiences of cultural producers from a wide range of contexts and generations, will generate a set of ideas or proposals—concrete descriptions of the hopes we have for culture and its institutional setting. If not, we will all have fun talking through the possibilities.

Addendum 2: The meeting you have been invited to is "Beauty and Its Discontents" and it is the second conversation of *Who Cares*. Primarily I am there to help us get the conversation going and to keep it moving. Where we go with this dialogue about our hopes and concerns for visual culture is meant to be unplanned and open to changing directions. I am open to all subjects that might intersect or emerge from our experiences and plans. To get us started though, I thought it might be a good idea to suggest a few points of departure:

First, I am curious to see how each of us fits in to the now mythical critical trajectory that some understand as the "denigration of beauty"— what our experiences as producers are—of the constructed dichotomies between beauty and politics. I'm curious to compare our experiences of the constructed dichotomies between beauty and politics from our position as producers: how do we fit in to the critical trajectory that some understand as the "denigration of beauty." Is it possible that the "anti-aesthetic" positions of the seventies and eighties, developed to free visual production from the constraints of commodity and decoration, have become distorted into formulaic institutional events that however "relational" often celebrate the status quo?

Can or should artists work to reclaim these traditions of skepticism as inclusive of emotional resonance, philosophical alienation, contemplation, and pathos? For many of us though, the idea is absurd that recent democratic discourses in the arts are or ever were positioned "against beauty." But if the break between contemplation and action is an artificial separation, how do we change this—a dichotomy so useful in keeping art in a safe place, away from social context? How do the existing models of anti-commercialization that are out there affect artists today? How do we build on the nonmarket-based narratives that are so crucial to public expression in a time of media spectacle? How do critical institutions based in cultural polemics, like schools and museums, end up excluding or shaping the discourses of contemplation and catharsis? Is there a public critical cultural practice that can be abstract or contemplative *and* help us socially re-define the time we live in?

In many ways this meeting can be an interrogation of what many of us feel to be the false divide between beauty and politics; a re-description of the emancipatory communities we have all imagined in relation to the work we do. I am hopeful that in our evening together we will do more than just respond to the difficult context of art production today. Instead, I am looking forward to the possibility that we will generate concrete descriptions for new kinds of production and institutional settings. And even more important, I am looking forward to the possibility that we will have fun.

Addendum 3: You have been invited to "War Culture," the final round table of the *Who Cares* initiative. Primarily I am there to help us get the conversation going and to keep it moving. I would like this dialogue about our hopes and concerns for public expression to be unplanned and open to changing directions. To get us started though, I thought it might be a good idea to suggest a few points of departure:

In a post 9/11 political context, all cultural questions change. In this meeting, the discussion will be directed toward the immediacy of this particular historical moment, a time of empire, displacement, and war. War culture connotes not only the shifting sense of self in the face of physical peril, but the transformation of subjectivity in relation to an increasingly repressed and dysfunctional public sphere. With war comes a concomitant management of public expression—of direct consequence and concern to artists of any definition.

When we began the planning *Who Cares* the reality of the American war machine was proceeding relatively unexamined by dominant institutions. Since those beginnings, public opinion seems to have changed radically. What cultural shifts have accompanied this change and how can the political imagination of artists engage with this new landscape. How can war be represented to create momentum against it?

Alternatively, how can creative practices respond to a war culture that is in remission or hidden; in an information context that is secretive and designed to obscure, do artists' roles change? What social containers and spaces exist for counterculture today and do they allow for and encourage new public practices? Can we and should we distinguish the activist and artistic characteristics of our work? How does the separation between our work and the museums, magazines, and schools we work for deny our role in the continuation of the conditions produced by war culture?

Enemy Kitchen is a project begun by Michael Rakowitz in 2006. Collaborating with his Iraqi-Jewish mother, he compiled Baghdadi recipes and taught them to different public audiences. The project is intended to continue in the fall of 2006 and 2007, in the form of a live cooking show featuring Rakowitz, his mother, and the students from the Hudson Guild Community Center, to be broadcast on public access television and the Internet. The project also plans to incorporate a series of lessons for chefs in New York City's public school cafeterias, so that Iraqi food can be served as part of their everyday menus.

Kubba or kibbeh, is a dish found throughout the Middle East and North Africa, most commonly cooked as spiced meat mixed with pine nuts and onions stuffed inside a bulghur wheat shell. It is usually fried and served with sesame paste.

Kubba Bamia is a traditional Iraqi dish in which the kubba is also made of spiced meat, but stuffed inside a rice flour-based dough, giving it a soft, chewy texture like a dumpling. It is cooked in a stew of tomato stock with plenty of fresh okra, called bamia in Arabic.

1 1/2 pounds lean lamb or beef, ground
2 cups natural rice flour
1 box (10 ounces) frozen whole baby okra,
or 1 pound fresh okra
two 8 ounce cans crushed tomatoes
1 small onion, chopped fine
salt
1 tablespoon oil
3/4 cup lemon juice
1/2 teaspoon ground turmeric
1/2 cup minced parsley leaves
1/8 teaspoon pepper
4 tablespoons sugar
3 1/2 cups hot water

Method
First, prepare the meat mixture, the filling inside the shell. Mix 1 pound of the meat with ground parsley, a teaspoon of pepper and 1/4 teaspoon of turmeric (go easy on the turmeric as it can leave the meat tasting too bitter). Add 1 1/2 tablespoons lemon juice and some salt. Mix all ingredients together.

Next, mix 2 cups of natural rice flour with 1/2 pound of the meat to create the dough that forms the outer shell of the dumpling. Water should be added gradually to keep the dough smooth. Keep a saucer of water nearby to keep your palms wet. Break off small pieces of the dough and roll them into spheres smaller than a golf ball.

To make the dumplings, pinch each piece of dough with your fingers (remember to keep them wet), to make a hollow. Fill the resulting "crater" with 1/2 teaspoon of the meat filling. Then close the ends together, pinching firmly to ensure a good seal. With your wet palms roll the kubba and shape into a round ball. Place in refrigerator when done.

In a large, deep pot, sauté the onion in the olive oil, adding half a teaspoon of pepper and 1/4 teaspoon of turmeric. Next, add the crushed tomatoes. Fill the two empty cans of crushed tomato with water and add (this gets all of the remaining tomato out of the can in the process). Bring to a boil and let cook for 15 minutes. Reduce heat, simmer for about 7 minutes, and then add the okra (fresh or frozen) along with a teaspoon of salt and the remaining lemon juice. Introduce the kubba into the simmering mixture by dropping them in carefully, two at a time. Distribute evenly around the pot. Allow it to cook for 15 minutes, then add the sugar and let simmer for 10 more minutes. Serve with plain rice.

Makes 3 servings

Based on my mother and grandmother's Kubba Bamia recipe, with additional information from *The Best of Baghdad Cooking* by Daisy Iny.

When, in the course of human events, it becomes necessary for people to solidify the creative, intellectual, and political bonds that connect ourselves to one another, a respect to the opinions of Everyone requires that we should Declare the Causes which impel us to the confederation. It is to this ultimate end that I wish to address you, that this proclamation be heard by All who find themselves in the midst of War.

This is a Call to Art!
Whereas the issues before us, rapidly assuming a portentous magnitude, deserve formal acknowledgement, I hereby proclaim that the means which conduce to a desirable result are now in Your Hands. Are you ready to devote your time, energies, blood and treasure to the Declaration of your Cause? For the opportunity is now at hand, not only to make your voice be heard but to receive ample reward from your comrades for the services you render in the Field. We need volunteers to march immediately and report for duty to the Muster, an assembly of troops for the purposes of inspection, critique, exercise and display. Engaging in a collective spirit that aims to Proclaim rather than Protest we will form a diverse regiment of our own design.

Enlist!
The place of general rendezvous will be in the heart of New York Harbor on Governors Island, where troops have mustered for over two hundred years. Permits have been secured to assemble on the marching grounds of Fort Jay, a splendid star-shaped fortification, flanked by Civil War cannons and framed by spectacular views of the Statue of Liberty and the majestic Manhattan skyline. On the 14th day of May 2005, we will gather under the banner of a polyphonic marshalling of voices, which come together to form a multi-layered, collective Cause, a portrait of our community in all its prismatic variety.

Get your uniform ready!
Using the American Civil War battle re-enactment as our aesthetic palette and point of departure, we will participate in the cultural practice of Living History, founded on the belief that historical events gain meaning and relevance when performed live in an open-air, interactive setting. And in effect, we will create our own unique historical event, for future re-enactors of the world.

Let every person come out!
Emblazon your Cause on a self-fashioned uniform. Enact your own costume drama. Wear your war on your sleeve. Show off your revolutionary style. Assume a historical personage. Dress up in soldier drag. Go into total role-playing. Take your shirt off. Form alliances. Form companies. Raise a border regiment. Marshal a Middlesex infantry. Lead a bugle brigade, drum corps, or dance troupe. Cause a Rebellion, provoke a skirmish, or go AWOL. Use your art supplies to make new forms of trench art. For, wherever you place yourself amidst the advances and retreats of art history, we are making an arsenal, a record, a form of currency, and a conversation.

We want You!

Proposals are now being accepted for a volunteer militia of up to fifty participants, who will build an encampment and produce, on-site, the contents of a public festivity. If Enlisted, you will be called upon to Muster into Action on the installation days of May 10th through May 13th, 2005, during which time you will pitch your tent, in the form of an artistic elaboration of the Cause you are representing at the Muster. There are already troops in place to assist you with your equipment, and there will be a Muster ferry service to transport you by boat onto Governors Island. On the evening of May 13th, you will be served excellent campaign rations, and in recognition of your participation in the Muster you will be ceremoniously welcomed and rewarded with a respectable cash bounty. That night, we will sleep under the stars. On the morning of May 14th, you will register your name on the official Muster Roll and pose for a traditional portrait, in uniform. At noon, the general public will be invited to tour the encampment and participate in whatever activities you deem necessary to engage spectators in your Cause. This could take the form of mock-battles, field games, cheerleading squads, grand processions, quilting bees, performances, demonstrations, or other colorful displays. The event will culminate in a formal Declaration of Causes, in which you will be called by name to an especial platform erected in your honor, to boldly state your response to this question:

What are you fighting for?

Accept this invitation with the promptitude and pleasure that has heretofore marked your response to every call that has been made to you by your friends in need. Conjure your insurgent grandparents, bra-burning aunts, funny uncles, and the transrevolutionaries who have paved the way for your life's work. Summon your historical peers and chosen family throughout time, and the Causes for which they fought and bled. Fly to arms and succor your brave sisters and brothers already in the field.

Rally at Once, before it is too late!
Muster!

Originally published on the Internet at http://www.themuster.com/ in conjunction with Allison Smith's project, *The Muster,* held on Govenors Island on May 14, 2005.

Appendix 4
A Few Postprandial Thoughts on "Creative Time" and Globalism
David Levi Strauss

I said that one of the things granting institutions that want to have an effect can do now is to slow things down, to give artists and writers time. Several of the younger participants in the first dinner told me afterwards that they were sorry things ended so early and that they wished it would have gone on for another few hours. People want to take time to talk.

One of the things that's changed about the art world in the last two decades is that it has become much more *managed*. There are certainly more managers (curators, handlers, etc.) than there ever have been. Many young artists don't think it's possible to be "outside" of the system; they don't believe there is an outside. As art becomes more and more managed, the possibility for improbable acts and ways of thinking is diminished. Vilém Flusser's definition of art is "any human activity that aims at producing improbable situations, and it is the more artful (artistic) the less probable the situation that it produces." Things have gotten to be all too *probable* in the current art world.

To understand why "creative dialogue and action on timely, public issues is impoverished" in the art world, one needs to look at the originating structures. People go to art school right out of high school and then into teaching. They have little experience outside the art world. It's becoming a closed system, a specialist system (which is, I think, what Tania meant about artists and "real people"). So dealing with "public issues" is considered presumptuous; out of order.

People don't believe in reality anymore; they believe in images. And this belief makes it possible for us to be manipulated through images. The symbolic world, the phantasmic world, matters. We are all subject to it. And since this is where artists and writers go to work, we have a special responsibility (ability to respond).

What happened to "urgent, socially responsive public practice" among artists? The NEA was gutted and cowed, and artist-run artspaces mostly disappeared, but the more comprehensive change was social and political: the public imaginary was seized by the Right. Public space vanished, public discourse was replaced by propaganda, and what Robert Smithson called the Establishment mutated and merged with (or was "synergistically" subsumed by) mass culture. "Contemporary American artists have every freedom except the one that matters: the freedom to act socially" (Peter Fuller). In some cases, they've given up that freedom willingly. But many others want it back.

Another reason fewer artists are working on public projects today is because we don't know who we're talking to these days. Public art projects are largely dependent on the social arrangements and valences in a given place at a given time, and certainly since 9/11, the public sphere in the U.S. has become "biased" (in the Elizabethan sense of "out of round").

When I published a "reasonable proposal" to do away with American artists in the *Brooklyn Rail*, some respondents didn't recognize it as satire and wrote in to argue with my proposal. That for me was a terrible indication of how far we've come. I mean, I stop just short of calling for dissident artists to be euthanized! (Reprinted in this volume, Appendix 5, page 156.)

Creative Time was founded in 1973. Rene Dubos's directive to "think globally, but act locally" was first given at the United Nations Conference on the Environment in 1972. Many of the big international art shows now tend to think locally, but act globally, which is also what the Bush regime does: it thinks locally, from an isolated American or Texan viewpoint, and acts globally, imposing its will on the world. So the dominant movement is certainly in that direction.

The discourse of globalization tends to occlude the political (think Tom Friedman). To globalization's proponents, its benefits are self-evident and undeniable (post-political and post-critical). Demonstrators against Bush & Co. in Venezuela and Seoul are depicted as delusional vestiges.

> That smooth-faced gentleman, tickling Commodity,
> Commodity, the bias of the world—
> —Shakespeare, *King John*

Harald Szeemann, who practically invented the role of nomadic independent curator of huge international shows, said "Globablization is the great enemy of art." In 1979, Rene Dubos argued for an ecologically sustainable world in which "natural and social units maintain or recapture their identity, yet interplay with each other through a rich system of communications."

Arts lobbies such as Americans for International Arts and Cultural Exchange are advocating cultural diplomacy "to persuade political and intellectual elites of the virtues of American civilization," while UNESCO last month (October 2005) passed a new convention on cultural diversity "designed to promote alternatives to American-style cultural globalization." Frank Hodsoll, head of the NEA under Reagan, is now chairman of the Center for Arts and Culture in Washington. In cooperation with the Coalition for American Leadership, they put out a report last year recommending "increasing cultural exchanges, facilitating visits to the United States by foreign artists and scholars, sponsoring trips abroad by American artists, reopening libraries and cultural centers and expanding English-language programs and cultural workshops." The director of the Center, Stefan Toepler, has said that corporations should be much more involved in this. "They have a big stake in this. They have markets to protect."

For the Market, everything; against the Market, nothing.

Appendix 5
Considering the Alternative: Are "Artists" Really Necessary?
(A Reasonable Proposal)
David Levi Strauss

As our newly duly elected leaders tell us at every opportunity, we live in a changed world after September 11th. This new world is divided between those who recognize and accept the conclusiveness of these changes (and will ultimately prevail) and those who do not (who will perish). The former must re-examine long-held opinions and assumptions and develop forward-leaning strategies in all areas of public life.

It has been clear for some time now that the American people love art—the museums are choked with visitors and the art market is booming—but hate artists, who are widely regarded as elitist troublemakers. In the old way of thinking, these two things were seen to be irrevocably linked; if we wanted art, we had to endure artists. In the new era, we can perhaps reconfigure. Globalization is providing answers to this dilemma in other fields, and will expand the possibilities in art as well. Art production in China, Turkey, South Africa, and elsewhere is up, and could easily meet the increased demand in the U.S. There is plenty of product out there already, and we can import whatever more we need. We've stopped making pencils, automobiles, and appliances in America. Why are we still making art?

Even though cultural issues played such a large role in the recent presidential election, cultural producers have failed to fully understand the long-term implications of this shift, and have been slow to respond to the new imperatives. In this new era, we must stand behind our fundamental principles and beliefs. We either believe in the free market, or we don't. If we do, we must embrace it completely, and stop making exceptions. For the Market, everything; against the Market, nothing. And that must include artists.

For those artists who embrace the market and reliably produce attractive consumer goods, no change is necessary. Let 10,000 flowers bloom. But for those artists who cannot make it in the market, and who see their role as being resistant, or even dissident, a rude awakening awaits. Let me be very clear: I am not advocating (as have some of my more Malthusian colleagues) either euthanasia or incarceration for these hapless souls. God knows we do not need the specter of more "detainees" at this juncture.

All I am saying is give the market a chance, and stop artificially propping up artists who can't or won't make it in the market. And that means eliminating art subsidies of all kinds, including "private" foundation support for nonprofit "artist-centered" or "alternative" organizations. Without those subsidies, these small community-based organizations will not long survive, and will go the way of free medical clinics, low-income housing, and other social welfare programs. And without their support and encouragement, independent "artists" will eventually disappear. Some of them may find gainful employment. I, for one, would support retraining centers for these people (as long as these are faith-based operations, of course).

The current system of "support for the arts" is really just another tax on the wealthy—an insidious marriage of the "culture wars" and class warfare, to make the rich feel guilty about their success. Once again we say, let the free market work: collectors, yes; alternative spaces, no. When we subsidize private companies, that's *investment*. When we subsidize public entities outside the market, it's *welfare*. In the new Ownership Society, we say "If you can't own it, don't support it!"

If the market was allowed to operate as God intended, without government regulation (or private foundation meddling), there would be no more need for theoretical discussions about relative values, or in-depth critical analyses. In a free market, consumers determine all values, and the majority rules. The artists who sell the most work for the highest prices are the best artists, period.

It has been argued in the past that alternative artist-centered spaces do serve a worthwhile function within the market, providing a sort of semi-pro "farm team" for the commercial galleries and museums. But these days the farm teams are at Columbia and Hunter, or the Art Center and Cal Arts, where young artists are less likely to pick up bad (nonprofit) habits. We should endeavor to close the gap between education and gainful employment. As the economy changes, even the marginal benefits of artists are disappearing. We no longer need artists for gentrification purposes, since it's easier just to move the lawyers into the lofts straightaway.

Let's face facts: non-commercial American artists have been an embarrassing anachronism for years now. They somehow manage to offend both faith and reason, mocking religious devotion and questioning scientific certainties. They sit out on the edge of society in their thrift-store chic and their precious eyeglass frames and snipe at everything we hold dear. They flaunt their "diversity," as if this was a positive value rather than a perversion. And they continue to ask uncomfortable questions that the rest of us have answered definitively long ago. If these "artists" want support and encouragement, let them go back to Europe, or Canada! Or let them go to Cuba, and see how they fare under their beloved Fidel. He loves "artists."

We will of course still need the full array of art managers—curators, dealers, consultants, etc.—many of whom will be more than pleased not to have to deal with "artists" anymore. And we all know the art market would function much more smoothly without "artist" interference.

In this post-9/11 era, things are becoming clearer ever day. Before long, everything will be revealed in black and white. Either you're for God and freedom and Bush and the market, or you're for the terrorists. Each of us must make a choice, and then resolutely defend it. A few dissident artists asking questions can be dangerous for us all, since it threatens the certainty on which our safety depends. If you want to help, please, support our troops, not artists.

Reprinted from David Levi Strauss, "Considering the Alternative: Are 'Artists' Really Necessary? (A Reasonable Proposal)," *Brooklyn Rail*, April 2005, p. 17, available online at http://thebrooklynrail.org/arts/april05/railingopinion.html.

DAVID LEVI STRAUSS We ended our last conversation with Pynchon's warning that if they can get you asking the wrong questions, they don't have to worry about the answers anymore. So I'd like to begin this time by trying to ask some better questions about art and pedagogy. Art schools and MFA programs are currently inundated with applicants and overflowing with graduates. Why do so many young people today want to be artists? How does the fact that almost all young artists are now university-trained effect the kind of art they make? And, how do you teach artists?

DANIEL JOSEPH MARTINEZ Those are big questions, and they overlap. It is a curious thing that there is such a large population of art students currently in graduate schools. I wonder if the popularity of art school suggests that the way you become an artist is by going to school. And I wonder if this popularity is actually a result of the production of culture in the museums and galleries, and the way the marketplace functions in terms of the crisis of meaning in the representation of ideas that we have talked about before. Is it possible that there has been a trickle-down effect, in the sense that art is seen as entertainment, as something that is popular, acceptable, having to do with leisure time and life-style choices? Art has less to do with the mining of meaning and the representation of ideas that have the potential to be transformational, to effect or challenge people, to call things into question. It seems to me that when things become this popular it is because they have become fashionable. And when something becomes fashionable, it is easy. So people go to graduate school and everyone comes out an artist.

STRAUSS I think that's part of it, but I think there is something else going on as well that is more fundamental, and potentially more far-reaching. My daughter is 16-years-old, and she and her friends talk about going to art school, not because they think it is fashionable, but because, in the midst of everything else that is going on in the world, art is the one thing they care about (in my daughter's case, it's art and writing). It is the one thing that is different from the normative spiel of consumerism with which they are continually being bombarded.

MARTINEZ I don't know your daughter well, but just from knowing you and your family, I think she might be an exception. She has been sensitized to the kind of motivation you talk about. Perhaps this is my cynicism to some degree, but having traveled through many art schools and MFA programs, and visiting students' studios and talking to them,

and looking at what they are producing, I wonder if that's what they're looking for.

STRAUSS That leads to the next question. All of these young artists are there in their studios, together, making art. How does this influence the kind of art being made?

MARTINEZ I'm very excited being around students, but I'm often disappointed at the same time. A lot of the work that I see is trying to tackle problems and questions that are fundamentally attached to their success in the market. The work is likable, but I see less experimentation, less risk, and I see less work that is clearly trying to set itself apart from the general tone of work being made. I guess I feel that a lot of the work I see is very safe, very generalized, and consequently much of it is uninteresting to me. When you do see somebody who is working on a particular question in the work, you can tell what they're thinking about, their motivations and behavior, and that they're thinking about something much greater than themselves or their individual success. I don't know if this is entirely clear....

STRAUSS Let's talk about what you do, in your own situation. In our earlier conversation, we said that the only effective antidote to fundamentalism is education, but in the current political climate we have to be clear about what we mean by education, since all of these terms are being redefined. George Bush was the "education president" before he became the permanent war president. Laura Bush is for education. Lynne Cheney is for education. So, what is different about your kind of education, your pedagogical practice? When you talk about teaching, you are the most idealistic about what can happen. So, what do you try to do as a teacher, teaching artists?

MARTINEZ I think we both believe that human beings should be in a constant state or process of education. One should always be involved in improving oneself and never rest from that. This is distinct from the "no child left behind" approach, where there is a quantification of education through testing and mandates in order to reach a "democratic" mean. I have heard many, many teachers complain about the manipulation of test scores, the rules and regulations attached to funding, and the privatization of education here in Texas. (Note: Martinez was an artist-in-residence at ArtPace in San Antonio at the time of this conversation.) How do you clarify the difference between this and genuinely exciting people about wanting to be educated? People have eyes and they think they can see. They don't think they have to train their eyes to see. They have ears and therefore can hear. They don't have to train their ears to hear. It's as if things were naturally assigned to them to be able to exist in the world.

This is a difficult question, David. I have thought about this a lot. I understand it better in my heart than I can explain it. When we talk about education and the potential

Reprinted from David Levi Strauss and Daniel J. Martinez, "Teaching After the End," *Art Journal*, Fall 2005, p. 28+. "Teaching After the End" was the last of three conversations between David Levi Strauss and Daniel J. Martinez, commissioned by Patricia C. Phillips, editor-in-chief of the College Art Association's *Art Journal*.

1 See especially *Culture in Action:
A Public Program of Sculpture Chicago*,
curated by Mary Jane Jacob (Seattle:
Bay Press, 1995), with essays by Jacob,
Michael Brenson, and Eva M. Olson; *The
Things You See When You Don't Have
a Grenade!* Daniel Joseph Martinez
(Santa Monica: Smart Art Press, 1996),
with writings by David Levi Strauss, Coco
Fusco, Mary Jane Jacob, Susan Otto,
Victor Zamudio-Taylor, and Roberto
Bedoya; *Points of Entry: The Three
Rivers Arts Festival in Pittsburgh,
Pennsylvania* (Pittsburgh: Three Rivers
Arts Festival, 1997), with essays by David
Levi Strauss, Mary Jane Jacob, and
Roberto Bedoya; and *Conversations
at the Castle: Changing Audiences
and Contemporary Art*, Arts Festival of
Atlanta (Cambridge, MA and London:
The MIT Press, 1998), edited by Mary
Jane Jacob with Michael Brenson.

2 Deep River was an artists' exhibition
space at 712 Traction Avenue in
downtown Los Angeles that operated
from 1997 to 2002.

for what can happen in the classroom, there is something miraculous, and organic, that can happen. Education is based on a series of relationships with students who are willing to place themselves in positions of trust. And the trust between a group of students and their teacher is that there is an exchange taking place; there is information that is being shared. I don't know if you can teach anyone how to be an artist. I think you can expose them to ideas and help to bring them through different processes, to open themselves to ideas, to augment their behavior and thinking patterns to allow them to be curious about the world they live in and to be problem-solvers. I have a genuine and radical idealism about what can happen in the classroom. This is not speculative. I have been teaching for 15 years and I have observed this. You can change the course of individual lives.

STRAUSS One on one, one by one. I think that one of the principle reasons people are drawn to art school is that it is an ontological haven for young artists and writers. It is a safe place where attention is lavished on you by older, more experienced practitioners, and where you can find a community of people that you can work with and trust. It is a platform on which to build a laboratory of practice, both social and artistic.

You were very involved with site-specific public art and community-based initiatives in the 1990s with Mary Jane Jacob and others.[1] Do you think that when those activities were no longer possible, for many reasons that we have discussed before, do you think that some of those same aspirations were transferred onto your teaching?

MARTINEZ That is an astute observation that I would amplify one degree further. As this extremely active social space began to dissipate, or the ability to be effective in this arena dissipated, I also started to notice that there was a community or a constituency that was consistently left out of the discourse, that needed to have attention paid to them, and that group of people was artists. That's one of the reasons that Deep River[2] was started. I saw that energy was going out to many different areas and that it was necessary to devote attention to this. But the community that actually needed some attention, love, understanding, and compassion was that community around and for artists. I think that this connected strongly with teaching. I often say that the last place for radical politics in the United States is the classroom. Even in the current climate, this can happen because of the qualities you identified: community, safety, trust, exchange. This can occur even in the most rigid of times and environments. Perhaps, like your daughter, people want to go to art school simply because it is worth their time and energy.

STRAUSS Right, this is the kind of place where the things she is interested in—free inquiry, critical thinking, expanding boundaries of thought and experience—are encouraged.

She doesn't see those things being encouraged in other places. It is important, given the current political situation in this country, to remember what is at stake politically in different models of education. In the last interview he did before he was killed, Pier Paolo Pasolini said that "Power is a system of education that divides us into the subjugated and subjugators…. A single educational system that forms us all, from the so-called ruling classes to the poor."[3] So, it is not like you can have education or not. We're all being educated under the terms of power![4] To put in place a different educational model that is not based on this, but on something else—creativity, respect, mutual aid—is an enormous task. But at least it is one area where it is still possible to work to change things and to ask these larger questions. At the classroom or studio level, it is still a place where things can happen—a utopian situation, a temporary autonomous zone.

MARTINEZ This is my dilemma. I believe absolutely in that utopian space, that autonomous zone that you describe. At the same time, there is still a degree of protective cynicism. But you help people, regardless. If people ask you for help, you help them.

STRAUSS The reason you keep returning to this model of the classroom (as a place to reclassify and make a new valuation) is because it can act as a free zone. You can work there. But when you get outside the classroom or studio and into the machinations of the larger institution, then you are talking about something else. You're talking about, for instance, the scam. These young people (or their parents) are paying large tuitions, and are being told that they will go out there and make money and art. But the truth is that most of them, including many of the really good ones, won't be able to do this.

MARTINEZ Yes, they're being told lies. I'm described as being very tough in the classroom. I am very candid with students in my descriptions of circumstances that I observe. So people see that as being very tough. The reason I am like that is, well, why should we be afraid to engage in the pragmatic realities of the world we exist in? Why should we shy away from this? Why don't we deal with it and try to evolve into artists who have the capacity to not lose our poetry—not lose the subtlety, not lose the sublime nature of the construction of meaning that we desire? Can we not protect that and still have enough self-knowledge to acquire the armor required to work in what is often a genuinely hostile environment? That's what we're talking about. You have young, sensitive artists at the most difficult time of their lives, and people don't tell them the truth. My job is to prepare them, to help them mature, and to provide them with the physical and intellectual tools to become an artist.

3 From an interview published in *Tuttolibri* November 8, 1975, a few hours before Pasolini died. Quoted in Andrea Zanzotto, "Pedagogy" (translated by Beverly Allen), in *Pier Paolo Pasolini: The Poetics of Heresy*, edited by Beverly Allen (Saratoga, CA: Anma Libri, 1982), p. 30.

4 "Over here, Imagination. Over there, Power," wrote Herbert Muschamp about the conflict between architects and corporate developers over plans for rebuilding at Ground Zero in Lower Manhattan. "Power, Imagination, and New York's Future," *New York Times*, October 28, 2001.

5 "Joseph Beuys and the Artist as Activist," a collaboration between the Three Rivers Arts Festival and the Warhol Museum in 1996, with contributions by Pamela Kort, Ann Temkin, Ronald Feldman, Richard Demarco, David Mendoza, Fred Wilson, Daniel J. Martinez, Faith Wilding, and Gregg Bordowitz. Quoted in David Levi Strauss, "Coming to the Point at Three Rivers: Art/Public/Community, What Do Artists Want?" in *Between Dog & Wolf: Essays on Art and Politics* (Brooklyn: Autonomedia, 1999), p. 138.

STRAUSS At the Joseph Beuys symposium held at the Andy Warhol Museum in Pittsburgh a few years ago, you talked about Beuys' ongoing relevance, and you said that Beuys didn't say to learn how to cut a piece of wood first. He said to have an idea first. Once you have an idea, the rest is simple.[5]

In times past, artists didn't receive liberal arts educations. They were taught their trades as artisans in commercial workshops and in apprenticeships. Liberal arts were not bound to the necessity of learning a trade. It occurs to me that today many art schools (and also curatorial programs) are moving back to that older model. They are really like trade schools, specialized training for artists. And there is an argument to be made for that. There is so much to know about the trade in order to make a living, or even survive in the field. So, why shouldn't art schools just concentrate on this, and forget about "ideas?"

MARTINEZ I'm not suggesting that artists shouldn't learn how to draw or to use a camera or other tools of the trade. But if a person has no capacity to engage their imagination, and no critical perspective with which to contextualize the fruits of that imagination, then they have no sense of responsibility, no generosity, no respect, no discipline, no way to know how to take ideas and put them to use, and it doesn't matter how great their exposures are, or how beautiful the colors are, or how sharp the 45-degree angle is on the piece of wood they just cut. It won't make any difference. Man Ray said "There are lots of people out on the streets who are brilliant technicians, but not one of them is an artist." There are many people who are technically good at what they do. But can they make art? Can they make works that actually effect people, that change their lives, that burn a hole into the soul, that cannot be escaped in your daydreams or nightmares, that become a part of you?

STRAUSS Maurizio Cattelan was overheard talking to friends at one of his openings, apologizing for his phenomenal success in the art market by saying "I am just really good at playing the game." So, if it is a game, shouldn't all of one's resources be dedicated to learning to play that game well, and forget about getting a liberal education? If you just want to learn how to play the game, the best thing you can do is to play it a lot. You don't need to go to school for that. If that's what you want, you should do what Jeff Koons did and work on Wall Street to train, or go get an MBA, not an MFA. Again, we come to this question of the remainder. After we have come to the end and everything is finished, what has been left out of the account? Shouldn't we just learn to play the game well, to win? What else is there?

MARTINEZ I am not sure that we can or should teach artists to want to be successful in the marketplace. A possible position now is to completely reject it—to discover other ways to work that can sustain one over a long period of time. Even if someone never achieves success in the market, there

are still ways to construct and develop a practice that is as dedicated and engaged as humanly possible. It would require a new sensibility, and a new mental space to exist in. External validation from shopkeepers would no longer be sought. This playing of the game bores me to tears. What would be the reason to get up each day? Just to play the game?

STRAUSS If artists are not going to do this, how will they make a living? I'll tell you how: they're going to teach.

MARTINEZ That is the current model. I tell my graduate students to not even talk to me about teaching. I won't even discuss it with them, because I don't think that someone who graduates in June should be allowed to start teaching in September! In three months they have somehow gained the experience to move from being on one side of the classroom to the other? I have yet to meet an individual who can actually do that.

STRAUSS I agree. I think it's a bad practice. In fact, I'm not sure that anyone should teach until they are over 50. Or even over 60.

MARTINEZ You go farther with this than even I do! Let's say that an individual should have a minimum of ten years in the field and actually have created a significant body of work about which they can be articulate. They have to have experience, David! They have to have something to show for what they think and what they say they do. It cannot be hypothetical. But most of the people teaching in art schools are very young. They have just gotten out of graduate school, having completed their graduate thesis exhibit and perhaps one other show. And that's it.

STRAUSS In that way, it reflects the market. The market usually only rewards the hares—those who are fast out of the gate. I find that I am increasingly interested in the tortoises, who take a long time to build a practice, and a body of work. The market doesn't generally reward longevity and certainly not slowness. In that way, art education reflects the rest of consumer society, where obsolescence is actually a value. Get them right out of art school, use them up, and get in the next generation, fast. It's a way to keep artists under control.

MARTINEZ But that's not a sustainable system.

STRAUSS Well, as long as people are streaming out of art schools it is. There's a surplus of artists.

MARTINEZ The net result of this system is banality. I would rather see people who are making work that is riddled with error and failure. At least they are risking something in order to aspire to something beyond themselves. Without that, you have an art world that is like McDonald's and Starbucks: uniform product. I am discouraged by this part of art, but I am

encouraged by students who are risking everything in their lives to be in school, to be students, and who aspire to really learn.

STRAUSS The people who teach in these burgeoning art schools are artists who can be divided into two groups: those who see teaching as a necessary evil, a job that enables them to continue to make art; and those who see teaching as an integral part of their work. Of course, these attitudes coexist and are in continual conflict for most artists who teach. But when I think of these two approaches to teaching, the extremity of the latter tendency is represented by Joseph Beuys, who said that "to be a teacher is my greatest work of art." This is an extraordinary statement coming from one of the most important artists of the twentieth century.

MARTINEZ My immediate response to Beuys' quote is, well, of course. His significant contribution was not what he made, but what he was able to pass on to others. Maybe it is a legacy, maybe it is a capacity to effect change in others. It is like a catalyst that just continues to multiply.

STRAUSS More than anything else, Beuys wanted to be a catalyst for change, a transformative agent.

MARTINEZ Absolutely. And that is the hope of teaching. Maybe, ultimately, the exchange that occurs with one student is more important than any object that can be made. Maybe the intangibility of the experience that takes place between students and teachers, the unquantifiable space that develops in the sharing and questioning of ideas, expanding the parameters of our intellects and our capacity to maintain a position of modesty while aspiring to great challenges, is the thing. I completely agree with Beuys. Perhaps everything that I have made is basically meaningless, and the only thing with genuine significance is that time that I spend in the classroom, the time that I spend with students. Oddly enough, this may be the role that has been crafted out of this idea of what it means to be an artist. I believe this for myself and I think that many other artists and teachers would agree. It is an amazing statement that Beuys makes. It is a statement of extraordinary generosity that, for me, is very inspiring. Yes, we have to take care of ourselves and our family, but there is another responsibility beyond who we are individually. It is especially salient in the United States, where the maximum degree of individualism has been forged at the expense of community, relationships, and responsibility to anything other than oneself.

STRAUSS And that's the danger in the kind of art school that only focuses on what you need to survive as an artist. That kind of specialization is part of this larger flight from, and denial of, the social. The things that matter about art and literature are not specialized, but are common and social, and you have to pursue them with other people. We are

talking about art and literature that speaks to us about things that concern all of us, not just specialized elites. I don't want artists and writers to become trained specialists producing high-end consumer goods for a select group of collectors.

Maybe the best way to counter the uniformity in recent art production (and the retreat into art about art) is for artists and writers to get broader educations (that provide information of general cultural concern) and experience.

MARTINEZ I agree, and would relate this with something you mentioned earlier. When students are coming out of schools and they are not encouraged to be participants in the marketplace, what other recourse do they have but to teach? Alternatively, what if they are discouraged from teaching right away and are taught that being an artist requires the ability to integrate oneself into the world? This means that they have to figure out how to make a living outside of the art market and teaching. It is possible to do this. Long before I even considered teaching, it was possible to get a job, to make a living, and to continue to make one's work.

STRAUSS That's a good point. It's been made out to be impossible, today. But I don't think it is. So you're saying, Artist, get a job!

MARTINEZ There are many ways to make a living and still be an artist. The competitiveness of the market, the current role of curators, the star system, and the overall Saatchification of the art world these days have to be taken into consideration, of course. But perhaps we have to come up with new, much more subversive means by which to integrate ourselves into these systems and structures. Yes, we do! But basically if we tell artists that they have two options: that they can participate in the marketplace or become teachers, then I think we have failed them. We have failed in our ability to engage our imagination to find ways to exist in the social space that we're describing.

We exist within a mono-structure. The arbitration of taste is highly centralized. P.S. 1 has a cattle-call for "Greater New York": hot new artists wanted. So you send in your slides and hope someone likes your work. There is such an abundance and over-saturation of artists in the field today, that your work is reduced to a cattle-call. The field cannot sustain so many individuals, but we continue to add more artists than there ever were, and they all have graduate degrees. And now there is discussion in our field that there should be Ph.D. programs for artists! There is a correlation being made, that I think is incorrect, that the gathering of degrees and time spent in institutional circumstances are the markers that qualify one as an artist. Can you imagine a Ph.D. program in studio art?

STRAUSS It's the logical extension of the scam—the pyramid scheme that runs on desire from below and greed from above. It's the same thing that happens with "Creative

Writing" programs. Most people won't be able to do it. Most will be able to make a little art for a little while and then teach. And it starts all over again. The few people who are able to make a living making art will help to support the extremely small number of artists on top who are making a fortune. Just like in the rest of Bush America.

MARTINEZ But if you have individuals who have only made a small amount of art and who turn to teaching, it seems to me that you have a flawed model. They're modeling a pattern based on themselves. It is a self-replicating system of failure. Artists teach and their students graduate, make a little art, and then teach. To perpetuate this is ludicrous.

STRAUSS But Daniel, you just described the logic of consumerism. That's how it works. You sell a product that doesn't work or deteriorates quickly, so consumers will throw it away and buy another one, and it goes around and around in a circle. Making something that works well is bad business.

MARTINEZ It is just wrong. I am a consumer like everyone else, but there has to be a point when consumption ends and one has to genuinely invest oneself in life. It's not about what you purchase, but about human interaction, building something with other people, and creating a social space.

STRAUSS What do you try to teach, Daniel? Give me a list of five things that you try to teach.

MARTINEZ I am not sure that the order means anything, but it is interesting to see where things come out. The very first thing on my list is discipline. Next is criticality. And attached to that with a hyphen is curiosity. Third on my list is generosity, and attached to that is responsibility. Number four is agency. Five is autonomy. And there is a sixth: a system of respect.

STRAUSS You are so succinct! Single word directives. And discipline is first.

MARTINEZ In order to make art, one must have discipline. And discipline is connected to motivation, as well as to individual philosophy.

STRAUSS I agree. The first thing on my list is to teach students about the labor of art, and about the place where labor and pleasure come together in one's work: hard work and the pleasure of building a practice. If they don't learn how to work and don't get pleasure out of it, they won't survive as artists and writers. The next is to encourage them to fail, over and over again. You will never make anything of real value unless you are willing to make a lot of bad work and to fail many, many times. You don't have to show these failures to anyone. In fact, like Burroughs said about early

writings, you might want to "tear it into very small pieces and put it into somebody else's garbage can."[6] But if you aren't willing to fail, you can never get better. Actually, our lists are very similar. Next, teach them how to scrutinize and criticize their own work—to be able to get outside of it and see it as if it was made by someone else. Perhaps this next one is more relevant for writers: to direct them to *sources* that they can trust and draw on for the rest of their lives. And the final one is to continually raise the stakes—to ask bigger and better questions.

[6] William S. Burroughs, "The Name Is Burroughs," in *The Adding Machine: Selected Essays* (New York: Seaver Books, 1985), p. 8.

Coco Fusco
A Room Of One's Own
Presented at P.S. 122, New York City
September 28 to October 1, 2006

Coco Fusco presents the U.S. premiere of her multi-media performance about the expanding role of American women in the "war on terror." The performance consists of a combination of a PowerPoint presentation (which the military uses for interrogation debriefings) and a simulated live feed from an interrogation room where a male prisoner is being prepared for interrogation.

To prepare for this role, Fusco convinced retired military interrogators to immerse her and six other women in the training courses, "How to Survive Hostile Interrogation" and "How to Interrogate." Fusco portrays a female graduate of military intelligence school and a seasoned interrogator who briefs the audience on the rationales for using various forms of psychological intimidation as a tactic for extracting information from military prisoners. The presentation stresses how a career in military intelligence represents great opportunities to emancipated women of the twenty-first century who seek to follow in the footsteps of prominent women in the defense department, such as Secretary of State Condoleezza Rice and former Brigadier General Janis Karpinski.

The work premiered in Europe at the Victoria and Albert Museum, London, June 30, 2006. A fifteen-minute version was showcased at The Kitchen as part of PERFORMA, 2005.

Participants in *Who Cares* were invited to submit socially-responsive and timely public art projects as an extension of the dinner party conversations. Creative Time is pleased to present the following four for public exhibition in the fall of 2006.

Michael Rakowitz
Return
Storefront, 529 Atlantic Avenue,
Brooklyn, New York
October 1 to October 31, 2006

For *Who Cares*, Michael Rakowitz will re-open Davisons &
Co., based on the import-export business his family operated
in Baghdad, and that his grandfather opened in New York
when the family was exiled from Iraq in 1946. Located in a
storefront on Brooklyn's Atlantic Avenue, the project will
provide free shipping for the Iraqi diaspora community, as
well as other families who have military personnel stationed
in Iraq, thereby creating a space where human concerns
on both sides of the conflict can meet.

In this incarnation, Davisons & Co. will also attempt
the importation of Iraqi dates and other products, offering
them at prices that are clearly the result of prohibitive import
charges and restrictions that remain years after the Gulf
War embargo was lifted. This absurd situation, three years
after the declaration of "Mission Accomplished," has kept
Iraqi products from legally entering the United States,
with severe repercussions for the previously thriving, world-
renowned date industry in Iraq that produced over 450
different varieties.

The storefront at 529 Atlantic Avenue will operate for
one month and has been generously donated by Art Assets
and The Atlantic Assets Group.

Mel Chin
9-11/9-11, Chile/U.S.A., 2006
Film screenings in New York City / Santiago / Houston
October 2006

September 11, 2001—New York City. September 11, 1973—Santiago. The terrorist attacks on the twin towers of the World Trade Center in New York forever scarred the trust of the American people, while the Chilean military coup of President Salvador Allende, that occurred on the same day twenty-eight years prior, ushered in seventeen years of autocratic rule that left more than three thousand dead and countless victims of torture. In this dark and intensely compelling, animated new film, *9-11/9-11*, Mel Chin creates a tale of two cities, a tragedy of two times, weaving a story of love and hope wrecked by overt and covert manipulations of power. *9-11/9-11*, presented as part of a global dialogue about the human impact of these collective traumas, is presented by Creative Time and will be shown in October in Santiago, Chile (Centro Cultural Palacio La Moneda, Santiago), New York City (location TBA), and Houston (The Museum of Fine Arts with support Ann W. Harithas). See http://www.911-911movie.com for more information.

Jens Haaning
Arabic Joke
Posters in various locations, New York City
October 2006

Known for his minimalist conceptual art projects that focus on the feeling of dislocation, Danish artist Jens Haaning frequently invokes social borders in his art, depicting and emphasizing the exclusion of marginalized groups. Through open-ended representations of foreign cultures fused with symbols of the majority culture, Haaning makes the artwork's effect on the viewer its primary focus.

For *Who Cares*, Jens Haaning will produce a number of posters featuring a clichéd joke written in Arabic script. Distributed without explanation as street posters in non-Arab communities, the typical joke is legible only to those who can read Arabic, and may appear menacing to those who can't read it, evoking feelings of fear and confusion.

While he has exhibited only rarely in the United States, Haaning has been very active in Europe over the past decade, as Denmark and other European countries have struggled to integrate growing immigrant populations and to combat populist, often racist, campaigns against them. Haaning's simple gesture highlights the divisions revealed during a year marked in Europe by violent riots among France's immigrant youth and the furor over Danish satirical depictions of the Prophet Mohammed, alongside the renewed American struggle with immigration policy and the hostilities and fear directed toward those of Arab descent in this country, since 9/11 and the continuing military conflicts with the Middle East.

Translation of poster
A Grain of Wheat
When Guha lost his mind, he started to believe that he was a grain of wheat. His biggest fear was that a chicken would eat him. His wife became tired and persuaded him to see a doctor, which he did. The doctor sent him to a mental hospital. After a short while, it seemed as though Guha had recovered and regained his sanity. His wife fetched him from the hospital and walked him back home. On the way home, Guha saw some chickens walking on the road. He became very frightened and tried to hide behind his wife. The wife could not understand what had got into him as they had just left the hospital and shouted at him: "What the hell do you think you are doing? Don't you understand that you're not a grain of wheat anymore?" Guha replied in anguish, "It doesn't matter what I think! The important thing is whether these bloody chickens understand that I am not a grain of wheat."

171

Participant Biographies

DOUG ASHFORD is an artist, writer, and assistant professor of art at The Cooper Union for The Advancement of Science and Art in New York. He has helped produce exhibitions, public projects, articles, and seminars on an international level for a wide variety of institutional and independent contexts.

JULIE AULT is a New York City-based artist and writer who independently and collaboratively organizes exhibitions and multiform projects. Ault views exhibition-making as a medium and sometimes assumes a curatorial role as a form of artistic practice. In 1979, Ault cofounded Group Material, the collaborative that until 1996 produced installations and public projects exploring interrelationships between politics and aesthetics. Her recent work includes *Points of Entry* (2004), a permanent art project for Powdermaker Hall, Queens College, City University of New York, and *Social Landscape and Economies of Poverty* (2004), a collaboration with Martin Beck at the Weatherspoon Art Museum, Greensboro, North Carolina. Together with Beck, Ault also creates exhibition designs, including *X–Screen: Film Installations and Actions of the 1960s and 1970s* (2003), Museum Moderner Kunst, Vienna. Ault and Beck are the authors of *Critical Condition: Selected Texts in Dialogue* (Kokerei Zollverein| Zeitgenössische Kunst und Kritik, Essen, 2003). Ault is the editor of *Alternative Art New York, 1965-1985* (University of Minnesota Press and The Drawing Center, 2002) and *Felix Gonzalez-Torres* (Steidl/Dangin Publishers, Göttingen, 2006). Ault has taught on a visiting basis, including at the Center for Curatorial Studies at Bard, Annandale-on-Hudson; Critical Studies, Malmö Art Academy; Ecole supérieure des beaux-arts, Geneva, and University of California at Los Angeles.

GREGG BORDOWITZ is an artist, an activist, a writer, and a film- and video maker. Bordowitz made his first videotape in 1986, when the AIDS activist movement was exploding. He spent seven years documenting the movement, working with the collectives Testing the Limits and DIVA TV. He was involved with ACT UP from its beginning. His films— including *Fast Trip Long Drop* (1993), *A Cloud In Trousers* (1995), *The Suicide* (1996), and *Habit* (2001)—have been widely shown in festivals, museums, and movie theaters and broadcast internationally. His writings have been published in anthologies such as *AIDS: Cultural Analysis, Cultural Activism*; *Queer Looks*; *Uncontrollable Bodies*; and *Resolutions*, and numerous publications and journals including *The Village Voice*, *frieze*, *Artforum*, and *October*.

He has received a Rockefeller Intercultural Arts Fellowship and a John Simon Guggenheim Memorial Fellowship, among other grants and awards. In addition to being a member of the faculty of the Film, Video, and New Media department at the School of the Art Institute of Chicago, he is on the faculty of the Whitney Museum Independent Study Program. His book—titled *The AIDS Crisis Is Ridiculous and Other Writings 1986-2003*—was published by MIT Press in the fall of 2004. For this recent collection, Bordowitz received the 2006 Frank Jewitt Mather Award from the College Art Association.

TANIA BRUGUERA produces political artworks through installations and performances. Recently she has incorporated the idea of behavior and social conduct as an artistic media. In January 2003 she opened Arte de Conducta, an artistic-pedagogical project in Havana. Her work has been shown at several international exhibitions like documenta 11 and biennales such as the 49th and 51st edition in Venice, the V and VII in Havana, 23rd in Sao Paolo, among others. She had solo shows at the Kunsthalle Wien, Casa de las Americas, and Museo de Bellas Artes. In 1998 she was a Guggenheim fellow and in 2000 she was awarded the Prince Claus Prize. Bruguera was featured in *Performance: Live Art Since 60s to the Present* by RoseLee Goldberg (Thames and Hudson, Ltd., London; Abrams Books, New York, 1998), considered by many to be the definitive written history of performance art. Her work has been featured in *The New York Times, Newsweek, The Los Angeles Times, The Chicago Tribune, Art News, Flash Art, Art Nexus* and *Kunstforum*. Bruguera is a 1992 graduate of the Instituto Superior de Arte de la Habana and received her MFA from the School of the Art Institute of Chicago in 2001. Currently she is part of the faculty at University of Chicago.

PAUL CHAN is an artist living in New York City.

MEL CHIN is an artist known for the broad range of approaches in his art, including works that require multi-disciplinary, collaborative teamwork and works that conjoin cross-cultural aesthetics with complex ideas. One of his most well-known works is *Revival Field*, an ongoing collaborative project which tests and develops the capacity of hyper-accumulator plants to remove toxic metals from contaminated soil. He is the recipient of many awards including Artist's Projects/New Forms, National Endowment for the Arts Fellowships in 1988 and 1990, a Penny McCall Foundation Award, a Pollock/Krasner Foundation Fellowship, and the Cal Arts Alpert Award in the Visual Arts. He exhibits extensively in the United States and Europe and has had several one-person exhibitions, including *Directions: Mel Chin* at the Walker Art Center, Minneapolis, Minnesota and *Degrees of Paradise* at Storefront for Art and Architecture, New York and most recently at the Station Museum, Houston, Texas. Chin received a BA from Peabody College in Nashville, Tennessee, in 1975 and an honorary doctorate

from the Rhode Island School of Design in 2006. He lives in North Carolina.

DEAN DADERKO is a curator based in New York. From 2000 to 2005 he ran Parlour Projects, a non-commercial space in Williamsburg, Brooklyn, that presented solo exhibitions in all media with specific attention given to work that was performative, interactive, and experimental. Exhibiting artists included: Andrea Geyer, Forcefield, Karin Campbell, Allora & Calzadilla, and Inhwan Oh, among others. He was a contributing curator to the exhibition *24/7: Wilno-Nueva York (visa para),* presented at the Contemporary Art Center, Vilnius, Lithuania. He has also presented exhibitions at Art in General, New York, and Artists' Space, New York, as well as *Can I get a witness?* at Longwood Art Project, Bronx, New York and *If a cat gives birth to kittens in an oven, are they kittens or biscuits?* at Roebling Hall, Brooklyn, New York. He has contributed writing on Allora & Calzadilla to their most recent monograph, and to publications by The Studio Museum in Harlem, P.S. 1 Contemporary Art Center, and Gay City News.

PETER ELEEY is Curator & Producer at Creative Time. While at Creative Time, he has organized a diverse range of artworks and events with artists including Cai Guo-Qiang, Jenny Holzer, Jim Hodges, Mark Titchner, Zhang Huan, and Marjetica Potrc, among others, and the exhibitions *The Dreamland Artist Club* (2004-5) with Stephen Powers, *The Plain of Heaven* (2005), and *Strange Powers* (2006) with Laura Hoptman. As a critic, he is a regular contributor to London-based *frieze.*

COCO FUSCO is a New York-based interdisciplinary artist and writer. In 2003, she received a Herb Alpert Award in the Arts for her work in film, video and multi-media. Since 1988, she has performed, lectured, exhibited, and curated internationally. Fusco's performances and videos have been included in the Whitney Biennial, Sydney Biennale, Johannesburg Biennial, Kwangju Biennale, the London International Theatre Festival, and the National Review of Live Art. Her 1993 documentary about her caged Amerindian performance with Guillermo Gómez-Peña, *The Couple in the Cage*, has been screened in over two hundred venues around the world. Her video, *a/k/a Mrs. George Gilbert*, was selected for the 2004 Shanghai Biennale, the Margaret Mead Festival, and the Museum of Modern Art's Documentary Fortnight. She is currently developing a series of videos and performances about the role of female interrogators in the "war on terror." Her latest documentary, *Operation Atropos*, about her training with retired U.S. Army military interrogators, was recently described by the *New York Times* as " reality television with the cracks between reality and artifice showing. It's in the cracks, Ms. Fusco suggests, that the political truth is revealed."

Fusco also recently curated a comprehensive exhibition on racial taxonomy in American photography for the International Center for Photography, *Only Skin Deep: Changing Visions of the American Self*. Her writing has appeared in a wide variety of publications, including the *Village Voice, Los Angeles Times, Art in America, The Nation, Ms., frieze, Third Text*, and *Nka: Journal of African Art*, as well as in a number of anthologies. She is the author of *English is Broken Here* (The New Press, 1995) and *The Bodies That Were Not Ours and Other Writings* (Routledge/inIVA, 2001). She is the editor of *Corpus Delecti: Performance Art of the Americas* (Routledge, 1999) and *Only Skin Deep: Changing Visions of the American Self* (Abrams, 2003). Fusco is an associate professor at Columbia University.

CHITRA GANESH is an artist based in New York. Ganesh's drawings and installations have been exhibited internationally including Toronto, Brazil, Italy, India, London, and Gwangju. In New York, her works have been shown at the Queens Museum of Art, Brooklyn Museum, Bronx Museum, Momenta Art, Bose Pacia Modern, Apex Art, and White Columns, among others. Ganesh's work has been reviewed in *Time Out New York, Art Asia Pacific Magazine, India Today*, and the *New York Times*. In 2003, Ganesh was a featured artist in *Velvet Park* magazine and chosen as one of *OUT* magazine's top 100 people of the year. In 2004, she received the Astraea Visual Arts Award, and was awarded an LMCC Workspace. In 2005, she was awarded a New York Foundation for the Arts Artists' Fellowship. Additional awards and residencies include Skowhegan School of Painting and Sculpture, the Henry Street Settlement Abrons Arts Center, College Art Association Fellowship, the Headlands Center for the Arts Project Space Residency, and the Center for Book Arts Emerging Artist Workspace Grant. She received a BA magna cum laude from Brown University and an MFA from Columbia University. Chitra Ganesh is represented by Thomas Erben Gallery.

DEBORAH GRANT resides in New York City. She has exhibited in group shows at the Bronx Museum; the Studio Museum in Harlem; the Santa Monica Museum of Art; Center for Contemporary Art, New Orleans; Carnegie Mellon's Regina Gouger Miller Gallery, Pittsburgh; and Triple Candy, Harlem, among others. She participated in the Artist In Residence program at the Studio Museum in Harlem in 2002-2003. Her recent exhibitions include *You Are Here,* The Ballroom, Marfa, Texas ; *Greater New York,* P.S. 1 Contemporary Art Center, New York; and *Propeller,* Steve Turner Gallery, Los Angeles. Her second solo project, *A GIN CURE* was presented in May 2006 at Roebling Hall, New York. She received a BFA in painting from Columbia College in Chicago in 1996 and an MFA in painting from the Tyler School of Art in the spring of 1999. She also attended the Skowhegan School of Painting and Sculpture in 1996.

HANS HAACKE is an artist who has lived in New York since the early 1960s. For more than thirty-five years he has been looking at the relationship between art, power, and money, and has addressed issues of free expression and civic responsibilities in a democratic society. A one-person exhibition, scheduled at the Guggenheim Museum in 1971, was cancelled by the museum because of a visitors' poll and two works analyzing New York real estate empires. One of these real estate works—now in the collection of the Centre Georges Pompidou in Paris—was part of the Tate Modern's *Open Systems: Rethinking Art* exhibition in 2005. Among the institutions that have held one-person exhibitions of Haacke's work are The Tate Gallery, London; the New Museum of Contemporary Art, New York; and the Centre Georges Pompidou, Paris. His work was included in the 2000 Whitney Biennial and in four documenta exhibitions, most recently in 1997. A permanent installation was inaugurated in 2000 in the Reichstag, the German Parliament building in Berlin. Haacke shared a Golden Lion with Nam June Paik for the best pavilion of the 1993 Venice Biennial. *Free Exchange*, a conversation by the artist with Pierre Bourdieu, was published in 1994 (Stanford University Press, 1995). Translations have since appeared in eight languages. Recently, his work was exhibited in *Monuments for the USA* at CCA Wattis Institute for Contemporary Art, San Francisco; *Open Systems: Rethinking Art* at Tate Modern, London; and *State of the Union* at the Paula Cooper Gallery, New York.

K8 HARDY is a New York-based artist concerned with turning over the stones that hold the patriarchy down and looking underneath. Hardy's work is based in video and performance. She is a founding editor of the queer feminist art journal, *LTTR*. Selected exhibitions include Reena Spaulings Fine Art, New York; The Kitchen, New York; Art In General, New York; Cubitt Gallery, London; Wexner Center for the Arts, Columbus, Ohio; and Centre National d' Art Contemporain de Grenoble, France. Hardy holds a BA in Film and Women's Studies from Smith College and participated in the Studio Division of the Whitney Museum of American Art Independent Study Program.

SHARON HAYES is an artist engaged in a practice that moves between video, performance, and installation in an ongoing artistic investigation into the relations of history, politics, and speech to the processes of individual and collective subject formation. To this aim, she employs conceptual and methodological approaches borrowed from artistic and academic practices such as theater, film, anthropology, linguistics, and journalism. Hayes' installation, video, and performance work has been shown in New York at P.S. 1 Contemporary Art Center, Andrew Kreps Gallery, Parlour Projects, Dance Theater Workshop, Dixon Place, HERE, Performance Space 122, the Joseph Papp Public Theater and the WOW Café, and the New Museum of Contemporary Art and in Los Angeles at Los Angeles

Contemporary Exhibitions, Track 16, Gallery 2102, and The Project. In addition she has shown in galleries, exhibition, and performance spaces in Bogotá, Berlin, Copenhagen, Malmö, Vienna, and Zagreb as well as in Florida, Rhode Island, Texas, and Vermont, and in forty-five lesbian living rooms across the United States. Hayes was a 1999 MacDowell Colony Fellow. She also received a 1999 New York Foundation for the Arts Fellowship. She was a participant in the Whitney Museum of American Art's Independent Study Program in 1999-2000, and received an MFA from the Interdisciplinary Studio at UCLA's Department of Art in 2003. Hayes was a resident at IASPIS in Malmö, Sweden in 2003, at Banff Centre for the Arts and the Lower Manhattan Cultural Council in 2004, and Smack Mellon in 2005.

EMILY JACIR is an artist living and working between Brooklyn, New York, and Ramallah, Palestine. Her work focuses on issues of movement (both forced and voluntary), dislocation, radical displacement and resistance. It also addresses the unconscious markers of borders (both real and imagined) between territories, places, countries, and states. She employs a variety of media in her practice including video, photography, performance, installation, and sculpture. Jacir has shown extensively throughout Europe, the Americas, and the Middle East. Her most recent group exhibitions include the 2005 Venice Biennale, the 2005 Sharjah Bienniel and the 2004 Whitney Bienniel. Recent solo exhibitions include Alexander and Bonin, New York; Anthony Reynolds, London; and the Sakakini Center, Palestine. She is also the recipient of numerous awards including the Lambent Foundation Fellowship and the Alpert/Ucross Residency Prize.

RONAK KAPADIA is program fellow at the Rockefeller Brothers Fund where he researches projects in immigrant justice/community organizing and the arts in New York City. A recent graduate of Stanford University, Ronak studied comparative ethnic studies and performance and wrote his thesis on New York-based South Asian queer cultural workers. As an actor, Ronak has worked with El Teatro Campesino and was featured in productions of Cherríe Moraga's *The Hungry Woman: Mexican Medea*, Migdalia Cruz's *Salt*, and Ricardo Bracho's *A to B*. Under the mentorship of playwright Cherríe Moraga, Ronak is currently working on a solo performance piece entitled "Terrorist Fag Drag and the Wild, Wild West," a multimedia cabaret piece that examines post-9/11 racial and sexual discourses as mediated through recent U.S. "homeland security" and "family values" measures.

BYRON KIM is an artist who lives in Brooklyn with Lisa Sigal and their three children. Kim's recent one-person exhibitions include *Recent Photographs and Sunday Paintings*, PKM Gallery, Seoul, South Korea; *Oddly Flowing*, Max Protetch, New York; *Permanent*, Hosfelt Gallery, San Franciso; and the traveling mid-career survey, *Threshold*, organized by

the Berkeley Art Museum. Kim has also had one-person exhibitions at the Whitney Museum of American Art at Phillip Morris, New York; Museum of Contemporary Art, Chicago; and Hirshhorn Museum and Sculpture Garden, Washington, D.C., among others. His work has shown internationally at the Kwangju Biennale; National Gallery, Warsaw, Poland; the National Museum of Art, Osaka, Japan; and Reina Sofia, Madrid, Spain. His numerous awards include the Joan Mitchell Foundation Grant; National Endowment for the Arts Award, and New York Foundation for the Arts Grant. Kim was born in La Jolla, California in 1961. He graduated from Yale University in 1983 with a BA in English. In 1986, he attended the Skowhegan School of Painting and Sculpture.

STEVE KURTZ is a founding member of Critical Art Ensemble (CAE). CAE is a collective of tactical media practitioners of various specializations, including computer graphics, Web design, wetware, film/video, photography, text art, book art, and performance. Formed in 1987, CAE's focus has been on the exploration of the intersections between art, critical theory, technology, and political activism. The collective has performed and produced a wide variety of projects for an international audience at diverse venues ranging from the street to the museum and to the Internet. CAE has also written five books, and has just released its sixth entitled *Marching Plague: Germ Warfare and Global Public Health*. Kurtz is an Associate Professor of Art at SUNY, Buffalo.

JULIAN LaVERDIERE is an artist who lives and works in New York City. Employing a pastiche of symbols, signs, and themes from the past and the present, LaVerdiere draws attention to pivotal moments and events that serve as historic harbingers of coming change and paradigm shifts. In 1999, LaVerdiere had his first New York one-person exhibition at Andrew Kreps Gallery. He has since had solo shows at No-Limits Gallery in Milan, Italy; Ever-Green Gallery in Geneva, Switzerland; and the Lehman Maupin Gallery in New York, and has participated in numerous group exhibitions in the United States and Europe. In 2000, his work was prominently featured in *Greater New York,* an exhibition at P.S.1 Contemporary Art Center, New York. In the same year, while developing *Bioluminescent Beacon,* a public art project with Creative Time, he was granted studio residencies at both the American Museum of Natural History and the Lower Manhattan Cultural Council Studio Program on the 91st floor of the North Tower of the World Trade Center. In 2001 and 2002, LaVerdiere worked with fellow-artist Paul Myoda, three architects, Creative Time, and the Municipal Arts Society to create *Tribute in Light,* the temporary light memorial to the victims of September 11th, 2001. This public artwork has subsequently been selected to become an annual addition to the WTC Memorial. In 2003, LaVerdiere had his first solo museum exhibitions at the Museum of Contemporary Art, Miami and the Museum of Contemporary Art, Cleveland. His work is included in

the permanent collections of P.S. 1 Contemporary Art Center New York; The Queens Museum of the City of New York; Museum of Contemporary Art, Miami; Museu Nacional de História Natural, Lisbon, Portugal; and the Library of Congress, Washington, D.C., as well as a number of major private collections. He is represented by Lehmann Maupin Gallery, New York. LaVerdiere has received awards and grants for both individual and public art collaborations. In 2002, he received the first Cooper Union Urban Visionaries Award. In 2003, he and his fellow *Tribute in Light* collaborators received the Brendan Gill Prize from the Municipal Arts Society. In 2004, he received a NYC Percent for Art grant to make a piece for FDNY Engine Company #277, which is to be installed in 2007. LaVerdiere was born in 1971 and was raised in New York City. He earned a BFA from The Cooper Union in New York and a MFA in sculpture from Yale University.

LUCY LIPPARD is a writer and activist, author of twenty books on contemporary art, feminism, politics, and place. After earning a BA degree from Smith College, she worked with the American Friends Service Committee in Mexico. She went on to earn an MA degree in art history from the Institute of Fine Arts at New York University. Since 1966, Lippard has published over twenty books on feminism, art, politics, and place including *On the Beaten Track: Tourism, Art and Place* (The New Press, 1999), *The Lure of the Local: Senses of Place in a Multicentered Society* (The New Press, 1997), *The Pink Glass Swan: Selected Feminist Essays on Art* (The New Press, 1995), *Mixed Blessings: New Art in a Multicultural America* (Pantheon Books, 1990), and *Get the Message? A Decade of Art for Social Change* (E.P. Dutton, 1984). Lippard was a cofounder of Printed Matter, the Heresies Collective, Political Art Documentation/Distribution, ARTISTS CALL Against U.S. Intervention in Central America, and other artists' organizations. She has also curated over fifty exhibitions. Lippard has been the recipient of numerous awards including a Guggenheim Fellowship for work on a critical study of Ad Reinhardt in 1968; National Endowment for the Arts grants in 1972-73 and 1976-77; and the Frank Jewett Mather Award for Criticism in 1976. She received a grant in 2001 to write *Scratching the Surface*, a book about the vortex of land and lives in the Galisteo Basin.

MARLENE McCARTY is a visual artist who works across media in New York City and Europe. McCarty's works, which range from abrasive text paintings to monumental figurative drawings, have been shown at Sikkema Jenkins and Co., New York; Bronwyn Keenan, New York; American Fine Arts, New York; Metro Pictures, New York; Sandroni Rey Galleries, Los Angeles; Neue Gesellschaft für Bildende Kunst, Berlin; Wiener Secession, Vienna; Reina Sophia, Madrid; ProArte Contemporary Art Institute, St. Petersburg, Russia; and The Project, Dublin. In 2005, her work was seen in shows at the Badischer Kunstverein, Karlsruhe, Germany and Neue

Kunsthalle St. Gallen, Switzerland. McCarty was one of the American representatives in the 2003 Istanbul Biennial. The Istanbul installation was also shown in 2004 at the Brent Sikkema Gallery, New York. McCarty was a recipient of a 2002-03 Guggenheim Fellowship. Her work is in numerous collections including the Museum of Modern Art , New York and the Museum of Contemporary Art, Los Angeles. Moving from Kentucky to New York City's East Village (via Basel, Switzerland where she studied design) in the 1980s, McCarty worked with Tibor Kalman at the famed M&Co. and also at the Museum of Modern Art, New York. In the late 1980s McCarty was a member of *Gran Fury*, the AIDS activist collective. In 1989, she founded Bureau, a company whose mandate was to produce art, film titles, political work, and brand identities. For Bureau, McCarty designed film titles for *Far from Heaven*, *Hedwig and the Angry Inch*, *American Psycho*, *Velvet Goldmine*, and *The Ice Storm* among many others. Bureau's corporate clients included Calvin Klein, Comme des Garcons, MTV, Elektra Records, and The Sundance Channel. Campaigns were also developed for the ACLU, United Nations Population Fund, GMHC, and Doctors Without Borders. Presently McCarty is adjunct professor at Cooper Union for advanced drawing. She has also taught at Harvard, Princeton, Rhode Island School of Design, Yale, and New York University.

JOHN MENICK is a filmmaker, artist, and writer living in Brooklyn, New York. His projects and films have been exhibited at the P.S. 1 Contemporary Art Center, New York; Palais de Tokyo, Paris; the Rooseum, Malmö, Sweden; and Muro Sur, Santiago, Chile. His essays, reviews, and fiction have appeared in various journals including *Parachute, UKS, The Progressive*, and *Tank Magazine*. Menick's most recent film, *Occupation*, is a narrative short concerning the politics of immigration in the suburbs of Paris. He is currently working on film essay about post-apocalyptic cinema. Menick was born in White Plains, New York, and graduated with a BFA from the Cooper Union. For more information see www.johnmenick.com

HELEN MOLESWORTH is the Chief Curator of Exhibitions at the Wexner Center for the Arts. Her most recent exhibition *Part Object Part Sculpture* charted a genealogy of transatlantic sculpture produced in the wake of Marcel Duchamp's erotic objects and his handmade readymades of the 1960s. From 2000 to 2002, she was the Curator of Contemporary Art at The Baltimore Museum of Art, where she organized *Work Ethic*, which traced the problem of artistic labor in post-1960s art. She is the author of numerous articles and her writing has appeared in publications such as *Art Journal*, *Documents*, and *October*. Her research areas are concentrated largely within and around the problems of feminism, the reception of Marcel Duchamp, and the socio-historical frameworks of contemporary art.

ANNE PASTERNAK, President and Artistic Director of Creative Time, joined the organization in the fall of 1994. She has since quadrupled the organization's budget and expanded its visibility as well as its commitment to commissioning experimental artworks in the public realm. Renowned projects under Pasternak's direction range from exhibitions and performances in the historic Brooklyn Bridge Anchorage, sculptural installations in Grand Central Station's Vanderbilt Hall, sign paintings in Coney Island, and skywriting over Manhattan to the Tribute in Light, the twin beacons of light that illuminated the former World Trade Center site six months after 9/11. Pasternak was director of the Stux Galleries in Boston and New York from 1985 to 1989, and from 1990 to 1991 was curator of Real Art Ways in Hartford. She curates independent exhibitions, consults on urban planning initiatives, and contributes essays to cultural publications. She lectures extensively throughout the United States and Europe. She served as a guest critic at Yale University in 2003 and has been teaching at the School of Visual Arts since the summer of 2005. Pasternak pursued a combined major in Art History and Business Management at the University of Massachusetts in Amherst and received her BA in 1985. From 1990 to 1993 she pursued her Master's Degree in Art History at Hunter College in New York City. She lives in New York City with her husband, artist Mike Starn, and their daughter, Paris Starn.

HEATHER PETERSON began working with Creative Time in May of 2003. After making the rounds through most departments—as a Curatorial Intern, Project Manager/ Producer, and Director of Development—Heather stepped into her role as Deputy Director in 2005, utilizing her cumulative knowledge to oversee the organization's day-to-day operations and long-range planning. Before joining the nonprofit sector, Heather had a successful career producing imagery with a wide range of commercial and editorial photographers and illustrators, working as an Art Buyer for advertising agencies including Merkley Newman Harty, SS+K, ZPFM, and M+C Saatchi, and as a Photo Editor for the magazine Real Simple . She holds an honors English degree from Vassar College and a Master's Degree in Modern Art and Curatorial Studies from Columbia University.

PAUL PFEIFFER is a New York-based media artist. Pfeiffer's groundbreaking work in video, sculpture, and photography uses recent computer technologies to dissect the role that mass media plays in shaping consciousness. He has had solo exhibitions at the Whitney Museum of American Art, New York; List Visual Arts Center, MIT, Cambridge, MA; The Barbican Art Centre, London; The UCLA Hammer Museum, Los Angeles; and Kunst-Werke, Berlin, Germany, among many others. Pfeiffer is the recipient of numerous awards and fellowships, including The Bucksbaum Award given by the Whitney Museum of American Art, a Fulbright-Hayes Fellowship, and a Project Grant from Art

Matters. In 2002, Pfeiffer was an artist-in-residence at the Massachusetts Institute of Technology and at ArtPace in San Antonio, Texas. Pfeiffer was born in Honolulu, Hawaii in 1966, but spent most of his childhood in the Philippines. He has a BFA from the San Francisco Art Institute, an MFA from Hunter College in New York and participated at the Whitney Museum of American Art Independent Study Program.

PATRICIA C. PHILLIPS is a writer whose concerns encompass contemporary public art, architecture, sculpture, landscape, and the intersection of these areas. She is the author of *It Is Difficult, a Survey of the Work of Alfredo Jaar* (ACTAR, Barcelona, 1998) and curator and editor of *City Speculations* (Princeton Architectural Press and The Queens Museum of Art, New York, 1996.) Her essays have been published in *Artforum, Art in America, Flash Art, Public Art Review*, and *Sculpture*, and collections of essays published by Bay Press, Princeton Architectural Press, MIT Press, Rizzoli International Publications, and Routledge. She is editor-in-chief of *Art Journal,* a quarterly on modern and contemporary art published by the College Art Association and is Professor of Art and Chair of the Art Department at the State University of New York at New Paltz.

MICHAEL RAKOWITZ is an artist living in New York. In 1998, he initiated *paraSITE*, an ongoing project in which the artist custom builds inflatable shelters for homeless people that attach to the exterior outtake vents of a building's heating, ventilation, or air conditioning system. Rakowitz's work has appeared in exhibitions worldwide including P.S.1 Contemporary Art Center, MassMOCA, the Tirana Biennale, the National Design Triennial at the Cooper-Hewitt National Design Museum, and Transmediale 05: BASICS at the House of World Cultures in Berlin. His work has been included in *SAFE: Design Takes On Risk* at MoMA, *T1: The Pantagruel Syndrome* at the Castello di Rivoli in Torino, and *Beyond Green: Toward a Sustainable Art* at the Smart Museum of Art, University of Chicago. He has had solo exhibitions at Lombard-Freid Projects, New York; Alberto Peola Arte Contemporanea in Torino, Italy; and the Stadtturmgalerie/Kunstraum Innsbruck. In 2006, Rakowitz received a Fellowship Grant in Architecture and Environmental Structures from the New York Foundation for the Arts. He is the recipient of the 2003 Dena Foundation award and in 2002 was awarded the Design 21 Grand Prix by UNESCO. A book on his work, *Circumventions*, was published in 2003 by the Dena Foundation of Contemporary Art and onestar press. Rakowitz is an Associate Professor at Northwestern University and is a contributing editor for *Surface Tension: A Journal on Spatial Arts*. He is represented by Lombard-Freid Projects.

BEN RODRIGUEZ-CUBEÑAS is Program Officer for the New York City portion of the RBF's Pivotal Place program. Prior to joining the RBF in early 1996, Mr. Rodriguez-Cubeñas was a program officer at the William Randolph Hearst Foundations, where he worked nationally in the areas of education, health, human services, and arts and culture. Mr. Rodriguez-Cubeñas' wide range of associations includes service as vice-chair of the board of directors of Casita Maria, the oldest Hispanic settlement house in New York. He is a board member of the New York Foundation for the Arts and served as a national advisory board member of New Ventures in Philanthropy. In 1998, he cofounded and serves as the chair of the Cuban Artists Fund, an international organization dedicated to helping individual artists and to using the arts as a vehicle for mutual understanding and relationship-building. Mr. Rodriguez-Cubeñas has also served on numerous committees and advisory boards, including the New York Regional Association of Grantmakers' City Connect Committee and Communications Committee, the Council on Foundations' Annual Conference Planning Committee, the Scholarship Committee for the Center for Public Service at Seton Hall University, and the Advisory Group for the Fund for New Citizens at the New York Community Trust. He is a fellow of the Institute for Urban Design and a member of the Americas Society and the Hispanic Society of America. Mr. Rodriguez-Cubeñas has a BA in political science from Seton Hall University and a master's degree in international affairs from Drew University.

MARTHA ROSLER is an artist working in video, photo-text, installation, and performance. She also writes criticism and lectures nationally and internationally. Her work on the public sphere ranges from everyday life and the media to architecture and the built environment. The exhibition cycle *If You Lived Here*, which she organized at the Dia Center in New York in 1989, centered on housing and homelessness and brought together artists, activists, architects, and urban planners. Her photographic series and her writing on roads, transport, and urban undergrounds further consider the landscapes of everyday life. Her photomontage series joining images of war and domesticity, first made in relation to Vietnam, has been reprised in relation to Iraq. Her work has been seen in documenta; several Whitney Biennials; at the Institute of Contemporary Art, London; the Museum of Modern Art, New York; and many other venues. A retrospective of her work has been shown in five European cities and in New York. Rosler was awarded the Spectrum International Prize in Photography for 2005 and the Oskar Kokoscha Prize (awarded by the Austrian government) for 2006. Rosler has published fourteen books and numerous other publications. Her book of essays, *Decoys and Disruptions: Selected Writings, 1975-2001*, was published in 2004. Rosler lives and works in New York City. She received her BA from Brooklyn College and her MFA from

University of California, San Diego. She teaches at Rutgers University in New Jersey.

RALPH RUGOFF is Director of Hayward Gallery, London. He has organized numerous group exhibitions over the past fifteen years, including *Irreducible: Contemporary Short Form Video* and *Monuments for the USA*. In addition, he has worked on individual projects with artists such as Jeremy Deller, Brian Jungen, Mike Kelley, Mike Nelson, and Shirley Tse. As a writer, he has contributed essays for books and periodicals on numerous contemporary artists and is also the author of *Circus Americanus* (Verso, 1995), a book of essays on popular visual culture.

AMY SILLMAN was born and raised in the Midwest and moved to New York City in 1975. Originally a student of Japanese language at New York University, she became a painter and received her BFA from School of Visual Arts in 1979 and her MFA from Bard College in 1995. Sillman began showing her work in New York City in the mid-90s, and is now represented by Sikkema Jenkins & Co in NYC. Solo exhibitions include Sikkema Jenkins & Co, The Institute of Contemporary Art Philadelphia, Susanne Vielmetter Los Angeles Projects, Dartmouth College, and Casey Kaplan. Sillman has been included in numerous group shows including the 2004 Whitney Biennial and *The Triumph of Painting* show at the Saatchi Gallery, London, as well as many other museums and galleries throughout the U.S. A book entitled *Amy Sillman: Works on Paper* with a text by Wayne Koestenbaum was published by Gregory R. Miller & Co. in 2006. Sillman is Co-Chair of the MFA Painting Department at Bard College and is also on the MFA faculty at Columbia University. Her many other involvements have included helping to run Four Walls in Williamsburg, Brooklyn, in the early 90s, collaborative painting with David Humphrey and Elliott Green as Team ShaG, and various writing and publishing projects.

ALLISON SMITH's diverse artistic practice engages in an investigation of the cultural phenomenon of historical reenactment and the role of craft in the construction of national identity. Smith is represented by Bellwether, New York. She has exhibited her work internationally at venues including P.S.1 Contemporary Art Center, MASS MoCA, and The Andy Warhol Museum. In 2005 Smith organized *The Muster,* a project of the Public Art Fund organized around the question "What are you fighting for?" in which hundreds of enlisted artists, intellectuals, and activists fashioned uniforms, built campsites, and declared their causes to an audience of over 2000 on New York's Governors Island (http://www.themuster.com). Her ongoing project *Notion Nanny* (http://www.notionnanny.net/) is a UK-based collaborative touring project originally commissioned by London-based curatorial team B+B, Sarah Carrington and Sophie Hope, in which Smith takes on the role of an itinerant

apprentice engaging with traditional craftspeople about the social histories as well as the revolutionary potential of present day craft-oriented practices. *Notion Nanny* is supported by Arts Council England, the Jerwood Charity, Grizedale Arts, The Wordsworth Trust, Center for British Romanticism, and Craftspace Touring's Transborder Craft Initiative. In the fall of 2006, Smith will be an International Artist-in-Residence at ArtPace San Antonio. She has taught courses in studio art and criticism at schools including Columbia University, Parsons School of Design, and Maryland Institute College of Art's study abroad program in Aix-en-Provence, France, as well as lectured at many other schools throughout the U.S. and abroad. She has been invited to speak at such institutions as the Spencer Museum of Art, the Whitney Museum of American Art, and the Museum of Modern Art. Smith was born in Manassas, Virginia in 1972. She received a BA in psychology from the New School for Social Research and a BFA from Parsons School of Design in 1995. She received an MFA from Yale University School of Art in 1999. Smith participated in the Whitney Museum of American Art Independent Study Program in 1999-2000.

KIKI SMITH is an artist of international prominence whose career has thus far spanned over three decades. Smith is a leading proponent of artists addressing philosophical, social, legal, and spiritual aspects of human nature. The artist lives and works in New York City and has exhibited with PaceWildenstein since 1994. Smith's work has been shown in numerous one-person exhibitions including the Corcoran Gallery of Art, Washington, D.C.; Louisiana Museum of Modern Art, Humlebaek, Denmark; The Israel Museum, Jerusalem; Whitechapel Art Gallery, London; the Montreal Museum of Fine Arts, Canada; the Modern Art Museum, Fort Worth; the Irish Museum of Modern Art, Dublin; the Hirshhorn Museum and Sculpture Garden, Smithsonian Institution, Washington, D.C.; and the International Center of Photography, New York. In 2003, The Museum of Modern Art, New York exhibited a survey of Smith's printed art, *Kiki Smith: Prints, Books & Things*. In 2005, Smith installed *Homespun Tales: a tale of domestic occupation* at the Fondazione Querini Stampalia, a museum house in Venice, Italy. The Walker Art Center, Minneapolis recently organized Smith's first major traveling retrospective. The exhibition opened at the San Francisco Museum of Modern Art and then traveled to the Walker Art Center; the Contemporary Arts Museum, Houston; and the Whitney Museum of American Art. In 2000, the Skowhegan School of Painting and Sculpture awarded Smith with their prestigious Skowhegan Medal for Sculpture. She was elected to the American Academy of Arts and Letters, New York, in 2005, and most recently, the Rhode Island School of Design honored her with the Athena Award for Excellence in Printmaking. Smith's work can be seen in public collections around the world.

DAVID LEVI STRAUSS is a writer and critic in New York, where his essays and reviews appear regularly in *Artforum* and *Aperture*. His collection of essays on photography and politics, *Between the Eyes,* with an introduction by John Berger, was published by Aperture in 2003, and has just been released as a paperback and in an Italian edition by Postmedia. *The Book of 101 Books: Seminal Photography Books of the Twentieth Century,* with catalogue essays by Strauss, was published by P.P.P. Editions and D.A.P. in 2001. *Between Dog & Wolf: Essays on Art & Politics* was published in 1999 by Autonomedia, and *Broken Wings: The Legacy of Landmines,* with photographer Bobby Neel Adams, came out in 1998. His essays have appeared in a number of recent books and monographs on artists, including Leon Golub and Nancy Spero, Alfredo Jaar, Martin Puryear, Carolee Schneemann, Miguel Rio Branco, Daniel J. Martinez, and Francesca Woodman. He was the founding editor of *ACTS: A Journal of New Writing* (1982-1990), and author of a book of poetry, *Manoeuvres,* before moving from San Francisco to New York in 1993. He has been awarded a Logan grant, three Artspace grants, a Visiting Scholar Research Fellowship from the Center for Creative Photography, and a Guggenheim Fellowship in 2003-04. Strauss currently teaches in the Graduate School of the Arts at Bard College.

NATO THOMPSON is a curator and writer serving as Curator at MASS MoCA. He has written articles for numerous publications including *Cabinet, Parkett*, *Tema Celeste*, *Art Journal*, *New Art Examiner,* and *Journal of Aesthetics and Protest*. He recently organized the exhibition *Ahistoric Occasion: Artists Making History* featuring the work of Paul Chan, Jeremy Deller, Kerry James Marshall, Trevor Paglen, Dario Robleto, and Allison Smith. In 2004, Thompson organized *The Interventionists: Art in the Social Sphere*, an exhibition which surveyed political interventionist art from the 90s to today, featuring twenty-nine artists and collectives including Krzysztof Wodiczko, Critical Art Ensemble, Lucy Orta, the Atlas Group, and William Pope.L. Thompson has edited major catalogues for each MASS MoCA exhibition distributed by MIT Press. In 2005, Thompson received the award for Most Distinguished Contribution in Art Journal awarded by the College Art Association. He received his BA in Political Theory from UC Berkeley and his MA in Arts Administration from the School of the Art Institute of Chicago.

THE YES MEN are culture-jamming activists. Its two leading members are known by the aliases Andy Bichlbaum and Mike Bonanno. In 1999, Bichlbaum and Bonanno, in collaboration with ®™ark, created the Web site GWBush.com, a parody of the campaign Web site of George W. Bush. Later that year, they created a Web site at gatt.org parodying that of the World Trade Organization (WTO). Some visitors to the site mistook it for an actual home page of the WTO. This misidentification led to unexpected invitations to The

Yes Men to make public appearances and presentations. The Yes Men would use these opportunities to impersonate WTO officials and make satirical presentations, a practice referred to by The Yes Men as "identity correction." The experiences of The Yes Men have been documented in the film *The Yes Men* (MGM, 2005) and in the book *The Yes Men: The True Story of the End of the World Trade Organization* (The Disinformation Company, 2004).

Image Credits

AP Images: 104
Gavin Ashworth, Photographer: Darger, *Untitled*; 72
Courtesy The Baltimore Museum of Art: 74
Matt Blackett, Photographer: FTAA protest; 72
Courtesy Paul Chan: Vieques; 79 (Photographer), 108, 136
Courtesy Mel Chin: *Support*; 26, *Truth Hertz*; 32, 42, 55
L. V. Clark, Photographer. Courtesy Getty Images/
 Hulton Archive: 85
Paula Court/PERFORMA, Photographer: 91, 168
Courtesy EMI Music Arabia: 68
Courtesy Thomas Erben: 31
Arthur Evans, Photographer: 134
Courtesy Exit Art Archives: 65
Courtesy Fiambrera: 39
Courtesy Francis Young Tang Teaching Museum: 58
Courtesy Friends of William Blake: 136
Mitro Hood, Photographer. Courtesy The Baltimore
 Museum of Art: 74
David Gardner, Photographer: Catholic Workers; 115
Oto Gillen, Photographer: 25
Courtesy Gladstone Gallery, New York: 51,
 Bataille Monument; 52
Courtesy Getty Images/CNN: 119
Paula Goodman, Photographer: 37
Courtesy Deborah Grant: 137
Courtesy Greene Naftali Gallery, New York: 108
Timothy Ivison, Photographer: 126
Bruno Jakob, Photographer: 60, McCarty; 86
Courtesy Kent Gallery: 78
Courtesy Campaign to Stop Killer Coke: 92
Annette Koch, Photographer: *Bataille Monument*; 52
Courtesy Steve Kurtz/Critical Art Ensemble:
 Flesh Machine; 105
Courtesy Laura Bartlett Gallery: 63
Courtesy Julian LaVerdiere: ribbon; 127, 128
Courtesy Library of Congress, Prints & Photographs Division:
 President Coolidge mourning;127
Gareth Lind, Photographer: 45
Courtesy Lucy Lippard: Gourfain button; 32
Courtesy Lower Manhattan Cultural Council: 36
Risé Cale, Photographer. Courtesy Adelle Lutz: 8
Jay Lynch, Designer: 92
Nancy Lytle, Photographer: 70
John G. Mabanglo, Photographer. Courtesy Getty Images/
 AFP: Anti-WTO; 105
Attilio Maranzano, Photographer: *For The City*; 26
Courtesy Marlborough Gallery, New York: 121
Courtesy Max Protetch Gallery: 41, 69

Courtesy Marlene McCarty: 60, 84, McCarty; 86
Phyllis J. McCarty, Costume: 60, McCarty; 86
Courtesy Museum of Contemporary Art San Diego: 109
Courtesy Musée du Louvre, Paris: 14
Courtesy New Directions Publishing Corp.: 99
Nils Norman, Photographer: 75
Courtesy the Oil, Chemical, and Atomic Workers Union: 46
Courtesy Plexifilm: 82
Jan van Raay, Photographer: 123
Courtesy Michael Rakowitz and Lombard-Fried Projects:
 77, 169
Enrique Mandujano Reyes, Photographer: demonstration
 by farmers; 29
Courtesy Roebling Hall: 137
Courtesy Martha Rosler: 6
Ron Saari, Photographer: Hershey, PA street lamps; 52
Photograph by Stephen Shames/Polaris: 124
Courtesy Sikkema Jenkins & Co: 67
Sebastiao de Souza, Photographer. Courtesy Getty Images/
 AFP: Anti-NAFTA; 29
Mario Tama, Photographer. Courtesy Getty Images/
 Getty Images News: 30, 89
Courtesy Thomas Erben Gallery: 31
Courtesy Verso Books: *Planet of Slums*; 79
Muammer Yanmaz, Photographer: 49
Courtesy The Yes Men: 22, Bhopal Legacy; 71
Emna Zghal, Photographer: 27

Creative Time

Special Thanks

Doug Ashford would like to thank all the participants and potential participants who volunteered to come to meetings and speculate on our work, and followed up with editing ideas and more work. For those of you who couldn't make it these forums: we will do this again soon.

On a more concrete level Doug would like to thank Anne Pasternak for her historical commitment to experimentation; Peter Eleey's advice throughout was instrumental and shockingly wise—but this whole project would be impossible without the creative managerial clarity of Heather Peterson and the editorial brilliance of Melanie Franklin Cohn. They made this happen with grace and passion.

Doug would also like to thank Alyse Yang, Angelo Bellfatto, Laurie Greenberg, and Sandy Kaltenborn for their thoughts and inspiration during the organizing of this project and essay, and Molika and Samuel Ashford for their beautiful examples of emancipatory life.